IMAGES
of America

CLINTON

IOWA

IMAGES
of America

CLINTON

IOWA

Clinton County Historical Society

ARCADIA
PUBLISHING

Published by Arcadia Publishing
Charleston, South Carolina

Library of Congress Catalog Card Number: 2003106284

For all general information contact Arcadia Publishing at:
Telephone 843-853-2070
Fax 843-853-0044
E-Mail sales@arcadiapublishing.com
For customer service and orders:
Toll-Free 1-888-313-2665

Visit us on the Internet at www.arcadiapublishing.com

CONTENTS

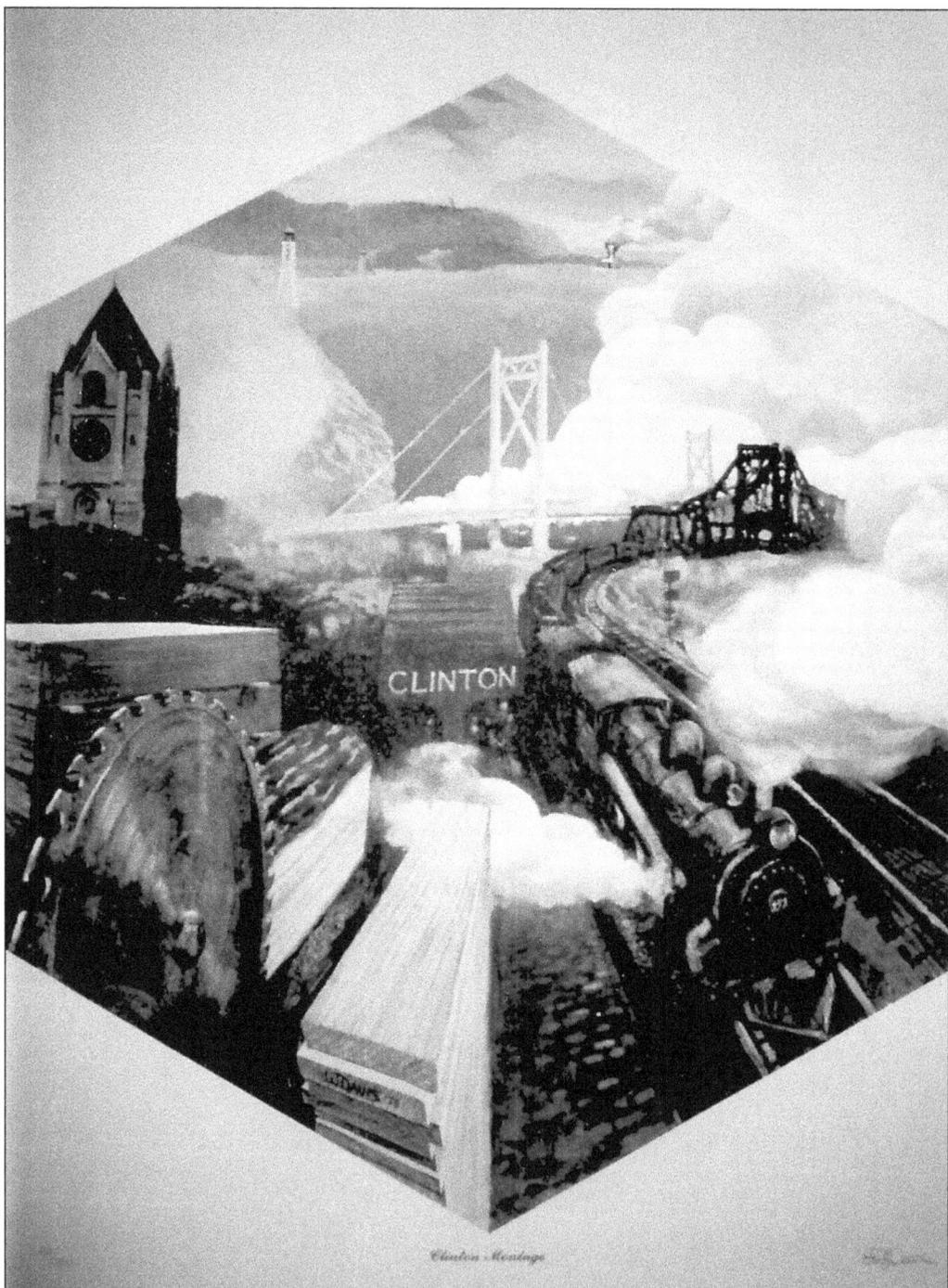

Clinton Montage by artist Larry Davis. (*c.* 1975.) (Photograph courtesy of the U.S. Bank, Clinton, Iowa.)

INTRODUCTION

"Things to Do with a River View." The use of the word "river" in the current promotional slogan of the Clinton Visitors and Convention Bureau reflects the relationship between the city of Clinton and the Mississippi River. The painting by Larry Davis, reproduced on the preceding page, is a montage illustrating a variety of factors contributing to the growth of the city: the river; the use of the river as a means of transportation; the river and its shoreline as recreational areas; the lumber industry critical to early development, which used the river to transport logs from the northern forests; the railroad bridging the river, enabling movement of goods and people; and the government location for Clinton County.

This book provides a pictorial essay of the businesses, people, and places—especially those not generally noted in histories of Clinton—which have made up the fabric of the community through the years.

Clinton, as we now know it, actually began in what is now the Lyons area in the north end of the city with the arrival of Elijah Buell in 1835. Buell, along with others, platted the town in 1837, and incorporation followed in 1855. What is now the central area of the city was, in 1836, home to a few settlers in a hamlet called New York. Platted at that time, it languished until 1855, when the Iowa Land Company was organized and the name was changed.

The completion of a railroad bridge across the river, along with the construction of a roundhouse and shops, propelled Clinton forward. Little development had occurred since the time both Lyons and New York were platted in the 1830s. This all changed in the 1850s with speculation of where railroads would cross the river and ultimately the completion of a bridge at Clinton in 1865.

Between the two towns lay another town, Ringwood, located between present-day 7th Avenue N. and 13th Avenue N., which was platted in 1856. It was incorporated in 1873 with the advent of a streetcar line running between Clinton and Lyons. The town was annexed to Clinton in 1878, and is still known as the Ringwood area. Chancy, a settlement located on the south side of Clinton, was annexed to the city in 1892, and it too is still known by its original name.

In 1894, the citizens of Lyons voted to be annexed to and consolidated with Clinton. This followed an election 17 years prior, in 1877, which resulted in a defeat of the proposal. In the interim, according to histories of the communities, there appears to have been considerable agitation in Lyons against merging with Clinton—hence the comment still heard in the community about being north or south of the "big tree," which is said to have been a landmark near 13th Avenue N., then the dividing line between Clinton and Lyons. Interestingly, even

though the communities had merged, Lyons continued to maintain a separate school district until the end of the 1954 school year.

It was also during this period that Clinton was made the county seat of Clinton County. Previously, the county seat was DeWitt, but in late 1869 a courthouse was built in what was then north Clinton between 6th and 7th Avenues N. Still the site of the Clinton County Courthouse, that building was replaced with the present building in 1894. Concurrent with the publication of this book, the courthouse will undergo a renovation project to historically restore the building while at the same time bring it to contemporary standards.

In that era, the first "wagon" bridges were built over the river, connecting Iowa and Illinois. First was the bridge from Lyons to Fulton. Completed in 1891, it later served as part of the Lincoln Highway, now Highway 30, until the time the old Clinton-Fulton high bridge, completed in 1892, was replaced in 1956. The old Lyons-Fulton Bridge was finally replaced in 1975.

The growth of the Clinton and Lyons communities was precipitated by building new sawmills along the river, which began in 1855. Running through the turn of the century, the mills produced millions of feet of lumber, stretching for about five miles along the riverbank. Logs to supply the mills were cut in the massive timber areas of Wisconsin and Minnesota. Rafts were made of the logs and up until 1865, floated naturally by the river current to the mills. Following that, to speed the supply of logs to the mills, the rafts were pushed by tows.

Among names familiar to the lumber business were Lamb, Young, Joyce, Gardiner, Batchelder, and numerous others. Millworks were established by the Curtis family in Clinton and the Disbrows in Lyons. Lumber from these firms was used to build many of the houses and buildings of Clinton, in addition to being shipped throughout the country. These families, as well as other business people of that era, built elaborate homes primarily along the central avenues of the city and in the Lyons area. While most of these no longer exist, several buildings still remain along those streets—notably the Clinton Women's Club and the YWCA.

Probably the most notable structure in the city is the Louis Sullivan-designed Van Allen Building. Standing on the corner of 5th Avenue S. and 2nd Street, it was completed in 1914 for the John D. Van Allen & Son Department Store. Presently, the building is being renovated to accommodate retail space and apartments. Structural decoration on the building is similar to that which appears on the Carson Pirie Scott Department Store building in Chicago, also designed by Sullivan.

Today the river continues to be a focal point for the city. While numerous businesses reside along it, the great benefit is of a recreational nature, reaching from Riverview Park, with its varied venues, in the center of the community, to Eagle Point Park on the bluffs of the north end of the city.

It is our hope that this book will provide a picture of how the Clinton community evolved through the years.

One

IN THE BEGINNING

Elijah Buell, an 1801 native of New York, was a river pilot on the midland rivers of the United States. In 1835, he decided to establish a home in what was then "the west." Elijah and a fellow traveler, John Baker, traveled up the Mississippi to a point on the river called the Narrows. Baker settled on the eastern bank and the city became Fulton, Illinois. Elijah chose the western bank of the river and settled Lyons, Iowa. He built a one-room cabin at what is now 25th Avenue N. and Grant Street, and by fall, his wife and son had joined him. Elijah Buell, as well as the city he settled, prospered and by the time of his death, he had become one of the wealthiest men in the state of Iowa. (Photograph from the Clinton County Historical Society Archives.)

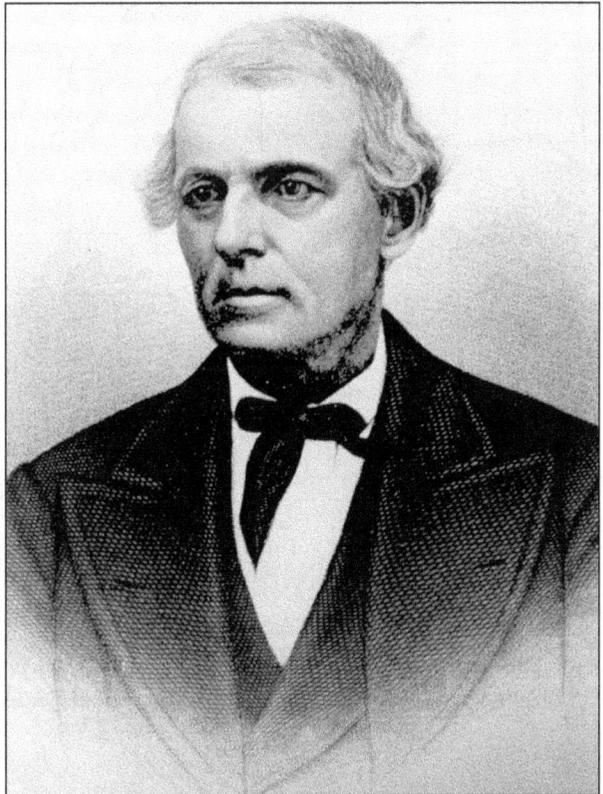

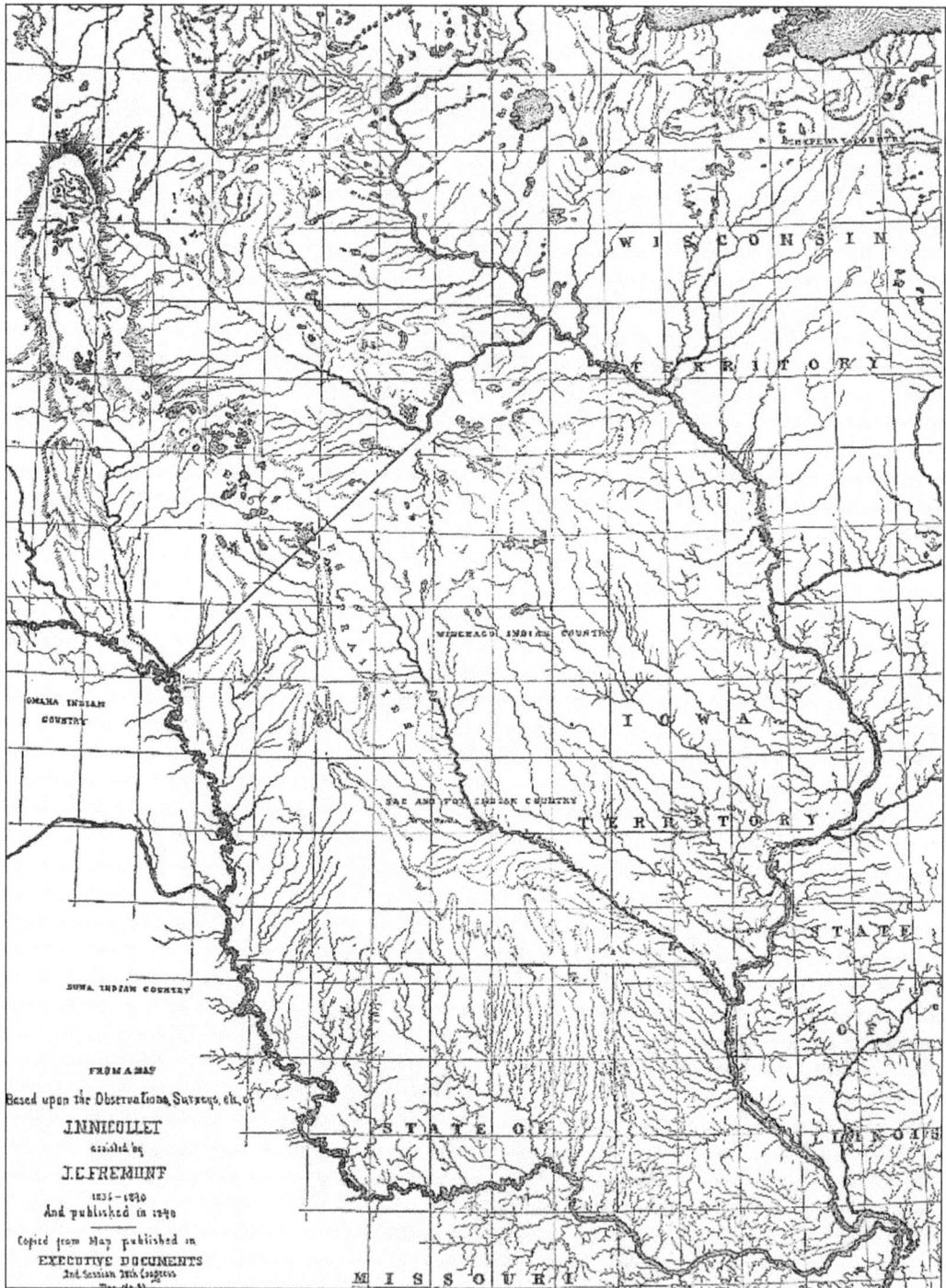

This is a map of the territory of Iowa as it was surveyed from 1836–1840 by J.N. Nicollet. (Photograph from the Clinton County Historical Society Archives.)

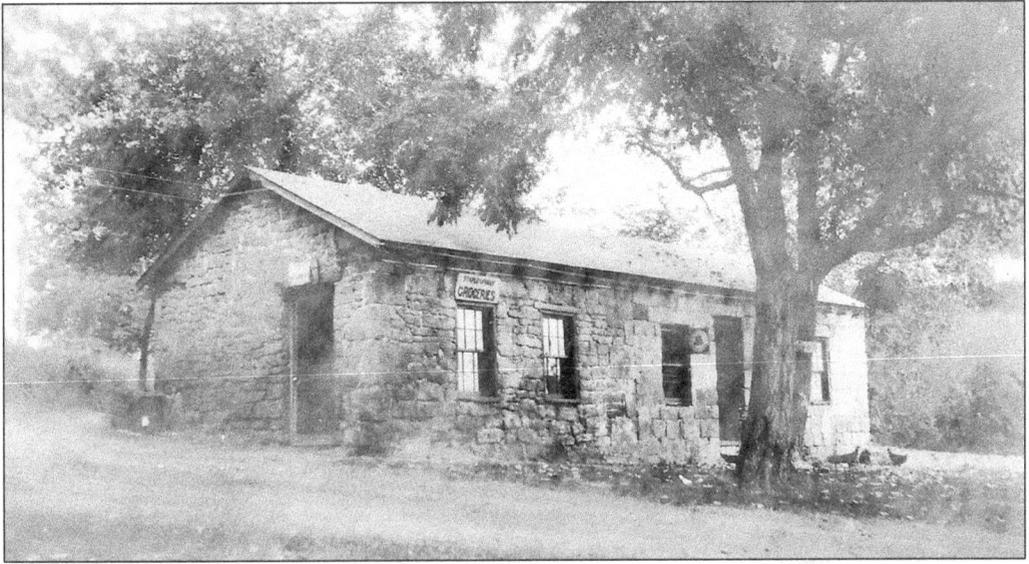

The old Stone House at 850 Bluff Road was built in 1836, by William Thomas, with thick walls of yellow limestone quarried right at the site. By 1837, it was used as a stopping point for the Pony Express by the authority of the U.S. Government and became known as 'the halfway house.' There is a long-told story that during the days of abolition, it was used as a station in the Underground Railroad. (Photograph from the Clinton County Historical Society Archives.)

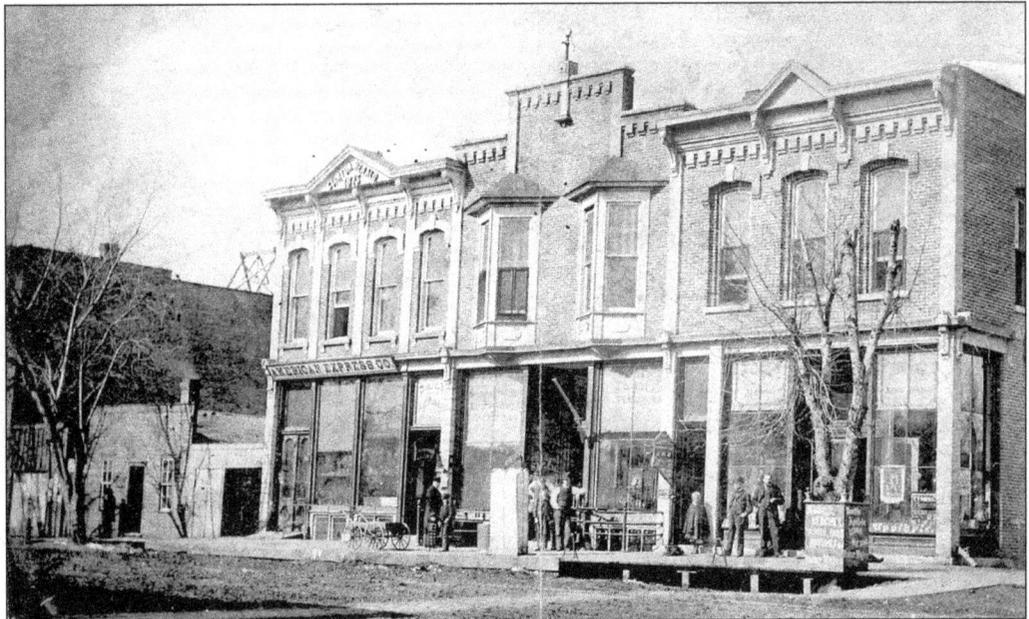

This is an 1883 view of the 400 block of South 2nd Street in Clinton, showing the west side of the street. The businesses shown, from left to right, are the Clinton Herald, the American Express Company, the Plumbing, Gas & Steam Fittings Co., and the Oscar Meyer Druggists. Note the pump on the top of the middle building and the gun in the doorway. Also note that the old City Hall had not yet been built. (Photograph from the Clinton County Historical Society Archives.)

The following quote is drawn from a document titled *Platting of the Town of Lyons, Territory of Iowa, County of Clinton*: "I, John Brophy, Surveyor of the above county, having at the request of Elijah Buell, George W. Heartland, Beale Randall, C.A. Hoag, and Dennis Warren, surveyed the Town of Lyons, on the Mississippi River, and platted the same. I hereby certify that it is correct and true according to the actual survey as expressed, and shown in the within map or plat, July 17, 1840. John Brophy, Surveyor." This plat map shows an update of that original survey. (Photograph from the Clinton County Historical Society Archives.)

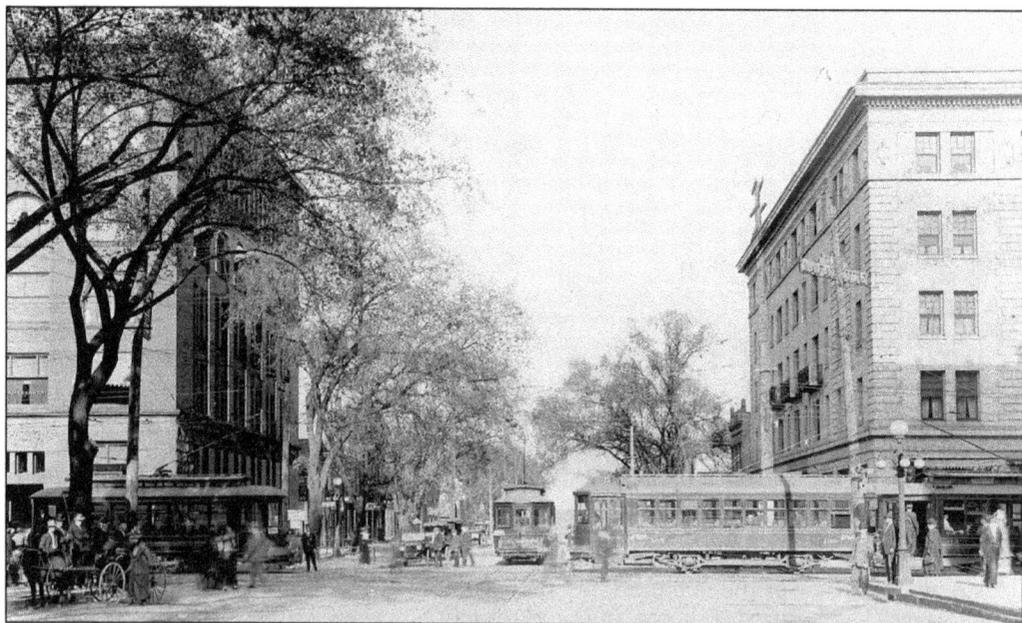

This 1915 view looks east toward the bustling street corner of 6th Avenue and 2nd Street in downtown Clinton, with the Weston Building on the left and the Lafayette Hotel on the right. The Weston Building was torn down in the early 1960s, and the site is now a downtown parking lot. (Photograph from the Clinton County Historical Society Archives.)

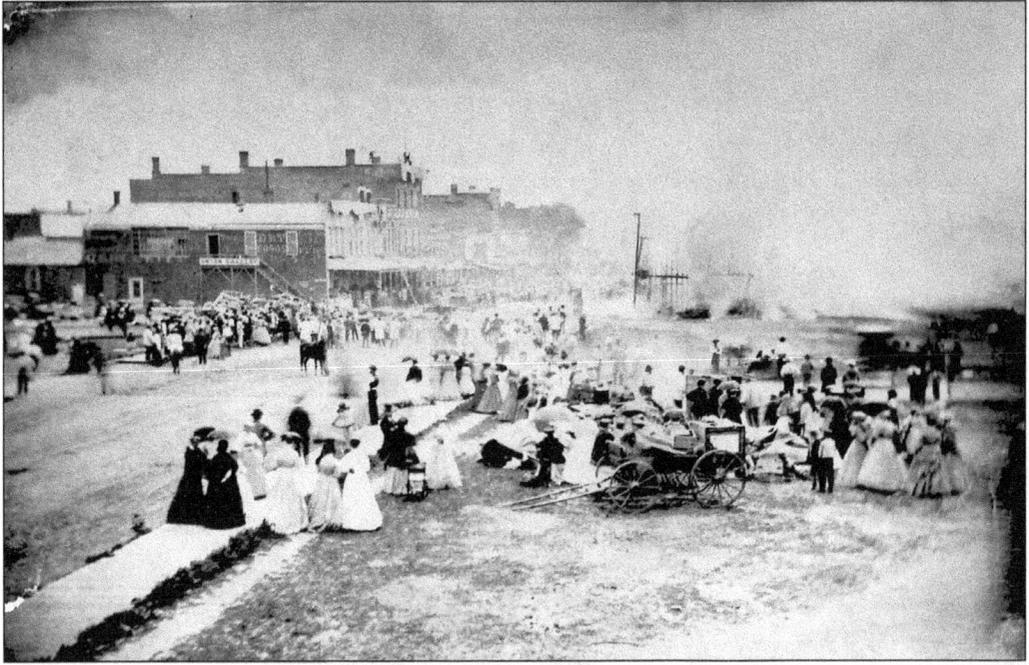

A fire in the city of Lyons on July 4, 1868 caused a crowd to gather. The building on the left is the Union Gallery. (Photograph from the Clinton County Historical Society Archives.)

The Clinton Steam Laundry Company was established in 1888 at 113 S. 2nd Street. The building became the Labor Temple in 1919 and was used by the Labor Congress for many years, followed by a tailor shop and also *The Town Talk*. Before being razed, the Labor Temple gave two of its ornate fireplaces to the Clinton County Historical Society Museum, where they are on display today. (Photograph from the Clinton County Historical Society Archives.)

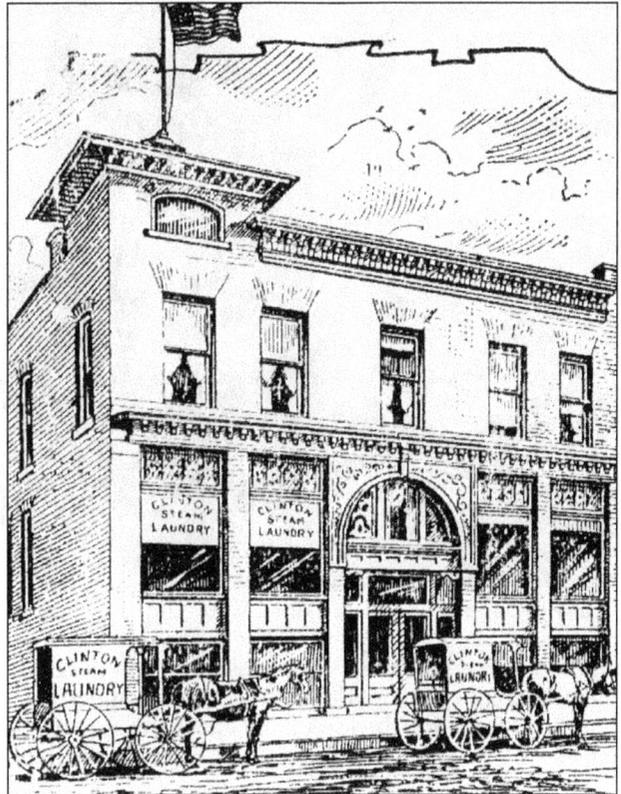

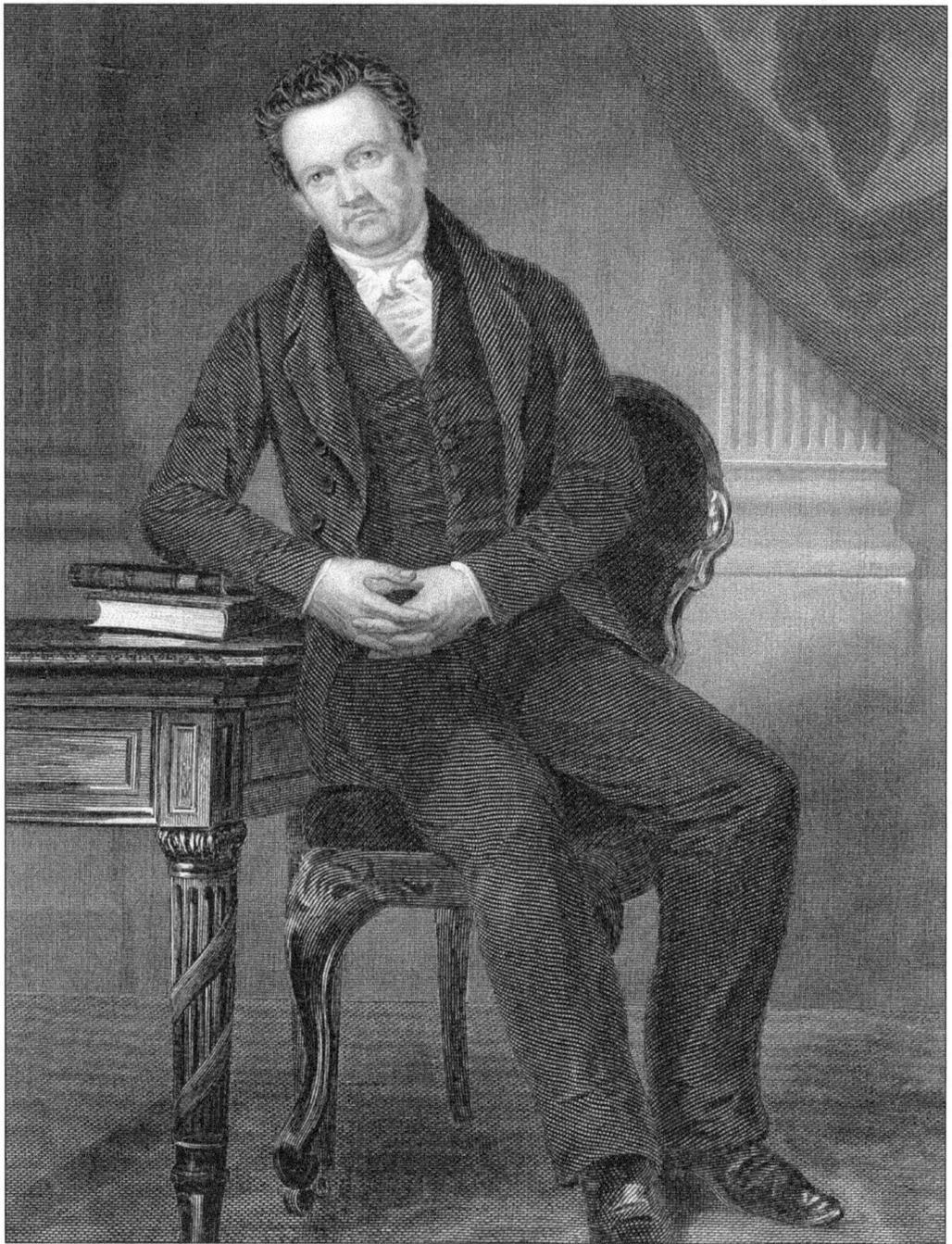

This is a pen-and-ink sketch of DeWitt Clinton, twice governor of the state of New York, and a prominent literary and public figure in that state. He was well-respected for his incorruptibility and was a chief promoter of the construction of the Erie Canal. Even though he had died before Clinton County was settled, the citizens considered it an honor to name their county after him. In 1855, when the Iowa Land Company re-platted the city of New York (Iowa), they also named the new city of Clinton after him. (Photograph from the Clinton County Historical Society Archives.)

14

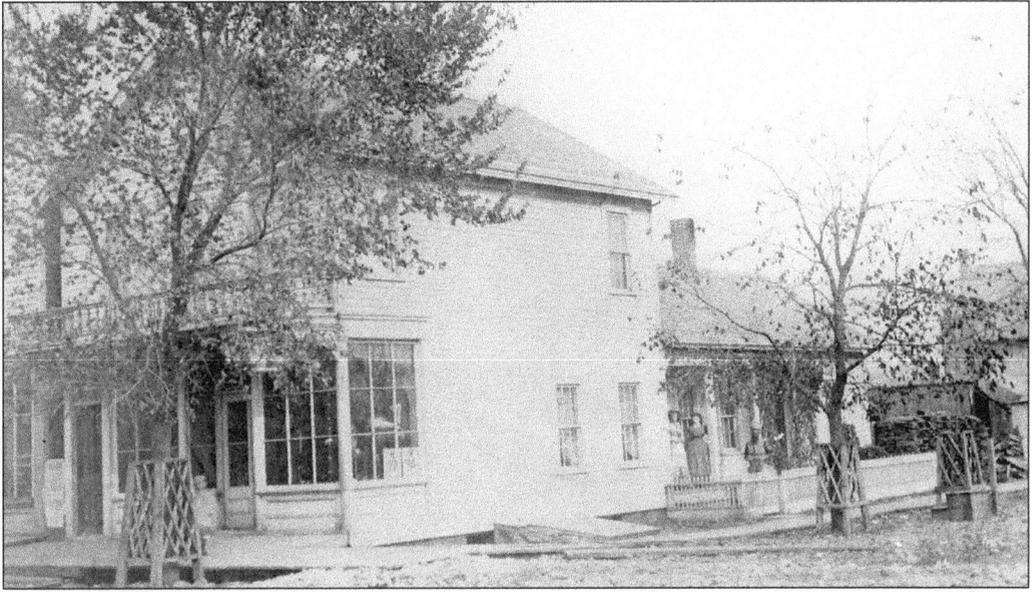

This 1869 photograph of the northeast corner of 6th Avenue and 2nd Street shows the home of Mr. and Mrs. J.L. Rumery (rear). The front of the building was used as the millinery shop of Mrs. Rumery and Mrs. Cornelia Heafie. In the 1890s, the Weston Building, generally considered Clinton's first skyscraper, was built on this site. The post office was located in the Weston Building until 1902, when it was moved to a new building at the 3rd Street location. At one time, 13 lawyers had their offices in the Weston Building. It was razed in the 1960s to make room for a municipal parking lot. (Photograph from the Clinton County Historical Society Archives.)

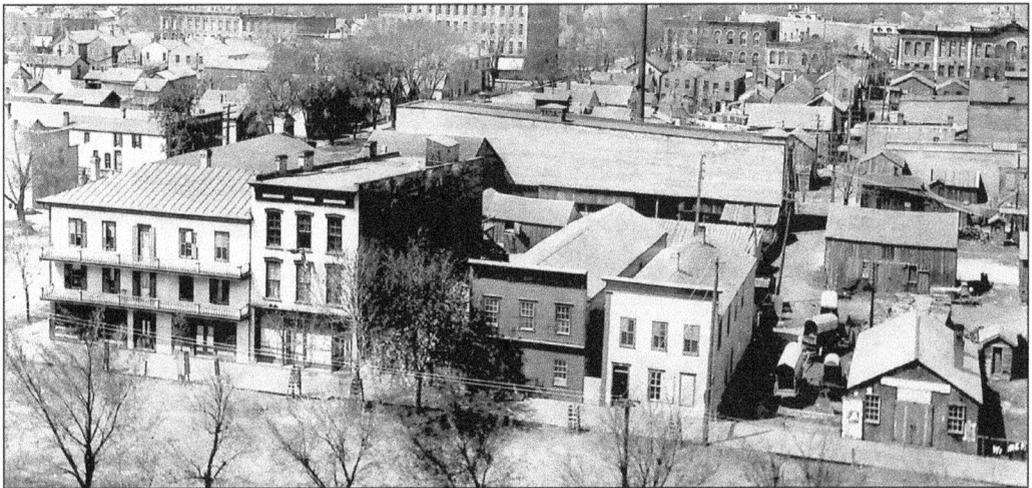

This 1880 view of downtown Clinton shows the Davis Block, which housed the famous Davis Opera House, the large four-story building in the center background. It was considered one of the most impressive buildings in Clinton. In the foreground on the left, at the corner of 6th Avenue and First Street, is a frame hotel built in 1864 and originally called the Mississippi House. It was purchased in 1865 by Henry Gerhard and renamed the Gerhard House. Three months later it burned to the ground and was later rebuilt. Mr. Gerhard operated the hotel for many years. Upon its sale, it was renamed the Grand Hotel, but was eventually razed. (Photograph from the Clinton County Historical Society Archives.)

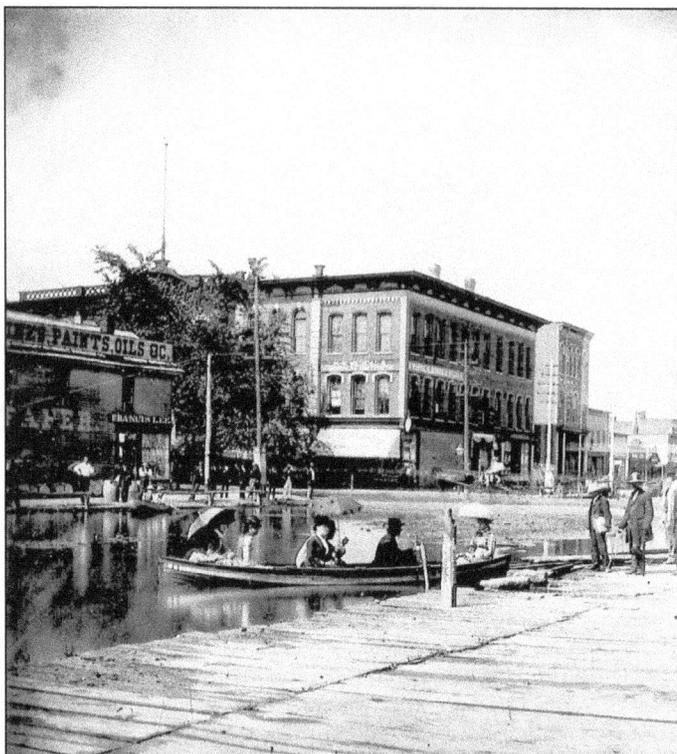

During the flood of 1880, citizens of the city traveled to their destination in spite of the high water. Looking west on 5th Avenue, Francis Lee Drugs is the store on the left with the three-story Toll Building in the background. The N.W. Medical & Surgical Institute was located on the second floor of the Toll Building, while the Howes Jewelry Store was on the corner. The Toll Building was contracted after Major Charles H. Toll returned from serving in the Civil War and was replaced by the Ankeny Building in the 1930s. (Photograph from the Clinton County Historical Society Archives.)

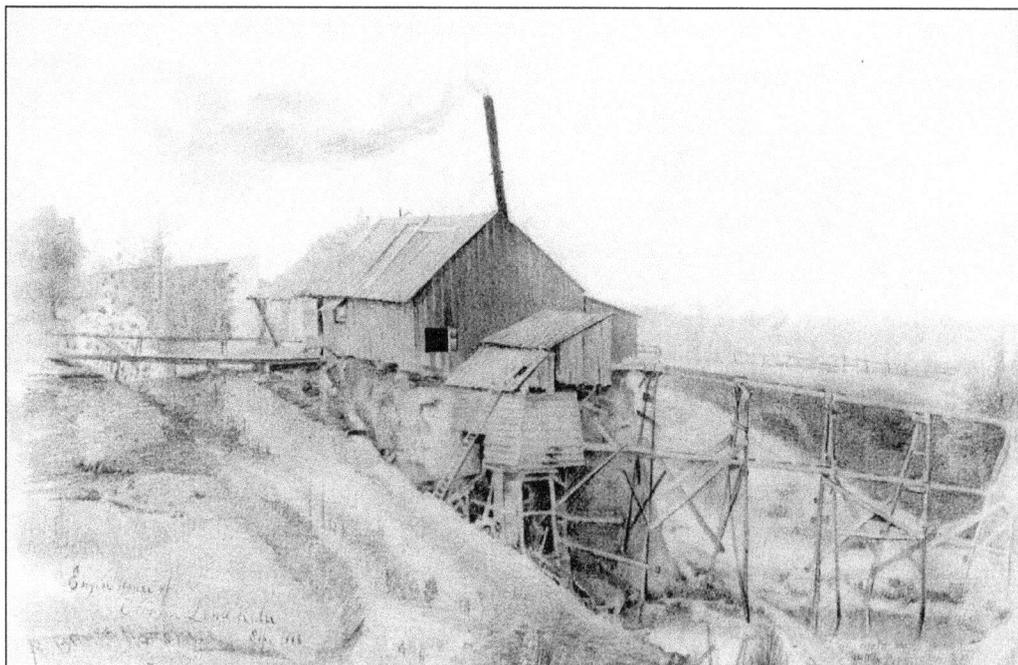

This is a pencil drawing of the Engine House of the Clinton Lime Kiln in 1889 by R. Bruce Horstfall. Mr. Horstfall was born in Clinton in 1863 and died in 1948. He achieved success as an illustrator of natural subjects and was known for his paintings of wildlife. He was a staff artist for *Nature* magazine. (Photograph from the Clinton County Historical Society Archives.)

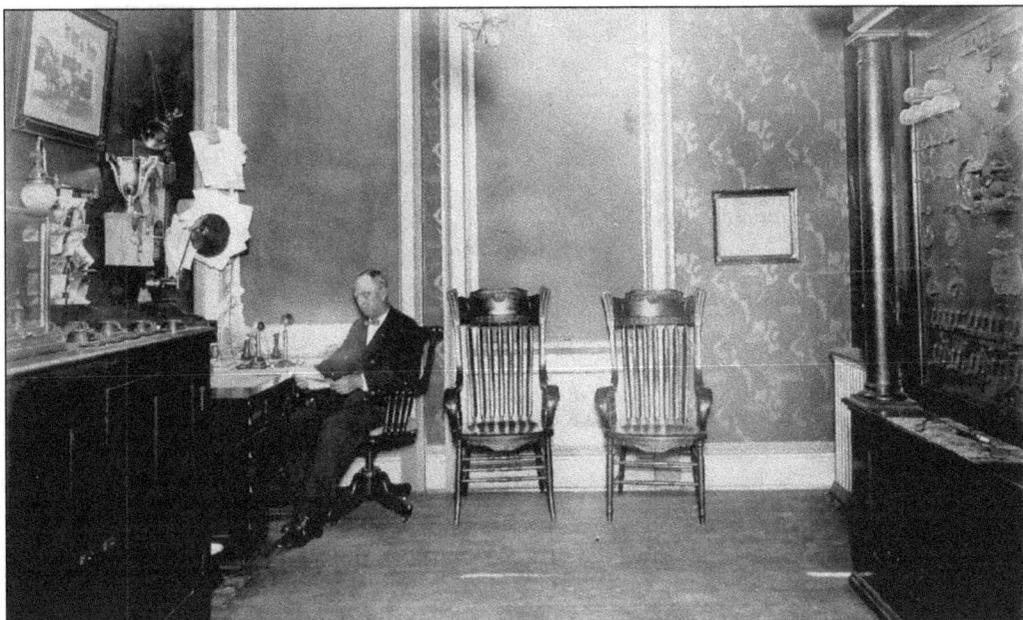

This image shows the interior of the Central Fire Station as it looked around 1900. The city was set up with call boxes, which came into the central call board shown on the right. This meant that the area of the fire was immediately known. The two chairs in the center of the photograph are now on display at the Clinton County Historical Society. (Photograph from the Clinton County Historical Society Archives.)

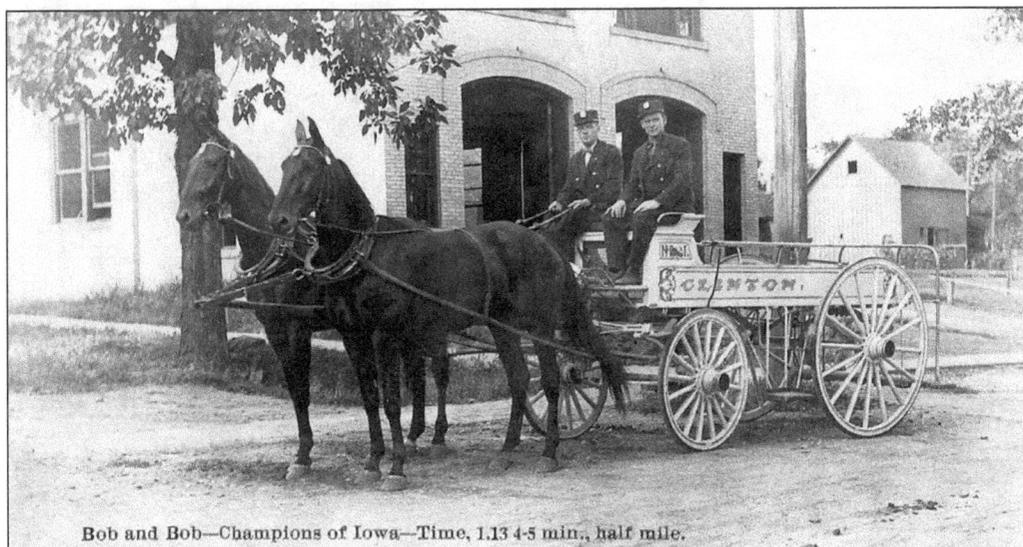

Bob and Bob—Champions of Iowa—Time, 1.13 4-5 min., half mile.

Bob and Bob were Clinton's State of Iowa champion fire horses. In 1907, they took first prize at an international meet in Kewanee, Illinois. They were known for their fast time of one minute 13 seconds on a half-mile track. Many times, the Clinton teams of fire horses were sent to neighboring cities to put on exhibition runs. The first race for champion fire horses was held in 1897, but the races were halted due to World War I, and the last race was held in 1919. The last tournament in which the Clinton horses participated was held in DeWitt; Clinton won over Davenport and Iowa City. (Photograph from the Clinton County Historical Society Archives.)

This is an 1880 photograph of downtown Clinton that shows the 500 block of 2nd Street before the annexation of Lyons to Clinton. The IOOF building stands on the left. The horse-drawn trolley tracks connecting the two cities are shown running down the center of the street. To the upper right, stacks of lumber from the sawmills can be seen two blocks away on the riverfront. (Photograph from the Clinton County Historical Society Archives.)

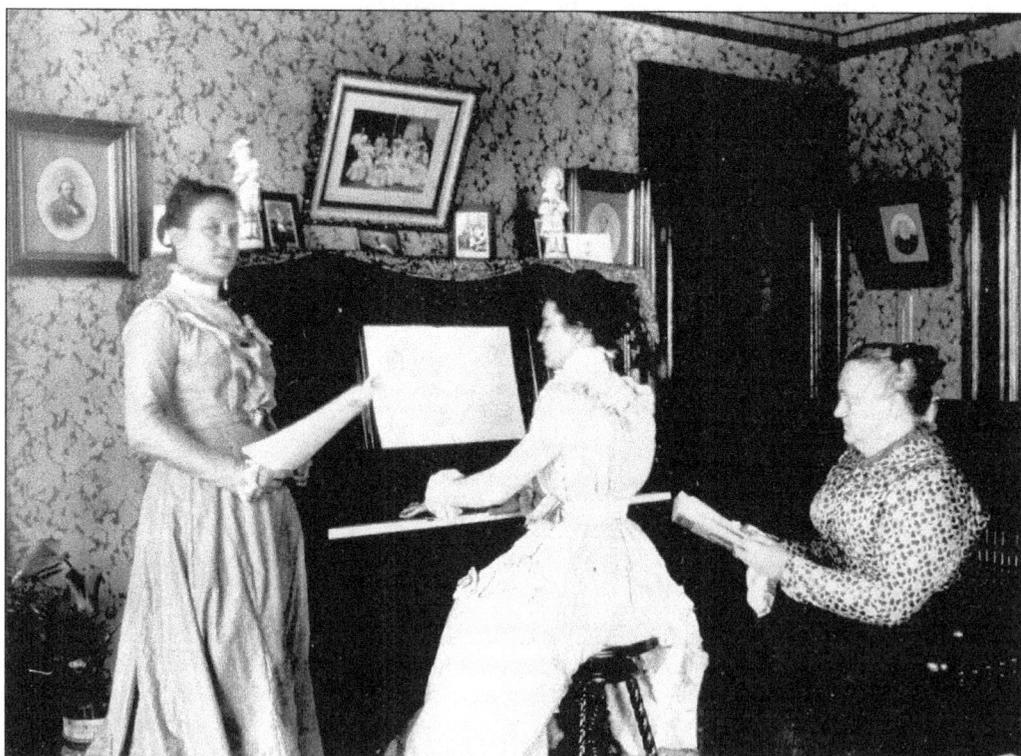

This image depicts a musical Sunday afternoon in a prominent Clinton family home in the early 1880s. Music was an important part of family life, and a piano could be found in almost every home. (Photograph from the Clinton County Historical Society Archives.)

Two

THE LUMBER INDUSTRY

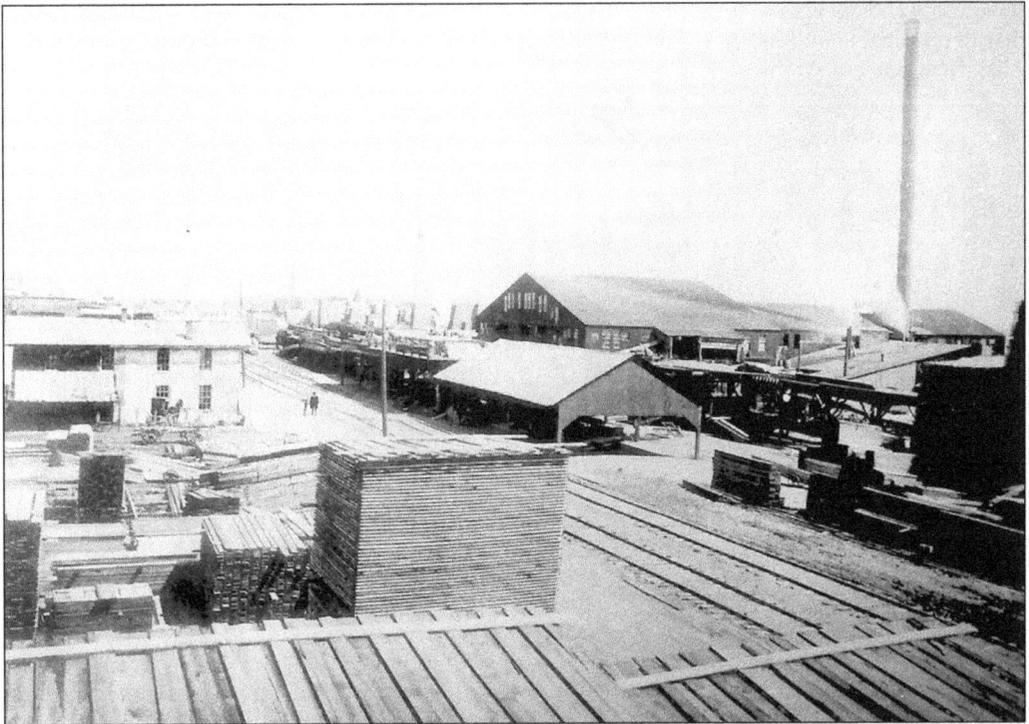

The first sawmill was built in Lyons between 29th and 30th Avenues N. in 1855 by Samuel Cox and G.H. Stumbaugh. By 1859, it had been purchased by Ira Stockwell. The first mill fire occurred at that location in 1874, though the property was uninsured. Mr. Stockwell sued the railroad for compensation but was unsuccessful. After rebuilding his mill, two years later lightning ignited another blaze that destroyed the mill, and Stockwell became a farmer for a few years. In 1883, he opened the Lyons Lumber Company, shown above in 1888, at that same location. (Photograph from the Clinton County Historical Society Archives.)

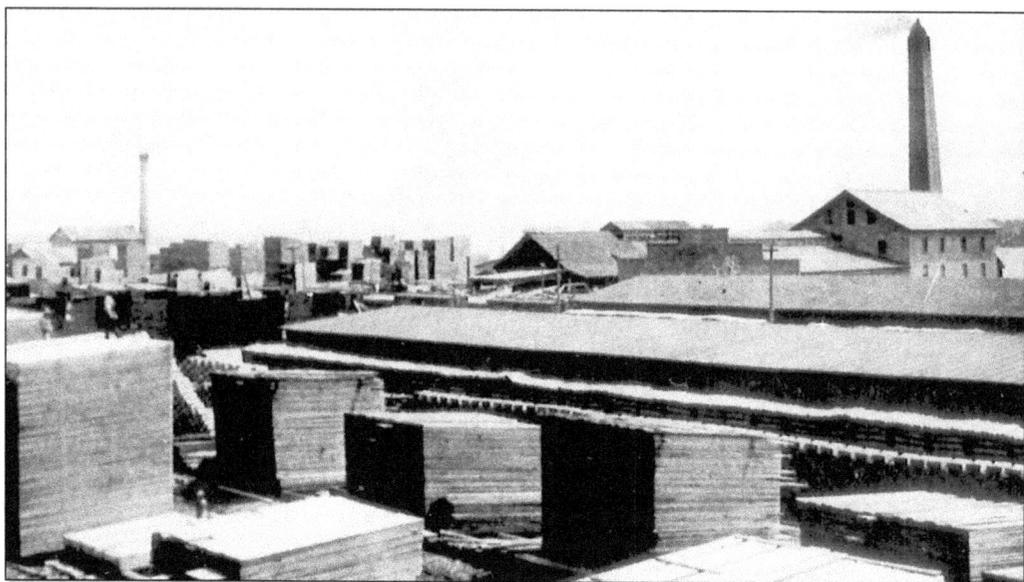

William G. Haun operated the Union Grist Mill in Lyons, built in 1856 and located between 31st and 32nd Avenues N. on the Mississippi riverfront. It was a sawmill, a grist mill, and a distillery, capable of grinding 90 barrels of flour per day. (Photograph from the Clinton County Historical Society Archives.)

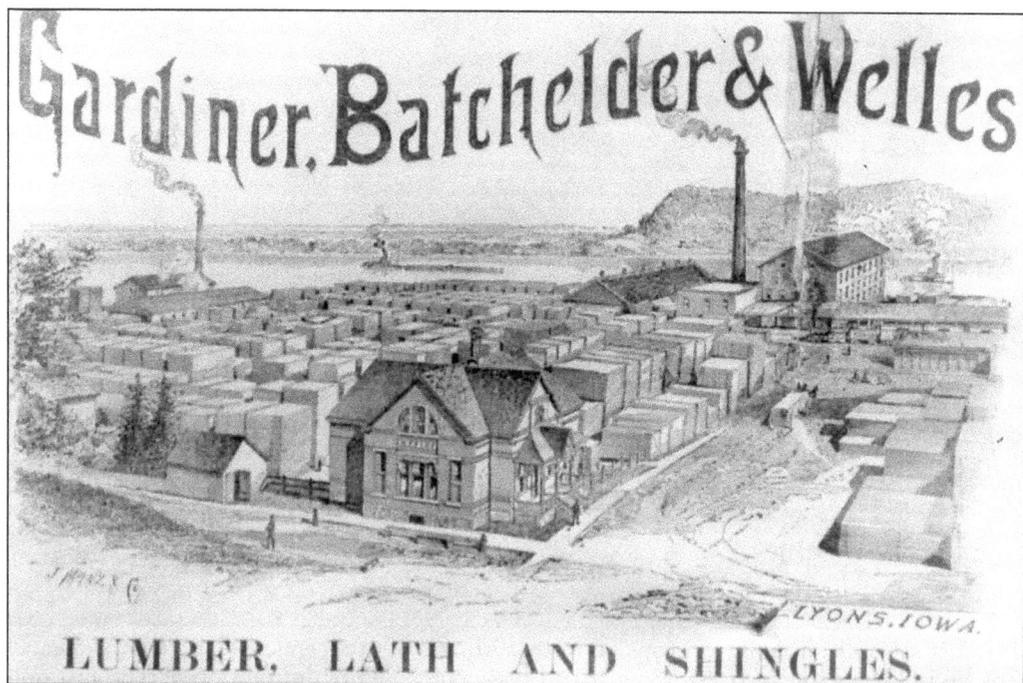

In 1874, Batchelder, Wells, and Wadleigh purchased the Union Grist Mill and converted it into one large lumber mill occupying one-half mile of riverfront. Four years later, Gardiner bought Wadleigh's interest in the company, and it became Gardiner, Batchelder, and Wells. The office building still stands on Garfield Street. (Photograph from the Clinton County Historical Society Archives.)

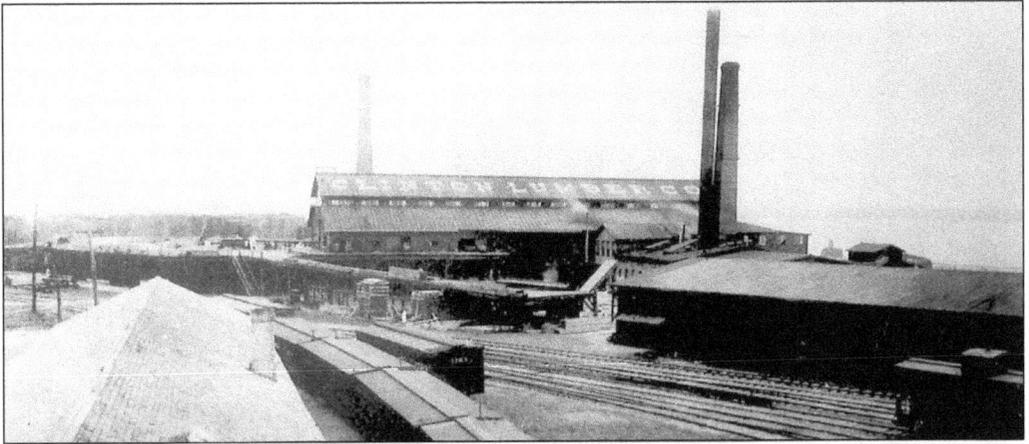

In 1857, Abrahm P. Hosford and Edmund Miller built a sawmill near the Stumbaugh and Cox mill in Lyons. Miller sold his interest in the mill to his partner, Hosford, in 1859. Hosford moved the mill to Clinton when the Chicago, Iowa & Nebraska Railroad was completed from Clinton to Cedar Rapids. The mill was located on the riverfront at the present site of the municipal swimming pool and was enlarged in 1861. It became the Clinton Lumber Company in 1866. (Photograph from the Clinton County Historical Society Archives.)

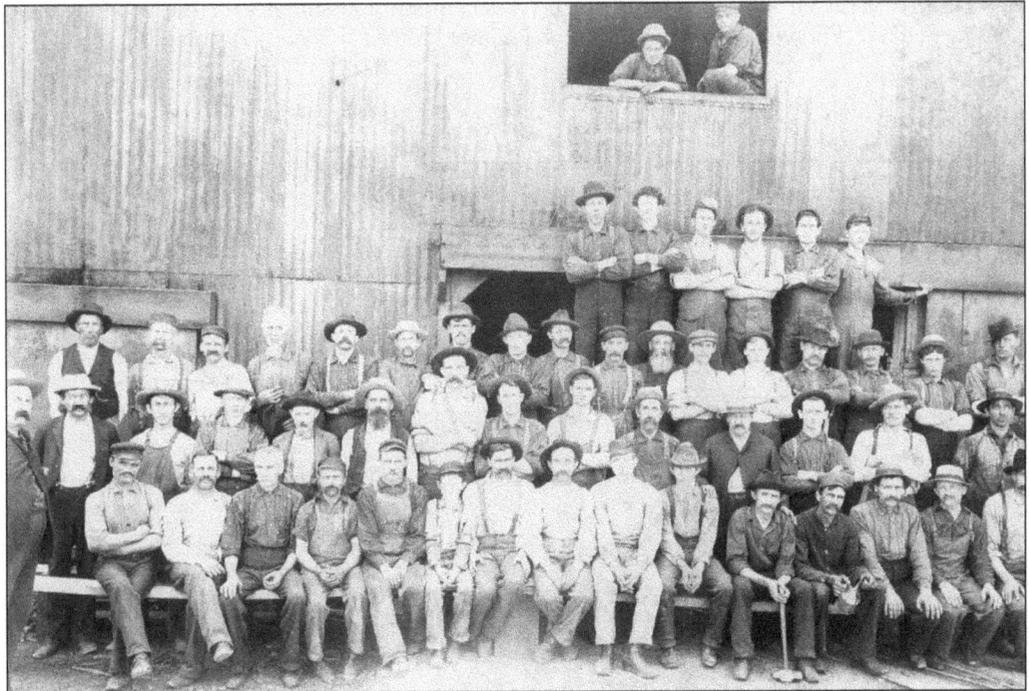

The Lamb & Sons sawmill gang worked 10- to 12-hour days, cutting 300,000 feet of lumber daily. On one particular day in the 1880s, they broke their record in a 12-hour day when they cut 408,209 feet of lumber, 69,000 shingles, and 50,000 feet of planed wood for a total of 507,209 feet of sawed lumber. During the winter months, the mills would shut down for three months or more because the frozen river prevented the transport of logs to the mills. During those months, some of the mill workers cut ice to supplement their incomes. (Photograph from the Clinton County Historical Society Archives.)

21

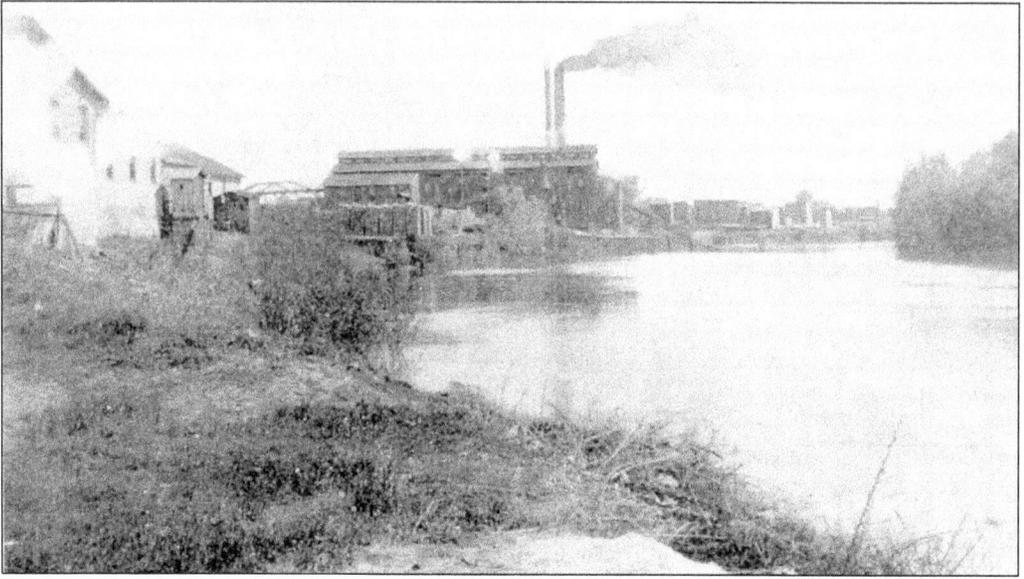

When the Civil War was over, David Joyce and S.I. Smith built a lumber mill on Ringwood Slough, now Joyce's Slough. In 1873, Joyce bought out Smith, and it became the Joyce Lumber Company. The business included a planing mill, which produced lath and shingles for the booming local housing market. (Photograph from the Clinton County Historical Society Archives.)

David Joyce's lumber empire stretched into Wisconsin, Minnesota, Texas, and Louisiana. He was such a popular Lyons citizen that he was elected Mayor of Lyons unanimously. In 1888, he purchased 100 acres from Elijah Buell and created Joyce Park, now Eagle Point Park, north of Lyons. His grandson sold the park to the city of Clinton in 1925. (Photograph from the Clinton County Historical Society Archives.)

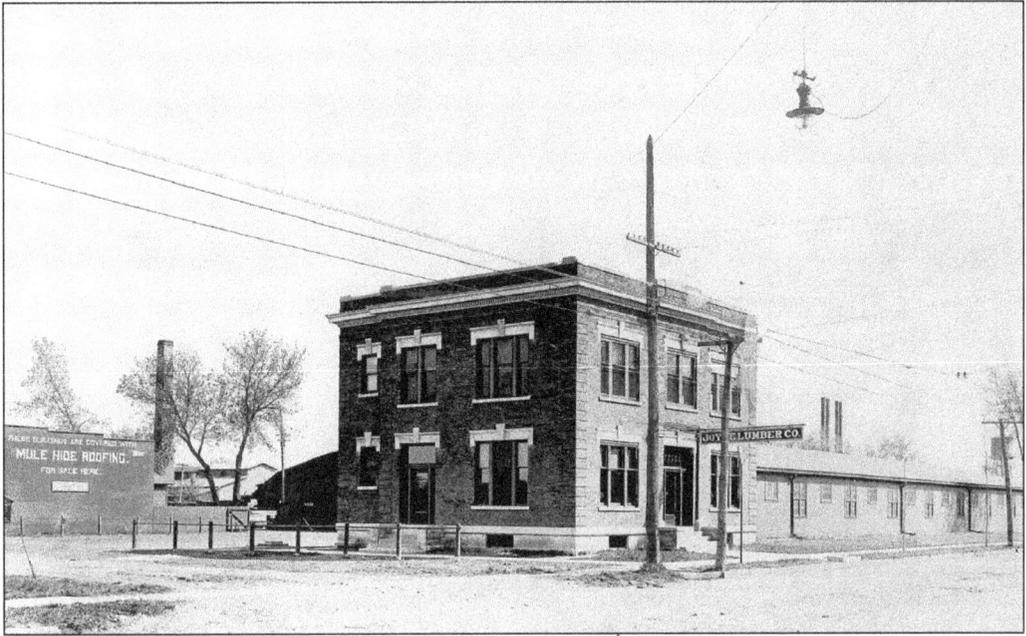

In 1909, the Joyce Lumber Company erected an office and lumber yard at 16th Avenue N. Fullerton Lumber Corporation of Minneapolis, Minnesota acquired the retail store and the other assets of the Joyce Company. At that time, the last of the Clinton lumbering interests passed from the scene. Today, the Clinton Family Hair Care Center occupies the office building. (Photograph from the Clinton County Historical Society Archives.)

William Joyce chose to continue operating the family's lumber empire from Chicago after his father's death in 1894. In 1895, he granted ten acres to Oakland Cemetery from Joyce's Park (now Eagle Point Park). In 1896, he built the Joyce Memorial Chapel on the grounds in memory of his parents. Before his death in 1909, he had increased the family's lumber enterprises and was able to donate a $50,000 endowment to Cornell College. (Photograph from the Clinton County Historical Society Archives.)

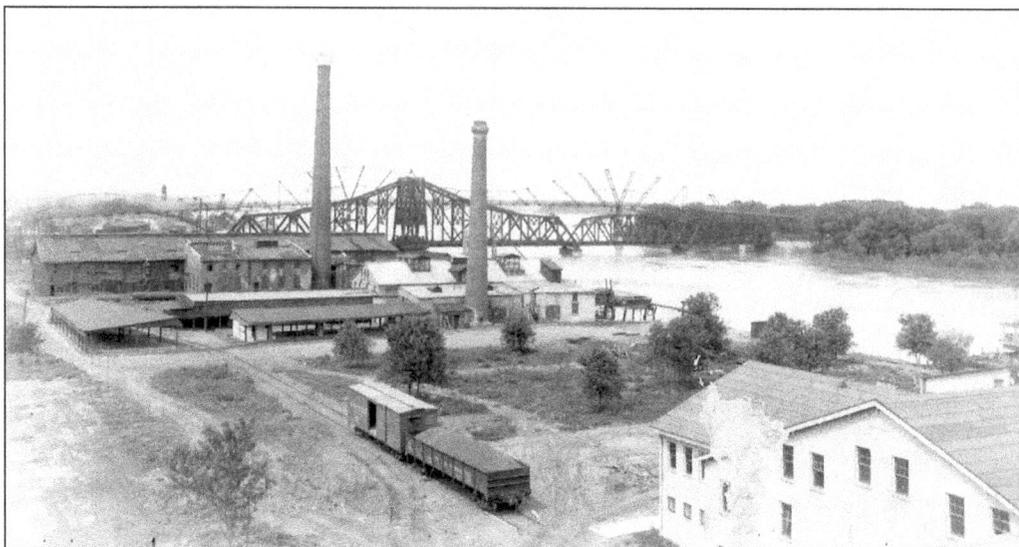

This image looks north at the mills, now idle, around 1910. Lamb & Sons Brick Mill is in the foreground, the Lamb & Sons Stone Mill is in the center, and the far background mill is the W.J. Young Upper Mill. (Photograph from the Clinton County Historical Society Archives.)

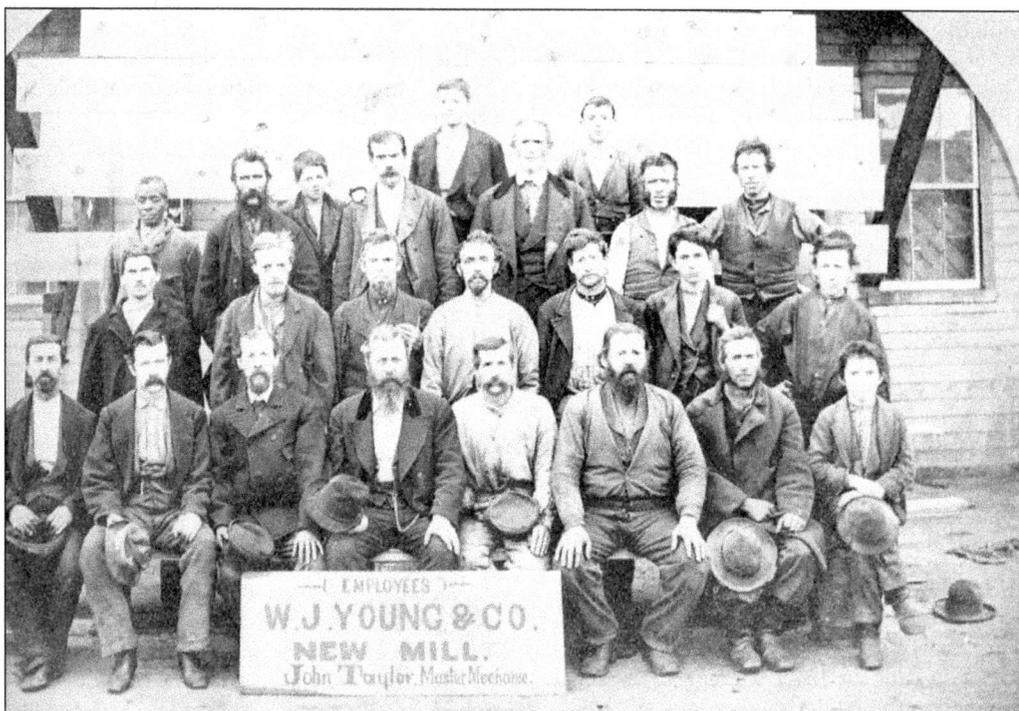

W.J. Young operated two sawmills in Clinton. The "Upper Mill," established in 1858, just south of the present railroad bridge, was the first mill he built. In 1860, he enlarged that mill, greatly increasing the number of logs that could be processed in one day. The "Big Mill," built in 1866, was considered the largest mill in the world at the time. Large galleries were installed in the Big Mill for visitors to view the sawmill process. (Photograph from the Clinton County Historical Society Archives.)

W.J. Young was truly one of the millionaires of the 19th century in Clinton. His company employed over 1,000 workers who earned between $1.50 and $2.00 per day for a 10- or 11-hour day, and worked seven months of the year. In 1880, the W.J. Young Company cut over 100 million feet of lumber. (Photograph from the Clinton County Historical Society Archives.)

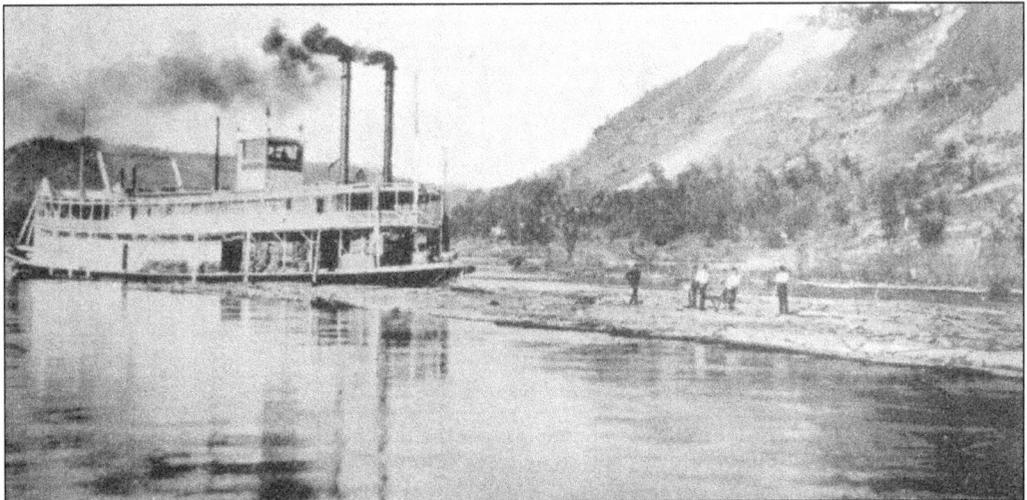

The steamer *W.J. Young Jr.* was a rafter, built in 1883 for the W.J. Young Company of Clinton. She is shown here towing a half-raft of logs. She was 166 feet long and 34 feet wide, with engines 14 inches by 6 feet. (Photograph from the Clinton County Historical Society Archives.)

C. LAMB & SONS

Manufacturers of and Dealers in

C. LAMB & SONS' MILLS

Lumber, Shingles, Laths

C. LAMB, President.
L. LAMB, Vice-President.
A. LAMB, Sec. and Treas.

Clinton, Iowa.

Until 1865, logs were brought downstream to the mills using only the current of the river. The logs were secured by pins and poles, and a shanty built on the rafts was used by the men. W.J. Young, wanting to eliminate the waste of the larger logs by this practice, revolutionized river transport by using steamboats to push the logs in booms. (Photograph from the Clinton County Historical Society Archives.)

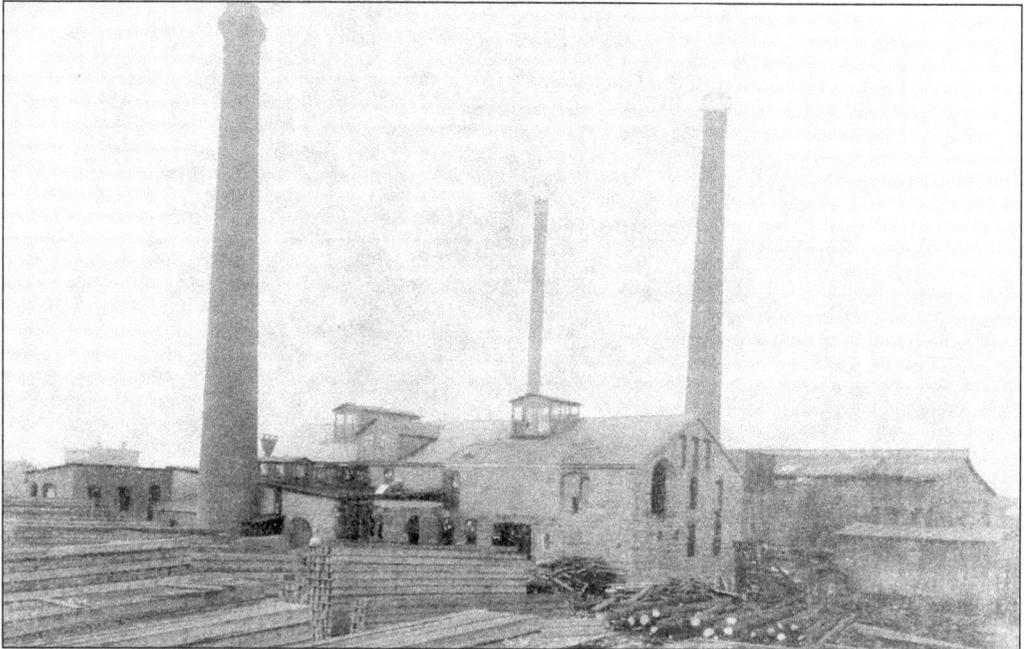

In 1858, with very little money, Chancy Lamb bought the mill south of the railroad bridge, which had been erected by Charles Lombard and then sold to Gray and Lunt. Chancy Lamb invested all his money in that mill, but it burned to the ground the same year. He rebuilt it, and along with his sons, Artemus and Lafayette, went on to own four mills he named A, B, C, and D. Pictured is Stone Mill A. Lamb & Sons was the largest mill company on the Mississippi, as well as the most successful. (Photograph from the Clinton County Historical Society Archives.)

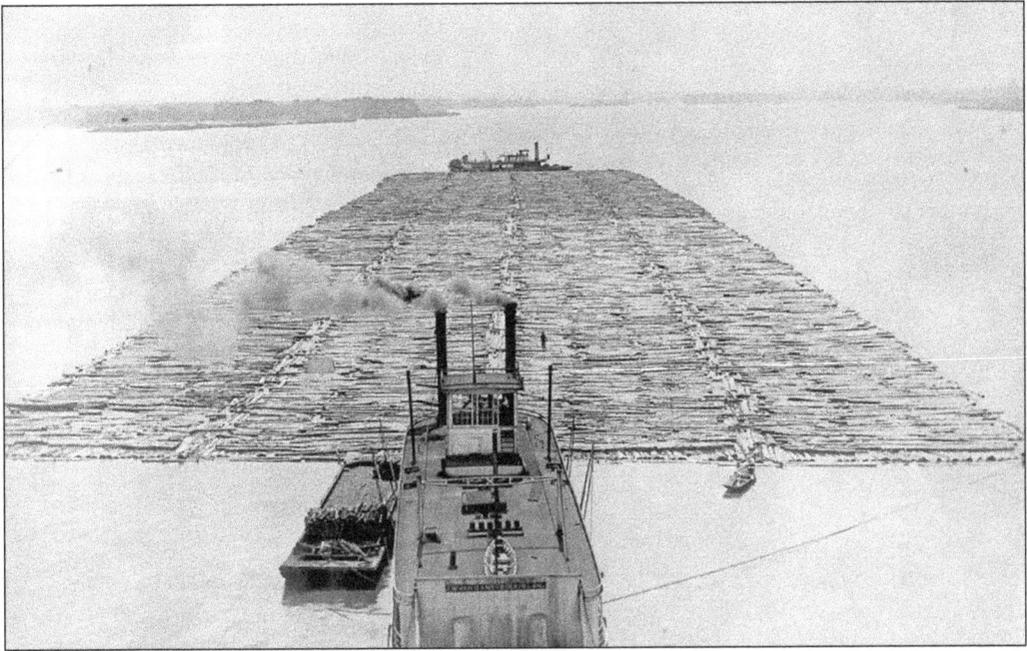

This 1890 photograph shows the raftboat, the *J.W. Van Sant II*, with the bow boat, the *Lydia Van Sant*, taking a doubleheader log raft down river. (Photograph from the Clinton County Historical Society Archives.)

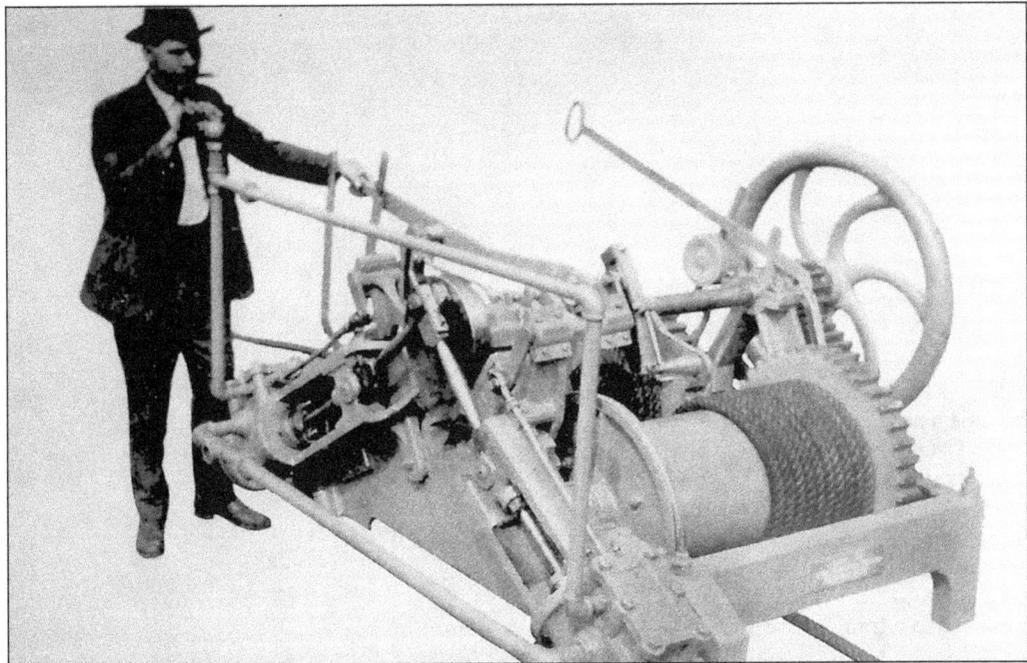

Chancy Lamb invented a double-spooled winch to control the rafts in the bends and turns of the river. The old-fashioned rafts were abandoned, and the logs were gathered in tiers, surrounded by booms, increasing the raft size to as much as 265 feet wide and 1,200 feet long. (Photograph from the Clinton County Historical Society Archives.)

Chancy Lamb has long been recognized as one of the most progressive leaders in the history of the city of Clinton. Besides managing the fire department from 1874 to 1879, he was a city councilman, one of the founders of the Tri-City Telephone Company, president of the People's Trust and Savings Bank, director of the City National Bank, and both secretary and treasurer of the Clinton Gas Light and Coke Company. Chancy Lamb's civic responsibilities also included being a trustee of the Agatha Hospital, which later was re-named for his wife, Jane Lamb. (Photograph from the Clinton County Historical Society Archives.)

Artemus Lamb was Chancy's oldest son and became a partner in the family business in 1864. One of his greatest local achievements was founding the People's Trust and Savings Bank in 1892. Mr. Lamb traveled extensively and even made a trip to Scotland to be admitted to the Order of the Shrine. While he died in California in 1901 after being involved in a train wreck in Wyoming, his remains were returned to Clinton, and he was buried in Springdale Cemetery. He left an estate of over seven million dollars. (Photograph from the Clinton County Historical Society Archives.)

28

Lafayette Lamb was the second son of Chancy Lamb and was admitted into the family business in 1874. Four years later, he became vice president. Lafayette Lamb was able to bring progress to the Lamb & Sons business, and later in his life he had added a one-third interest in a 4,000 acre ranch 50 miles west of Denver, Colorado known as Studebaker-Lamb-Witever Ranch. Upon his death, the family donated the site for the Clinton Public Library, and his mansion is now part of the YWCA complex. (Photograph from the Clinton County Historical Society Archives.)

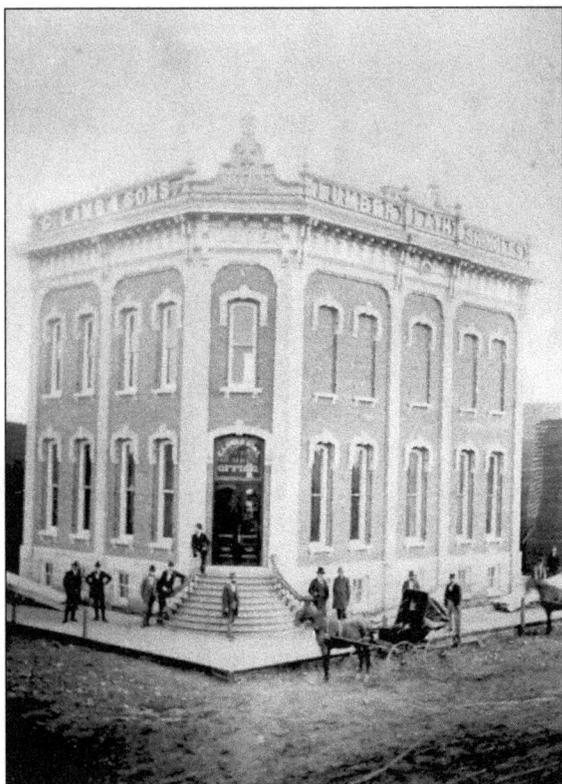

The Lyons and Clinton lumber mills were constantly threatened by fire. In 1879, the Chancy Lamb & Sons office building, located at 1100 2nd Street, was destroyed by fire along with much of the south side of the city. The Lamb & Sons Company lost mills to fires in 1858, 1876, and 1877, but each mill was rebuilt. The Lambs' loss, by fire alone, was estimated at an aggregated amount of $300,000. (Photograph from the Clinton County Historical Society Archives.)

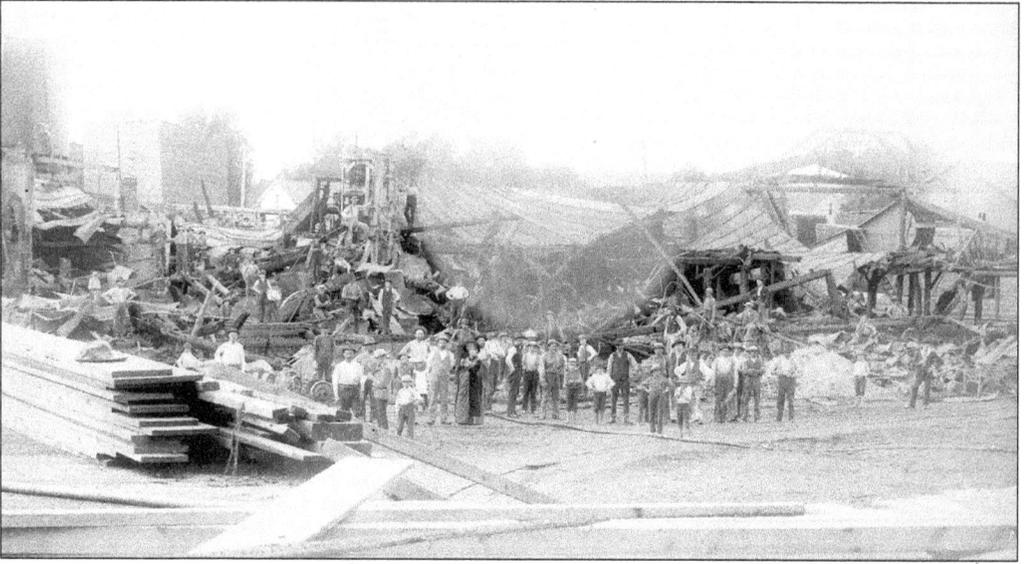

The David Joyce Mill, built in 1869, was lost to fire in 1888. It was rebuilt on the same site on Joyce's Slough where Custom-Pak is located today. The only mill that did not experience a fire was previously known as the Union Mill, built by William A. Haun, and later became the Gardiner, Batchelder, and Wells Mill. It closed in 1894. (Photograph from the Clinton County Historical Society Archives.)

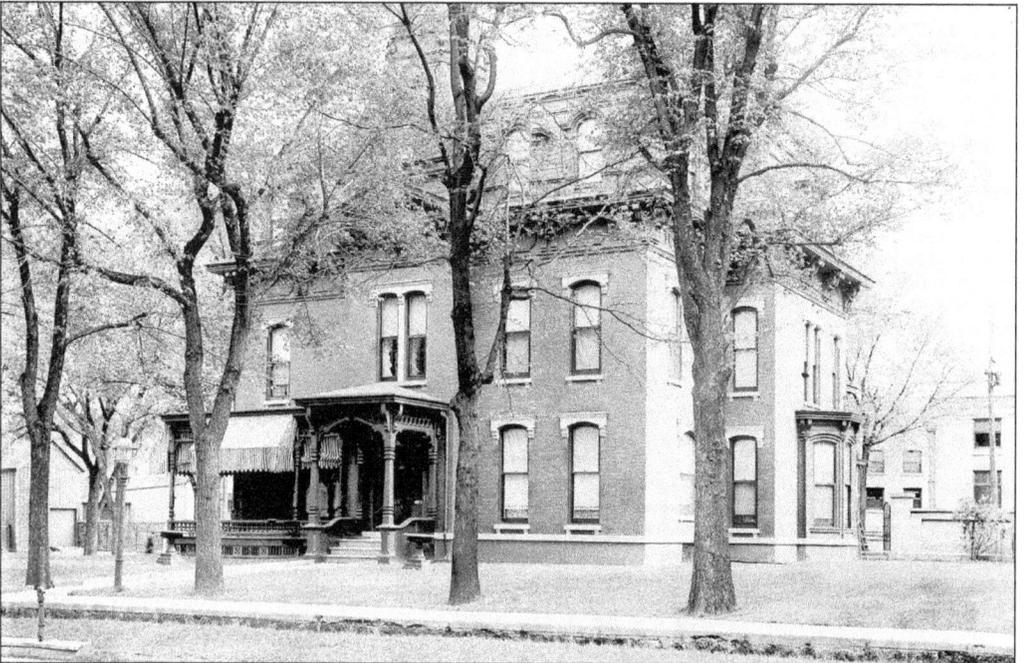

The Chancy Lamb home on 7th Avenue S. and 3rd Street was built in the late 1870s. Located on the southwest corner, it was situated next to his son Lafayette Lamb's home and two doors away from W.J. Young's home, which was at the other end of the block. Like Lafayette Lamb's home, it featured a 12-foot mansard roof; however, it had a curved turreted tower in the center. (Photograph from the Clinton County Historical Society Archives.)

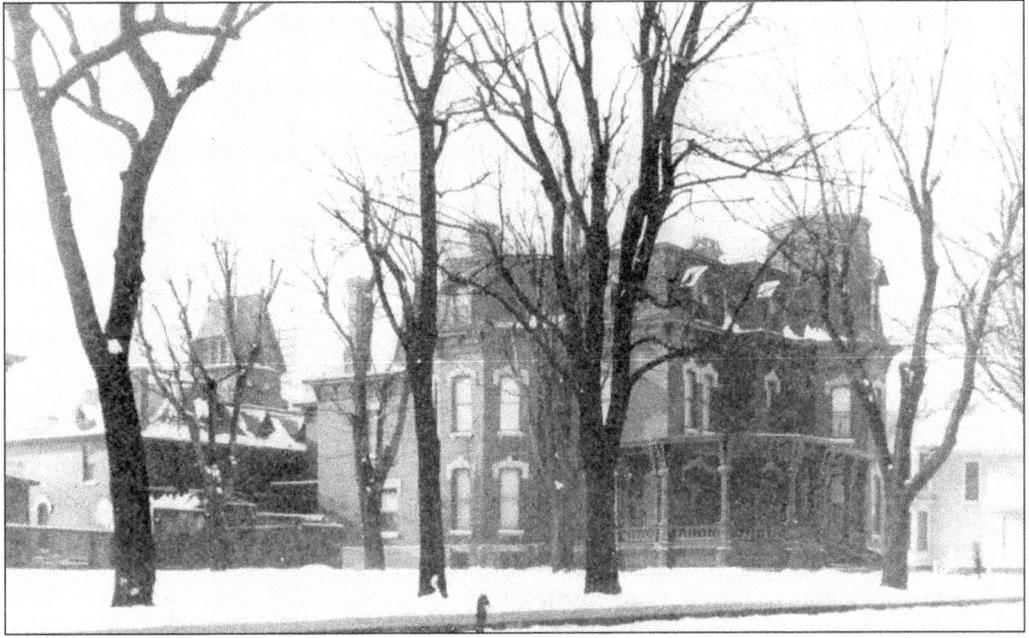

Erected in 1877, Lafayette Lamb's mansion located on 7th Avenue S. in Clinton was originally built of brick veneer. It was three stories high with a 12-foot mansard roof and a turreted tower. One of the costliest mansions, built in 1883 by the lumber barons, the home, carriage house, and outbuildings were painted red. (Photograph from the Clinton County Historical Society Archives.)

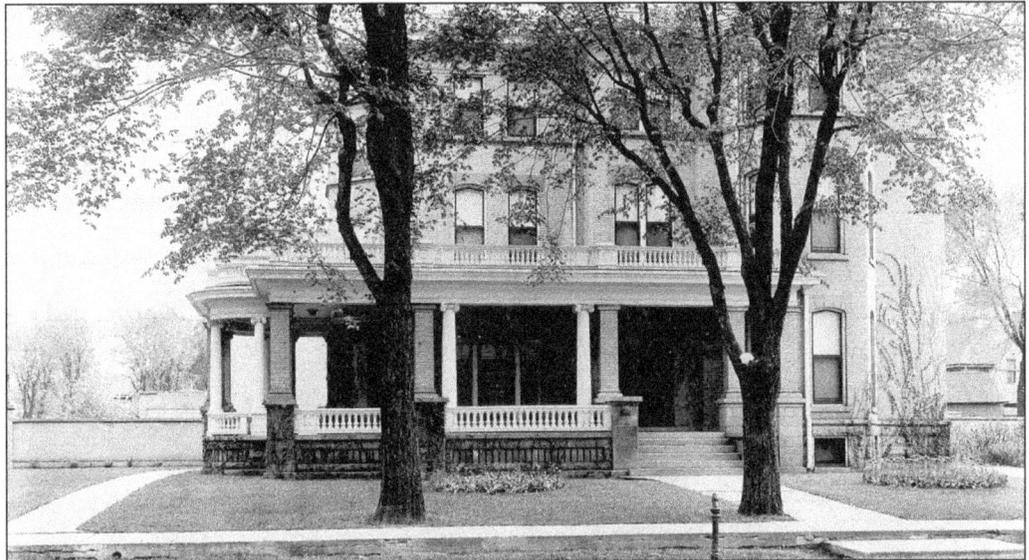

In 1906, the Lafayette Lamb home was remodeled. The brick veneer was removed, and grey cement brick was installed. The mansard roof was changed to a flat roof and the 54-foot tower removed. The original Second Empire style became a Georgian Revival style. In 1920, the house was donated to the YWCA by Lamb descendants, Judson and Olivia Detweiller Carpenter. The home is listed on the National Register of Historic Places. (Photograph from the Clinton County Historical Society Archives.)

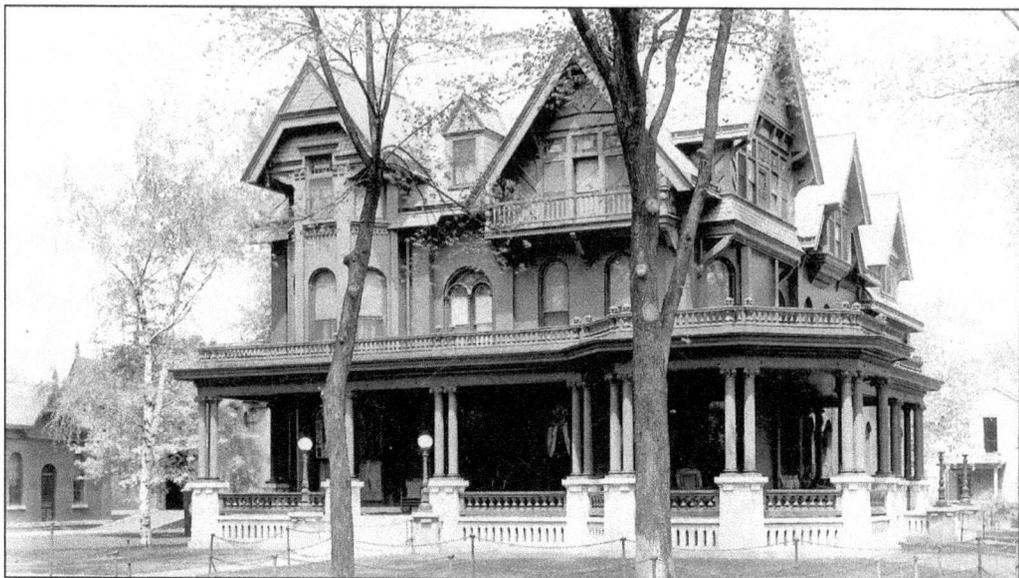

The home of Artemus Lamb, located on the corner of 5th Avenue S. and 4th Street, was so spacious that the Lambs entertained 350 guests inside its halls for their 20th wedding anniversary, with dancing on the third floor. The food, wine, and flowers catered from Chicago and St. Louis and the 11-course meals were common. In 1927, the home was torn down to make room for the First Presbyterian Church. The combination servants' quarters and stables were moved to 8th Avenue N. and Pershing Blvd. and converted into apartments. (Photograph from the Clinton County Historical Society Archives.)

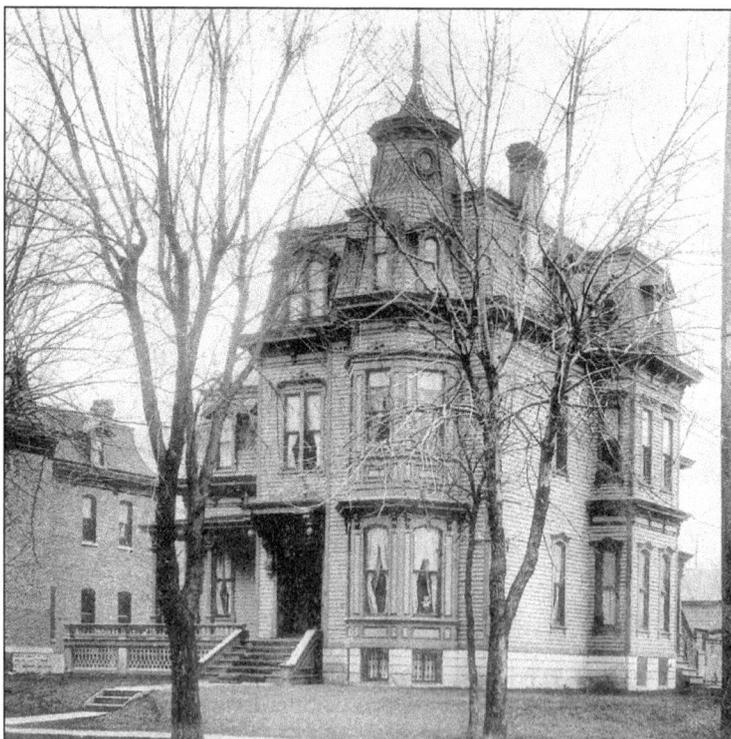

Schiller Hosford, secretary and treasurer of the Clinton Lumber Company, chose to build his mansion in the Second Empire style. Located on the southeast corner of 5th Avenue S. and 4th Street, it was kitty-corner from Artemus Lamb's mansion. The Hosford home was torn down to make way for the Sears, Roebuck & Company store. (Photograph from the Clinton County Historical Society Archives.)

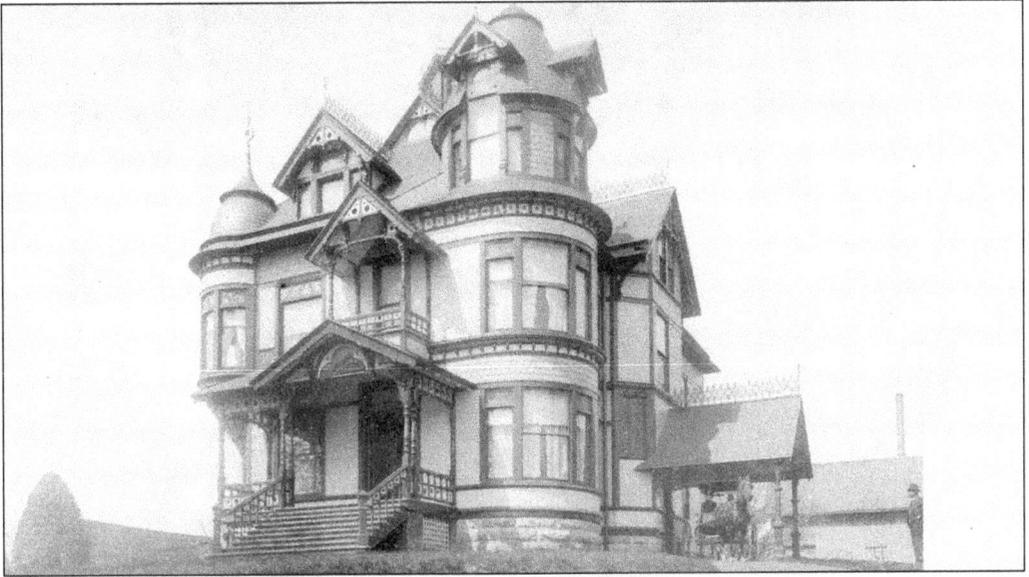

The William Joyce home in Lyons, now the 1800 block of N. 3rd Street, was built in 1887 in an Eastlake style. It featured a round tower with windows of rounded glass. Interior woodwork of cherry and mahogany was used extensively throughout the house. A large stable, with living quarters above, was located at the rear of the property. The Joyce family maintained the home, with staff, until 1974 when it was sold. (Photograph from the Clinton County Historical Society Archives.)

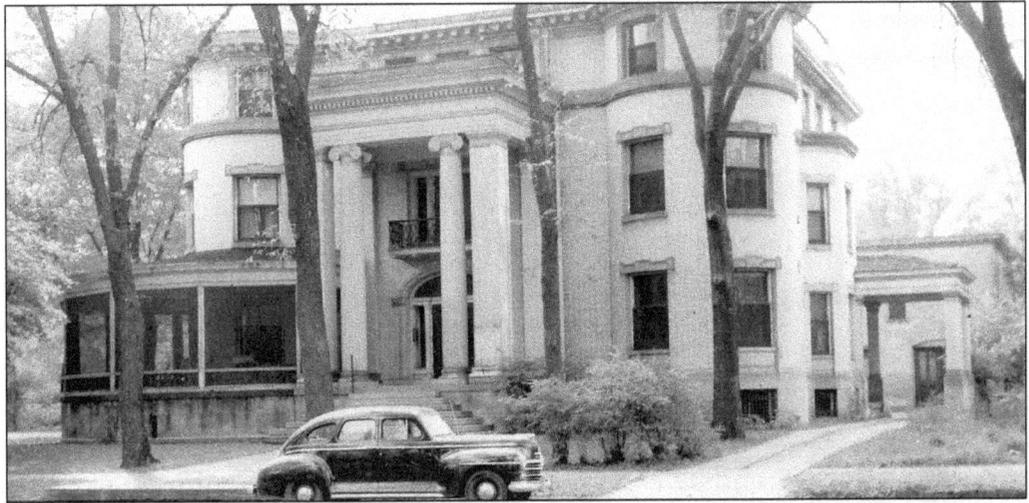

The W.J. Young home located on the southeast corner of 7th Avenue S. and 4th Street was the most impressive of the lumber baron mansions. It was three stories high with four entrance columns, with 19 rooms and a full basement, which held two wine cellars. The home had a built-in pipe organ, an elevator to all floors, a sweeping 10-foot staircase, seven bedrooms and five bathrooms. The third floor held seven bedrooms for the servants. The ornate Italian marble fireplaces were lit with gas, as W.J. Young was also president of the Clinton Gas Light and Coke Company. In 1946, the Amvets acquired the property, and in the mid 1950s, it was torn down to make way for a new Eagle's Grocery Store. (Photograph from the Clinton County Historical Society Archives.)

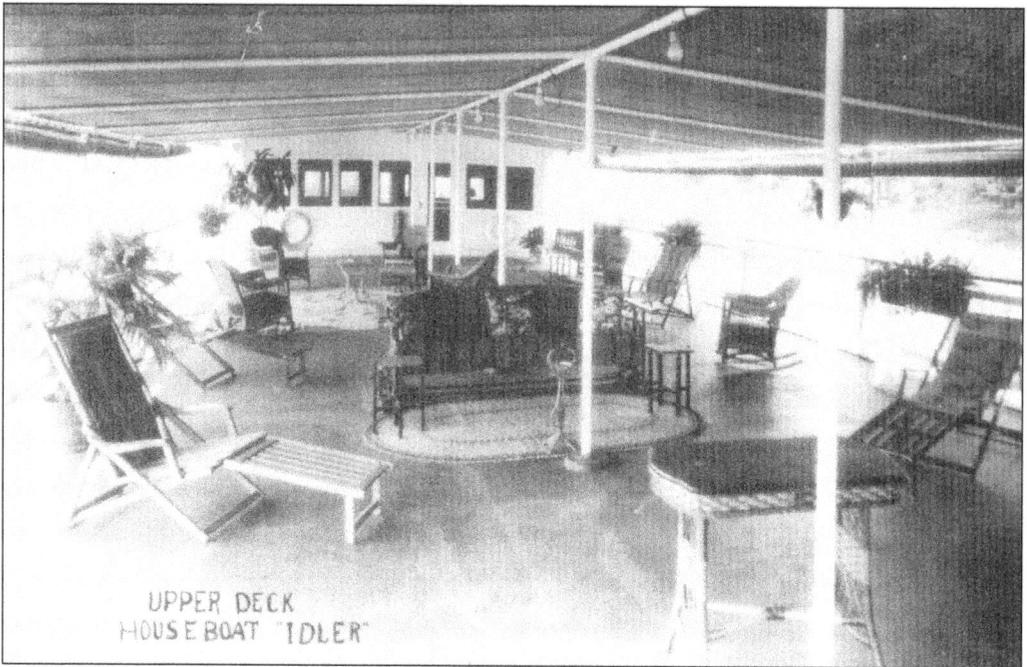

UPPER DECK
HOUSE BOAT "IDLER"

Lafayette Lamb's excursion boat, the *Idler*, was built in the Lamb Boat Yards for $7,000 in 1897. Pushed by the sternwheeler, the *Wanderer*, it was a floating palace. The *Idler* could be stocked with supplies for weeks or months and make stops along the river for visiting, parties, dances, and swimming from the sandbars at the leisure of the owners. (Photograph from the Clinton County Historical Society Archives.)

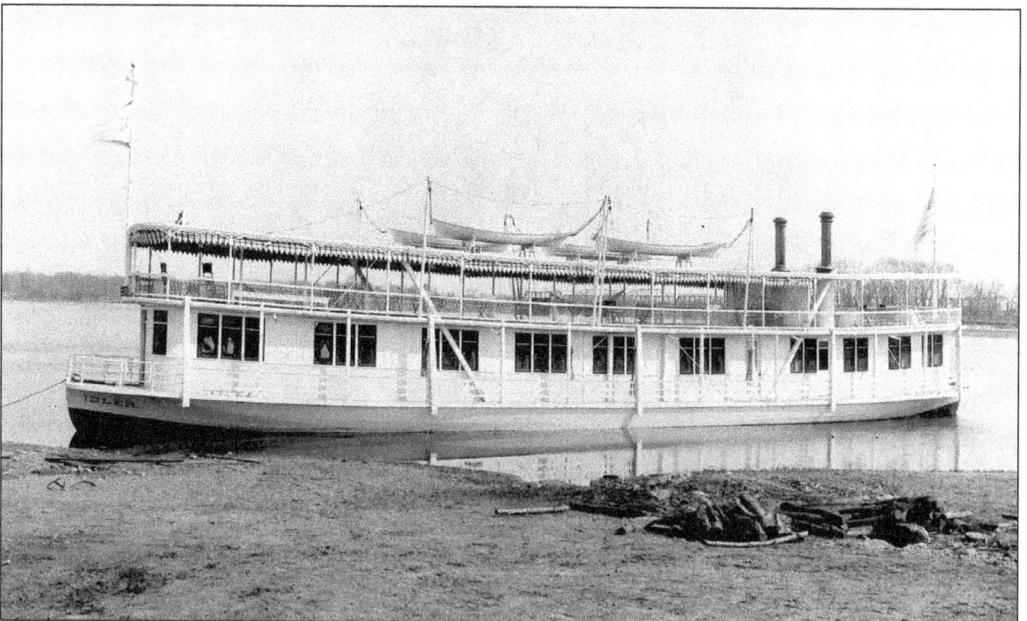

When Lafayette Lamb died in 1919, the Clinton Corn Processing Company bought the *Idler* to use as a company excursion boat. In 1981, the *Idler* was sold to a Michigan company and renovated into a restaurant. (Photograph from the Clinton County Historical Society Archives.)

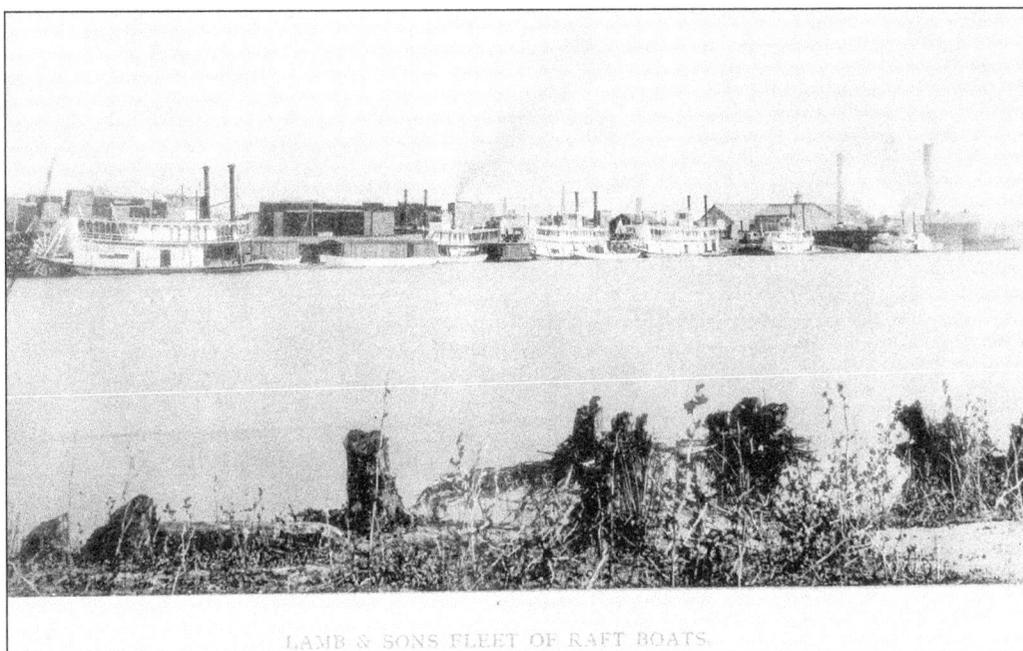

The Lamb & Sons Company owned its own boatyard and built a large fleet of steamers and pleasure boats for both the company and the Lamb family's personal use. Docked in front of the Lamb Mills were but a few of the fleet. Among these are the *Silver Crescent*, the *Artemus Lamb*, and the *Lady Grace*. (Photograph from the Clinton County Historical Society Archives.)

The last remaining sawmill structure was the W.J. Young Machine Works. The abandoned building was torn down in 1977 to make room for the flood protection dike, which was built to protect the city of Clinton from the ravages of the Mississippi River's many springtime floods. (Photograph from the Clinton Historical Society Archives.)

35

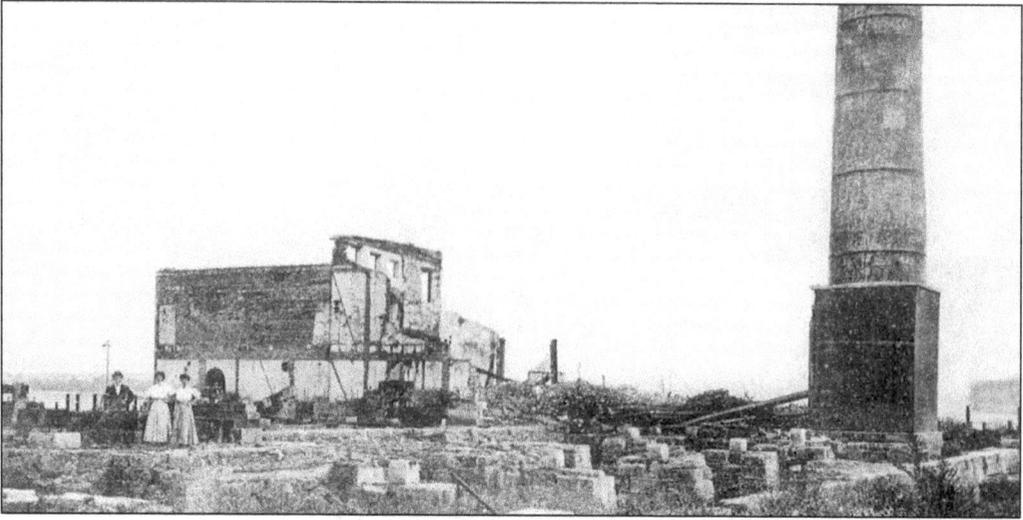

The "Big Mill" owned by W.J. Young, once said to be the largest sawmill in the world, closed in 1894 and lay in ruins after the lumber era. Located at the bend in the river near Riverside Slough, now Beaver Slough, it was a sad reminder to river traffic of the boom days in Clinton when the city was called "the Lumber Capital of the World." (Photograph from the Clinton County Historical Society Archives.)

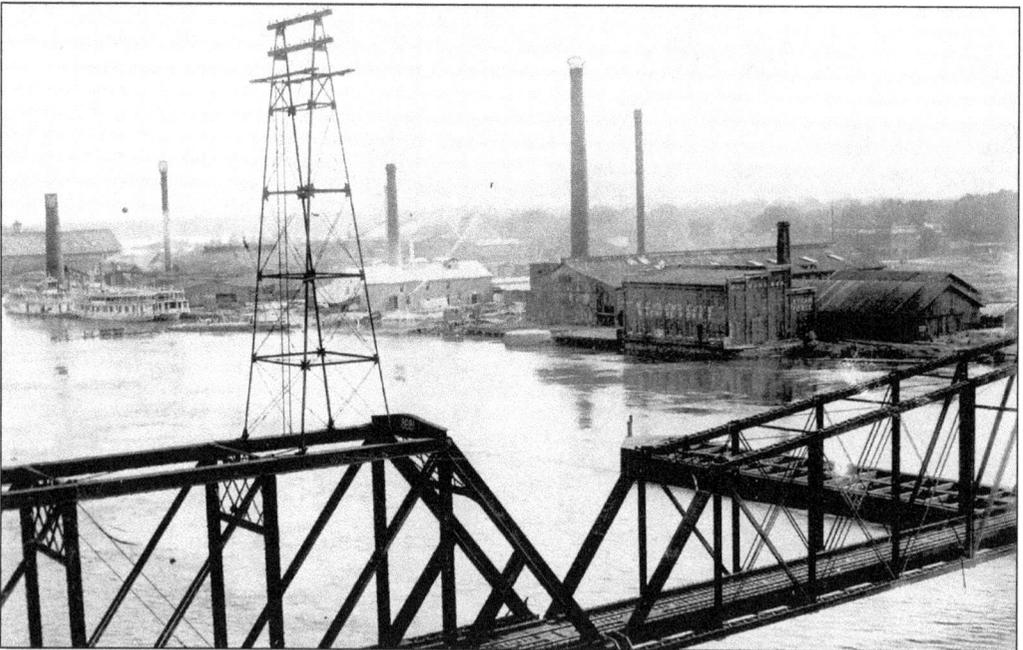

In 1892, the Lyons and Clinton sawmills produced over 265 million board feet of lumber with 20 to 40 shipments of lumber leaving Clinton daily by rail. The financial panic of 1893 dealt a harsh blow to the lumber industry, but it was the diminishing supply of logs from the depleted pine forests to the north that finally silenced the mills. By the time this photograph was taken in 1906, only the Joyce Mill, which closed in 1910, was still operating. The sights, sounds, and aromas that had made Clinton a sawdust town and a city of millionaires in the last half of the 19th century were gone. (Photograph from the Clinton County Historical Society Archives.)

Three

STEAMBOATS, RAILROADS, AND BRIDGES

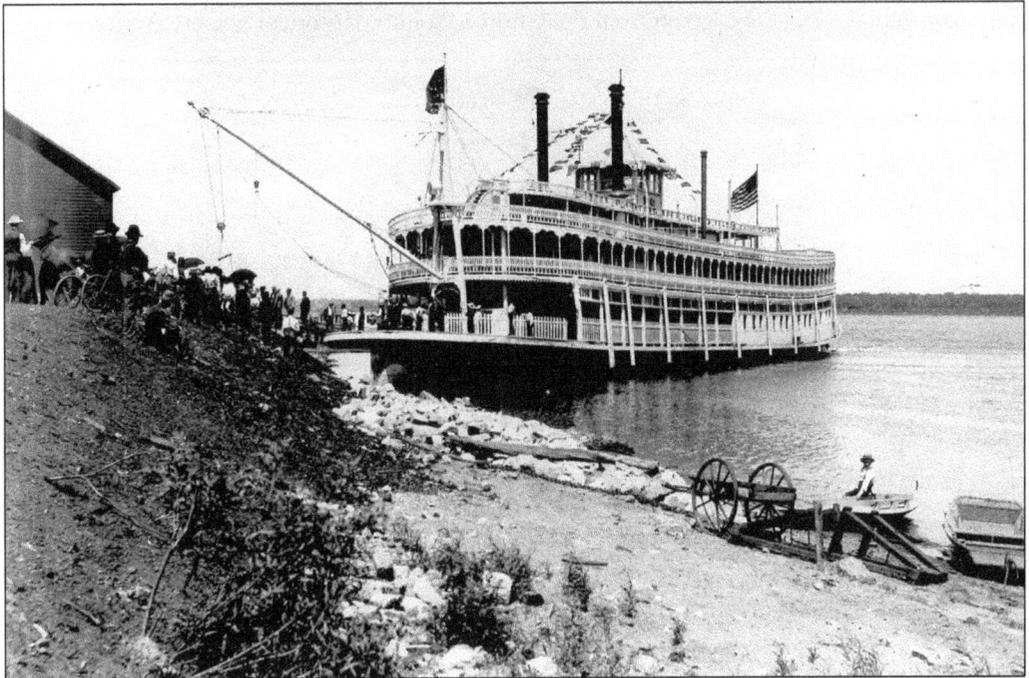

This is the daily packet steamer that traveled between Davenport, Rock Island, Fulton, and Clinton at the 6th Avenue Boat Landing in downtown Clinton. This water route transported passengers and goods up and down the Mississippi River, providing an alternate route for shipping and traveling. The steamboat office is shown on the left and was demolished in 1973 to build Clinton's riverfront dike. (Photograph from the Clinton County Historical Society Archives.)

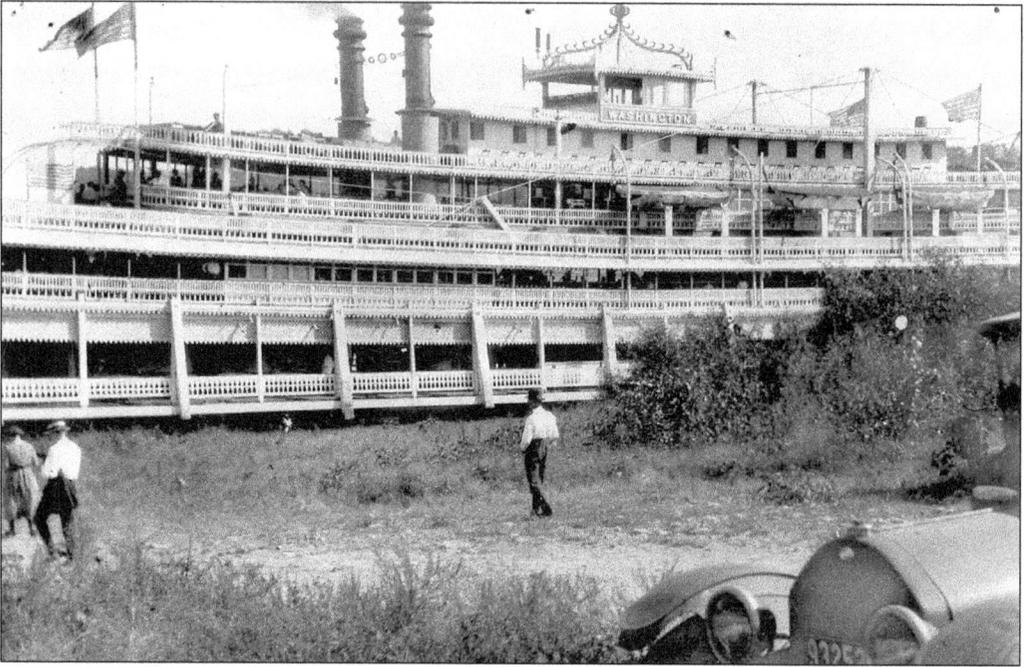

People are heading to board the excursion steamer, the *Washington*, at Clinton's 6th Avenue Landing in this 1920 image. The flags are flying, and the boat is ready for an afternoon cruise on the Mississippi River. (Photograph from the Clinton County Historical Society Archives.)

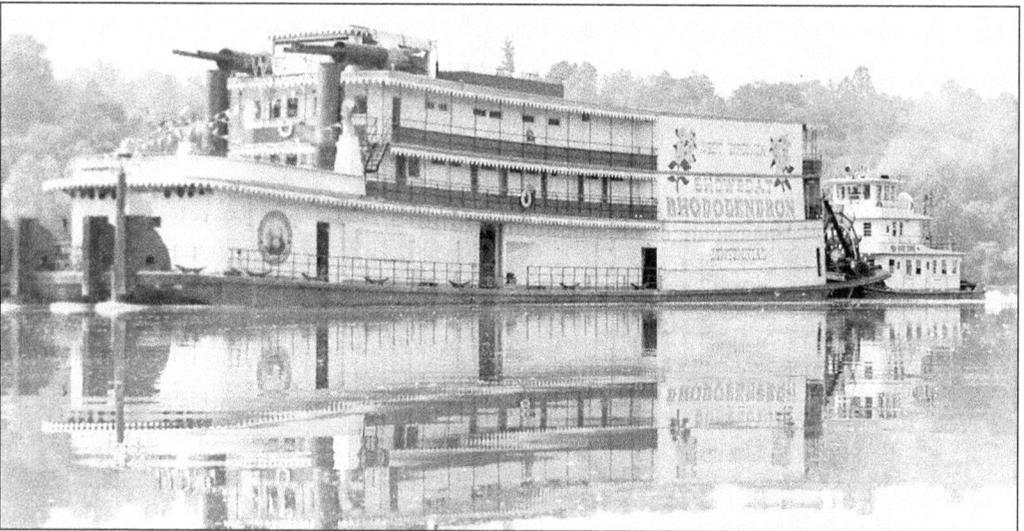

The *Showboat Rhododendron*, a converted tugboat, as it was being towed to Riverfront Park to be permanently docked. The 207-foot sternwheeler was originally launched in 1935 as the *Omar* and spent its first 25 years towing coal barges on the Ohio River. The city of Clinton acquired it from the state of West Virginia, where it had been renamed the *Rhododendron*. In 1966, it was towed to Clinton to be a permanent part of the new riverfront dike. It has again been renamed as the *City of Clinton Showboat* and is dry-docked and available to the public as a maritime museum. The 250-seat *Lillian Russell* summer stock theater on the boat enjoys one successful season after another. (Photograph from the Clinton County Historical Society Archives.)

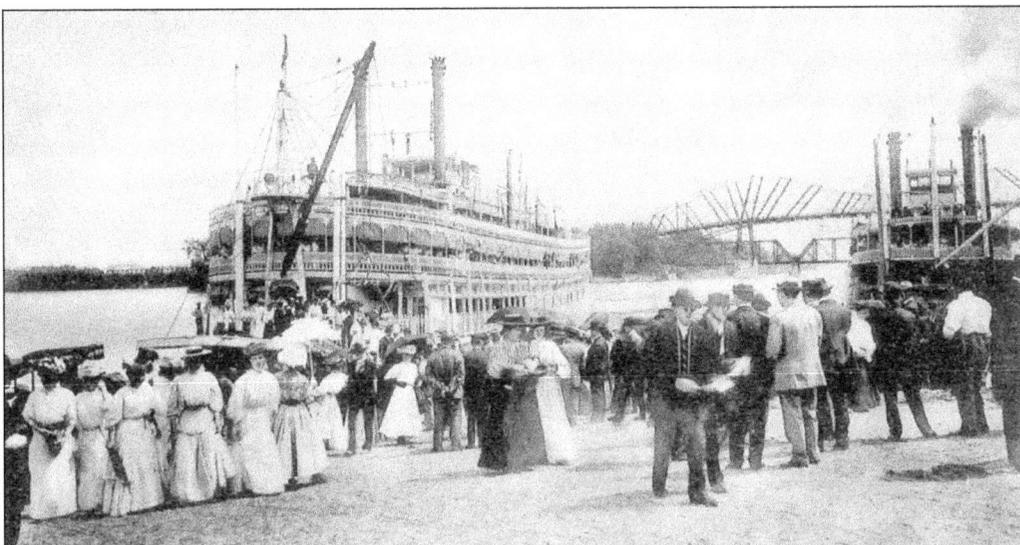

This picture shows two excursion steamers docking at the 6th Avenue Boat Dock in Clinton, c. 1890. Many excursion boats traveled the Mississippi River during the summer months, offering a chance for people to enjoy an afternoon or evening cruise and music. The Clinton Bridge and the C&NW Bridge are shown in the background. (Photograph of the Clinton County Historical Society Archives.)

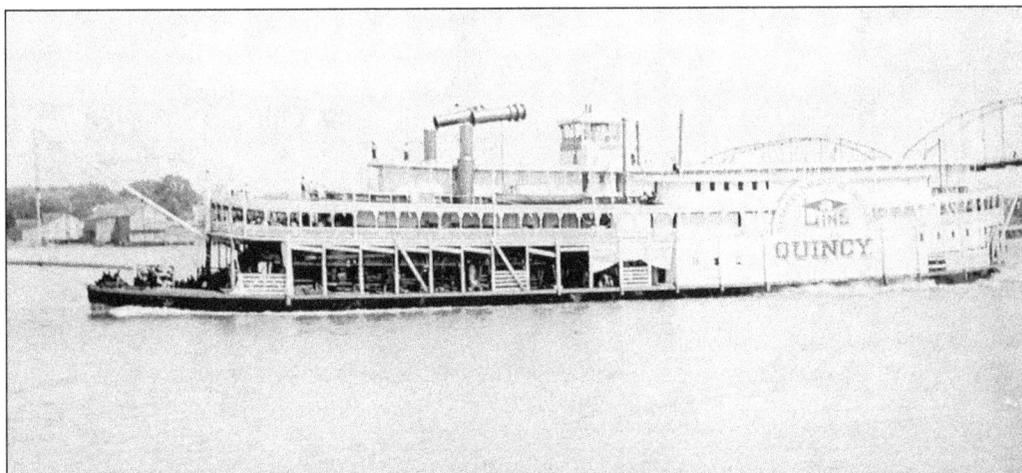

This 1895 image of steamer *Quincy*, of the Diamond Jo Line Packet, was taken in Lyons and shows lowered stacks necessary to pass under bridges in high water on the Mississippi River. (Photograph from the Clinton County Historical Society Archives.)

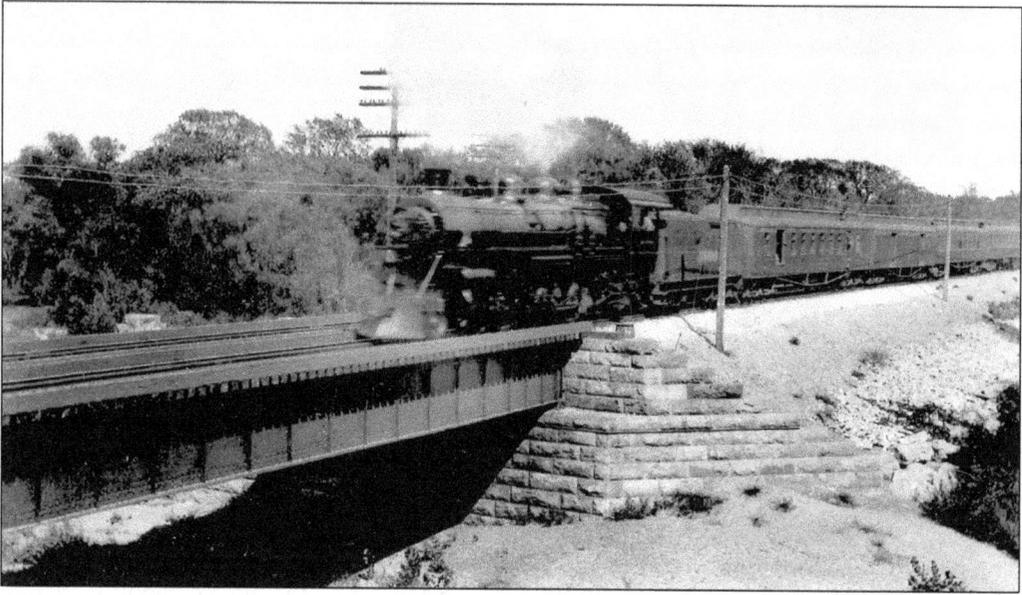

This 1910 photograph shows an eastbound passenger train crossing the Mississippi River Bridge just after picking up passengers at the Clinton Depot. The photograph was taken east of Little Rock Island. (Photograph from the Clinton County Historical Society Archives.)

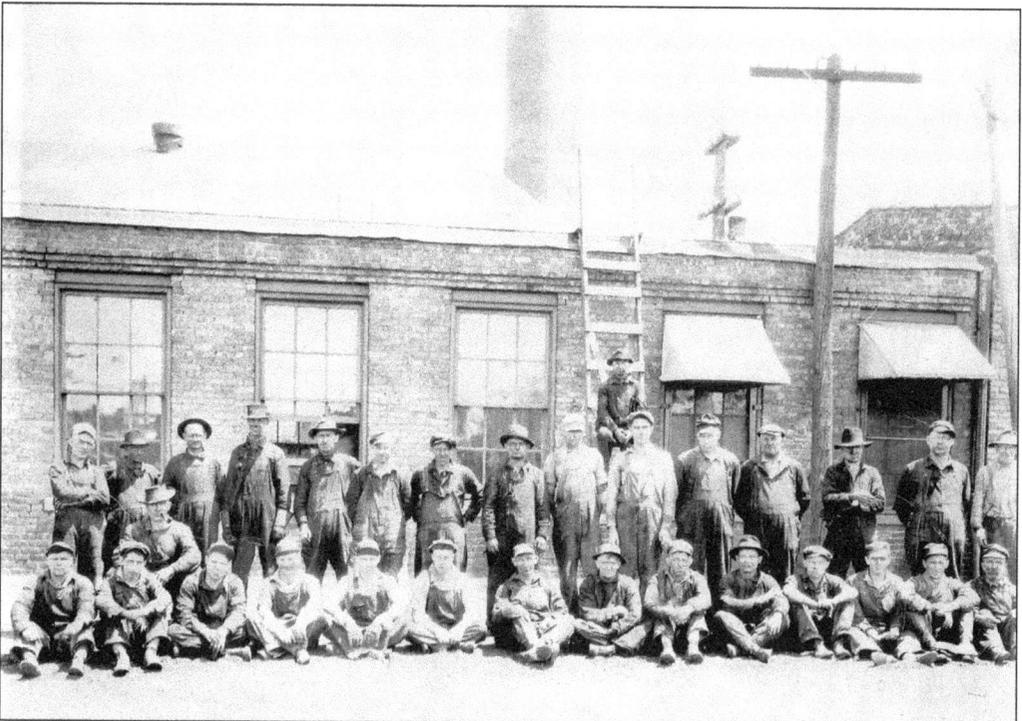

These are Camanche Avenue machine shop workers in 1920. The machine shop served the Round House, which was nearby. Among the workers pictured here are: John Vance Sr. (front row, first man lower left), R. Rudolph (last man on lower right), and Earl Fenn Sr. (back row, seventh from left). (Photograph from the Clinton County Historical Society Archives.)

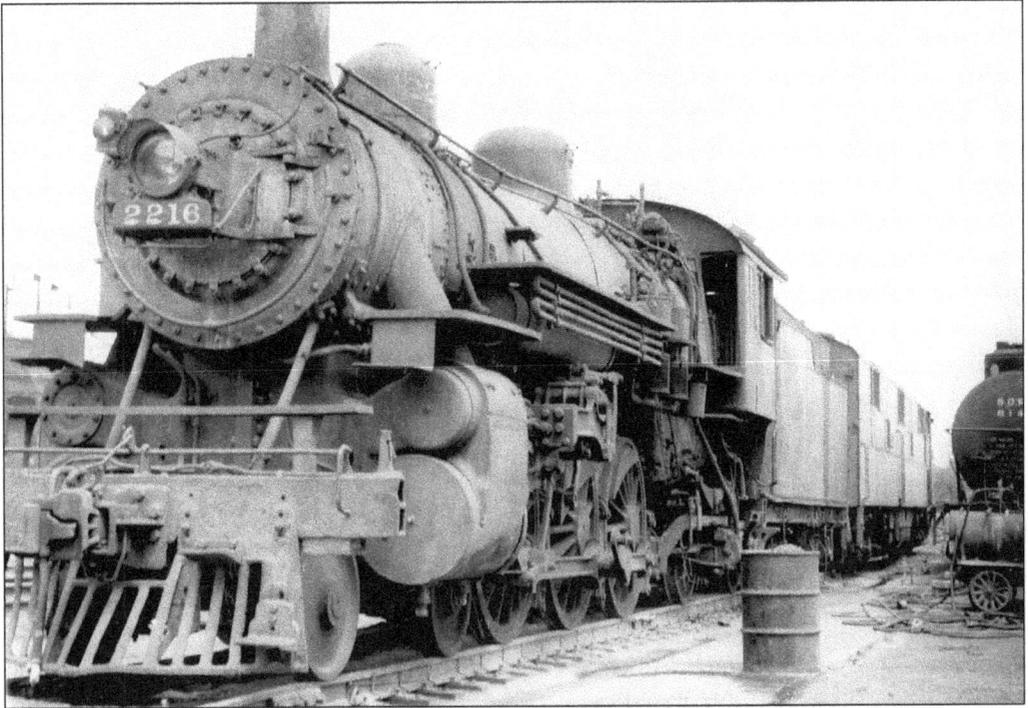

The C&NW steam engine #2216 with a 2-8-4 wheel arrangement is pictured here at the Clinton Depot, waiting to go out with a mail car c. 1910. The tank on the right probably had fuel oil in it for heat. (Photograph from the Clinton County Historical Society Archives.)

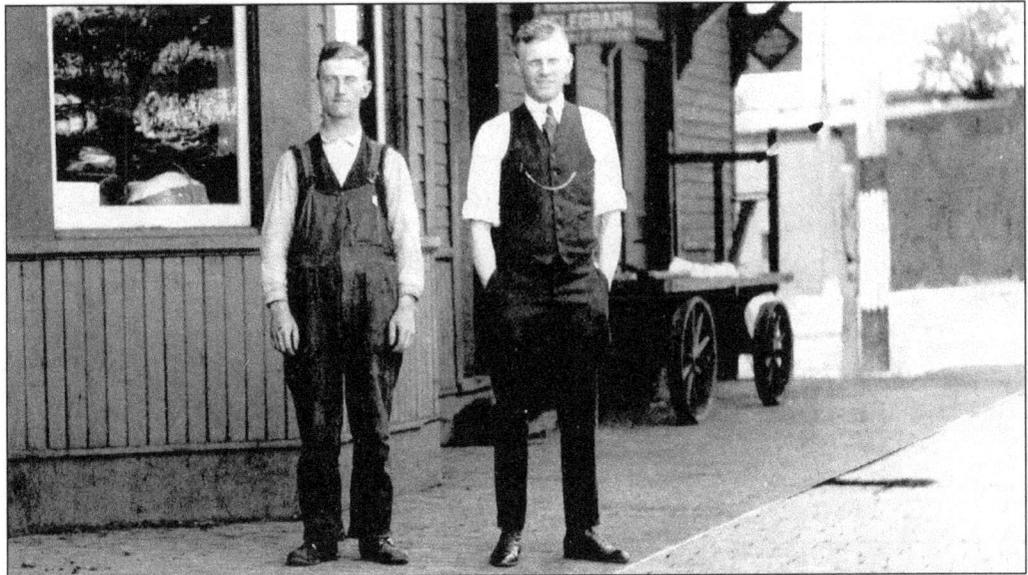

This is the station master at the Lyons Depot in front of the Western Union sign in 1916. The Depot is about a block south of Main Avenue near the Milwaukee and C&NW rail tracks and was an integral part of the Lyons community during its years of service. It has been preserved and is maintained by the park service as a North-end meeting place for local groups. (Photograph from the Clinton County Historical Society Archives.)

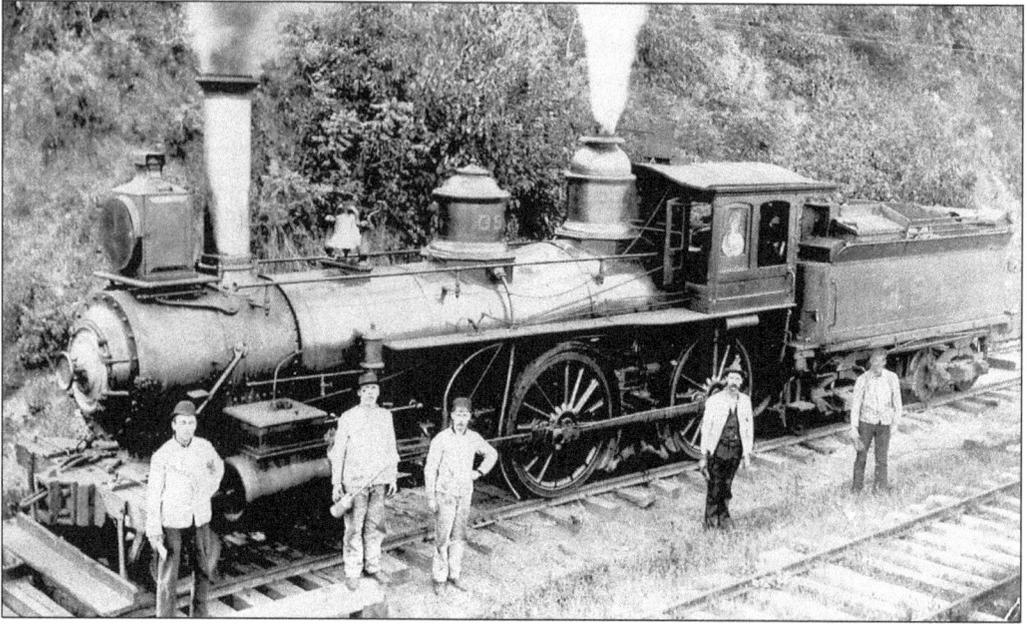

Engine 391 stopped at Eagle Point Park on the Milwaukee tracks in 1895. This engine was in service for 30 years; it was built in 1878 and scrapped in 1908. (Photograph from the Clinton County Historical Society Archives.)

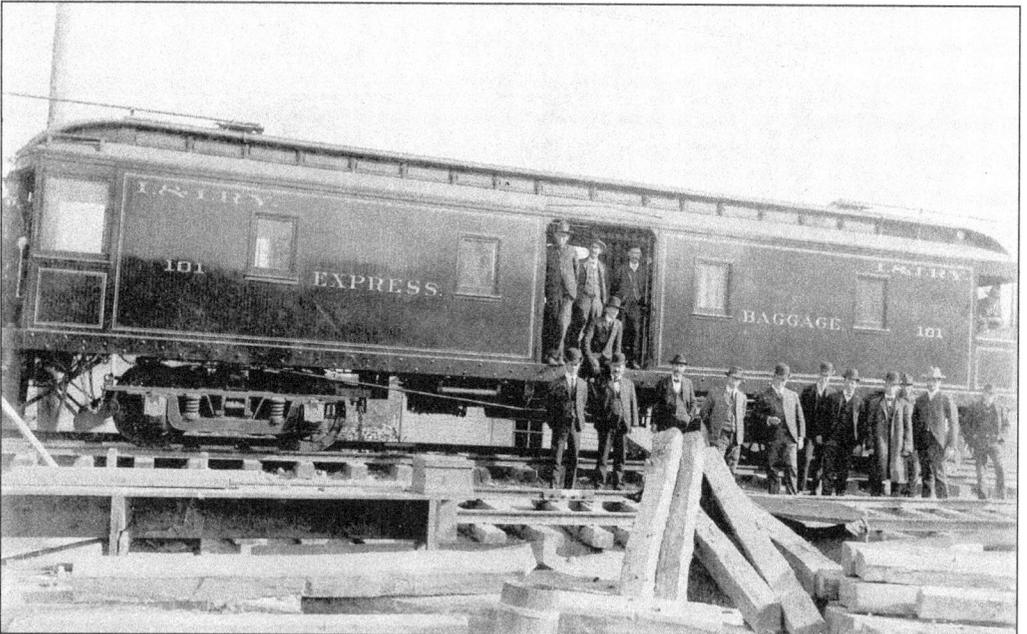

The Iowa & Illinois Railway began operating on electric lines in 1904, between Davenport and Clinton, and then consolidated with the Muscatine line in 1916. The I & I ran on 70-pound rails with 620-volt operating current lines. The Clinton Division had eight Stephenson cars that were 66 feet long and held 60 passengers. It cost 80¢ for a one-way ticket or $1.45 for a round trip to Davenport. The I & I went out of operation in 1940, and the cars were scrapped. Pictured here is one of the mail cars. (Photograph from the Clinton County Historical Society Archives.)

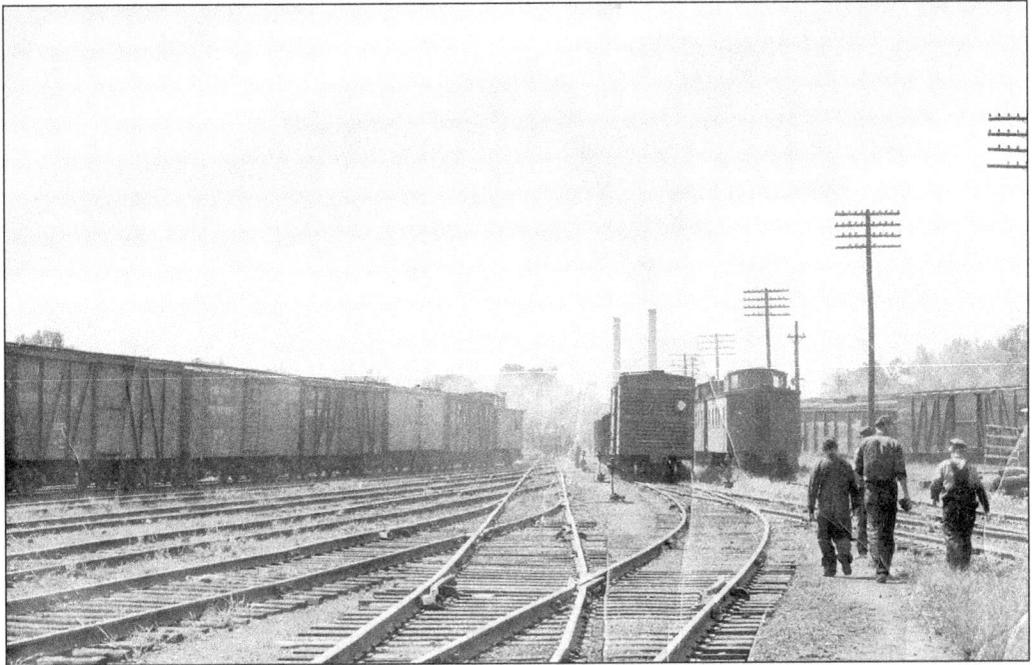

This view looks west toward Franklin Street in the West Ram area of the C&NW railroad yards in Clinton. Clinton Corn Processing smokestacks are in the background. (Photograph from the Clinton County Historical Society Archives.)

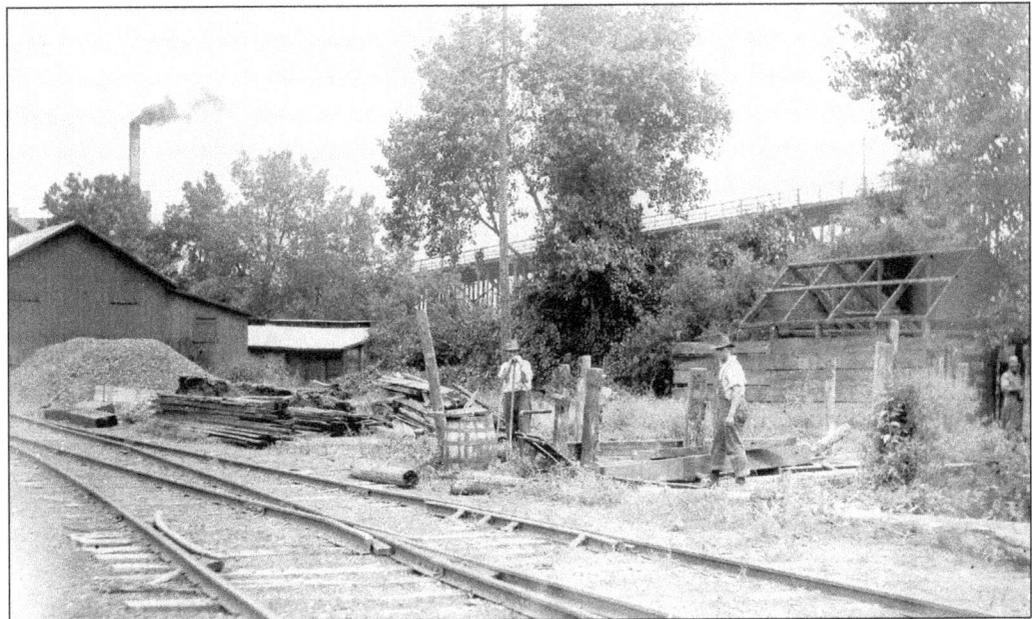

Railroad tracks always required repair, and these men are working in Lyons on the Milwaukee main line in 1916. The pile of gravel, at left, was used for ballast in the tracks. The building to the left is the button factory, and the smokestack belongs to the Gilbert Implement Company. The Lyons Bridge, which spanned the Mississippi River to Fulton, Illinois, is pictured in the rear center. (Photograph from the Clinton County Historical Society Archives.)

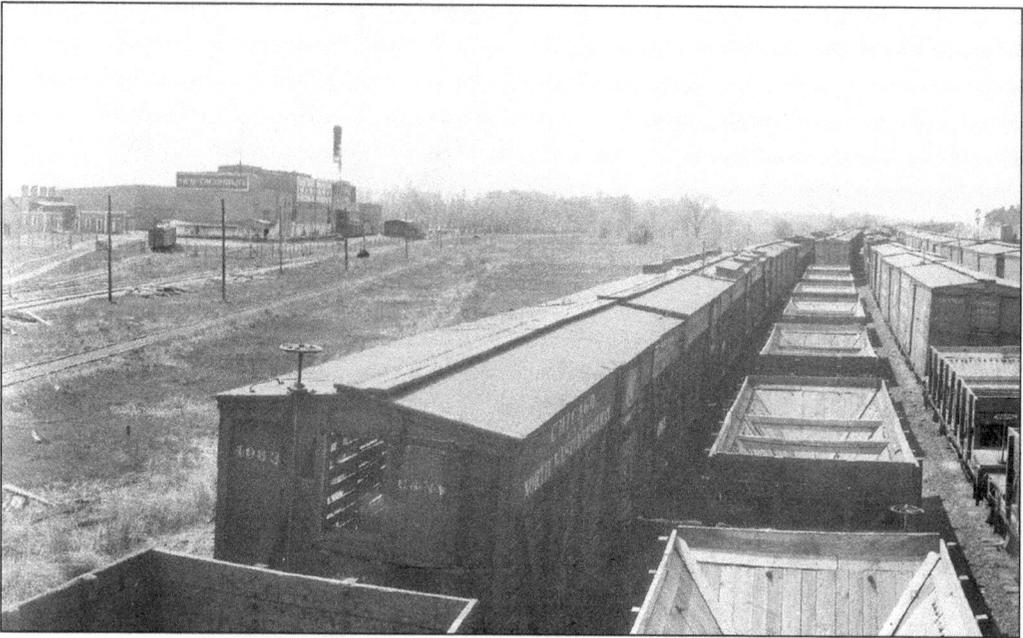

This is a 1925 photograph of the "now time" freight yard. Cattle cars are on the left, coal or ballast cars are in the center, and box cars are on the right. To the left is the Milwaukee main line, whose tracks lead directly to Swift & Company, a local chicken rendering factory. (Photographs from the Clinton County Historical Society Archives.)

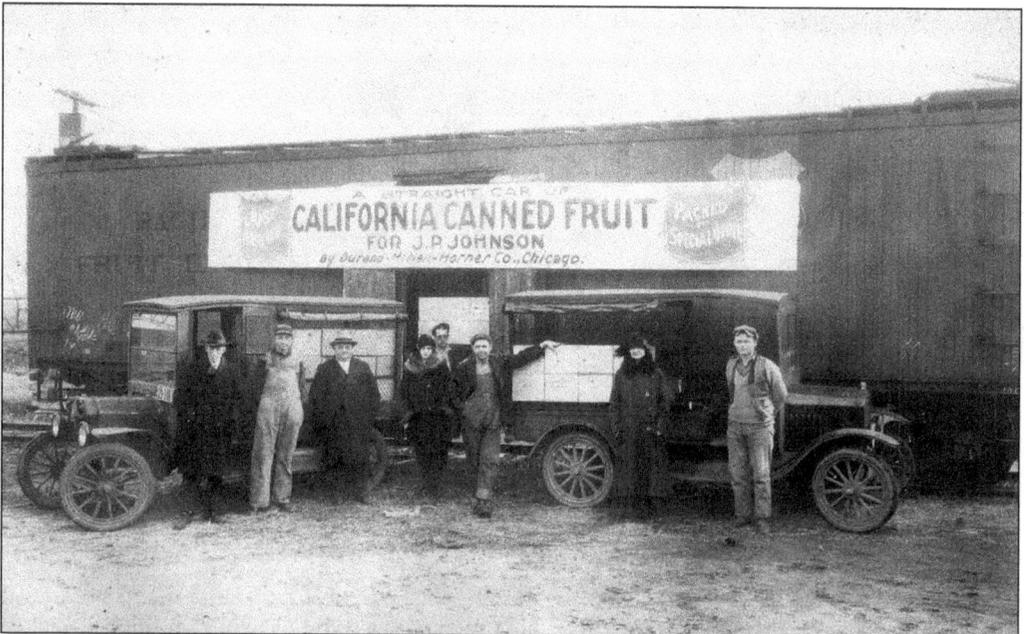

J.P. Johnson, owner of Johnson's Grocers at 802 4th Street in Clinton, ordered an entire boxcar of canned fruit in 1916. The Union Pacific and C&NW railroads hauled the Pacific Fruit Express boxcar to its destination, east of the depot near the Railway Express Agency. (Photograph from the Clinton County Historical Society Archives.)

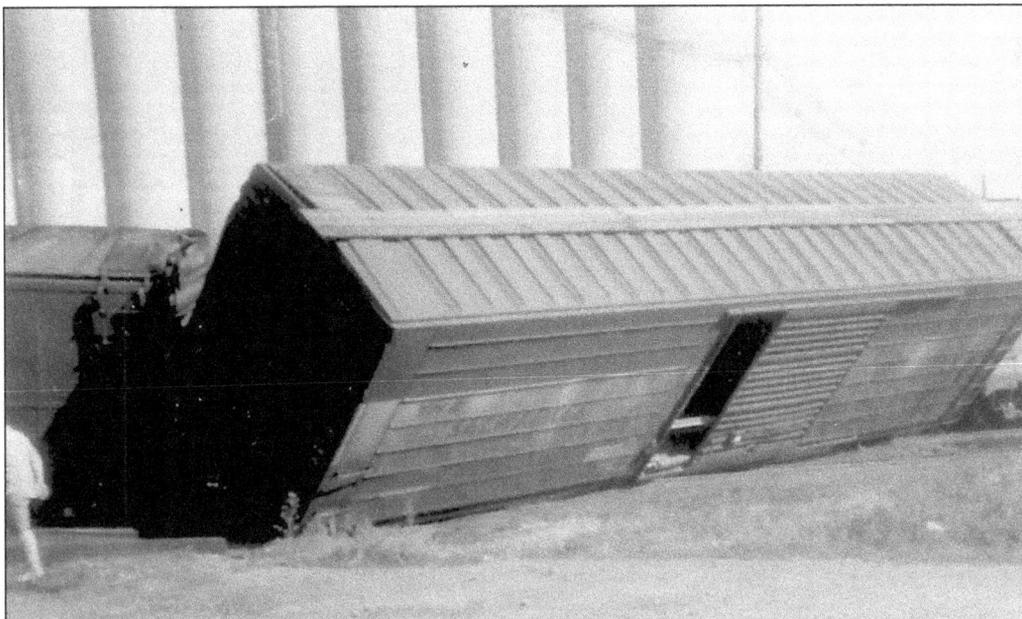

This is the aftermath of a derailment by S. 5th Street in South Clinton on the Milwaukee tracks in 1971. The 5th Street corn elevators are shown in the background. (Photograph courtesy of Jule Luckritz.)

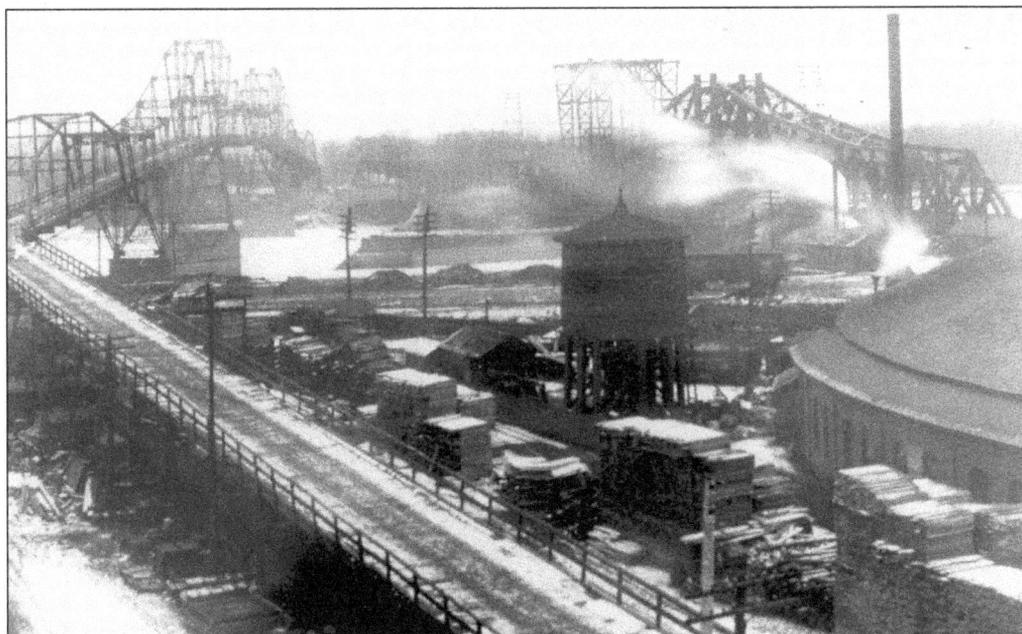

This 1909 photograph pictures both the 1888 wagon bridge—which was demolished in 1954— on the left and the C&NW drawbridge to the right. The drawbridge was the longest double track swing bridge on the Mississippi River at the time it was built and retains that distinction today. Also visible on the right are the huge 8th Avenue S. roundhouse and a water tower used for filling the tanks of the steam engines. (Photograph from the Clinton County Historical Society Archives.)

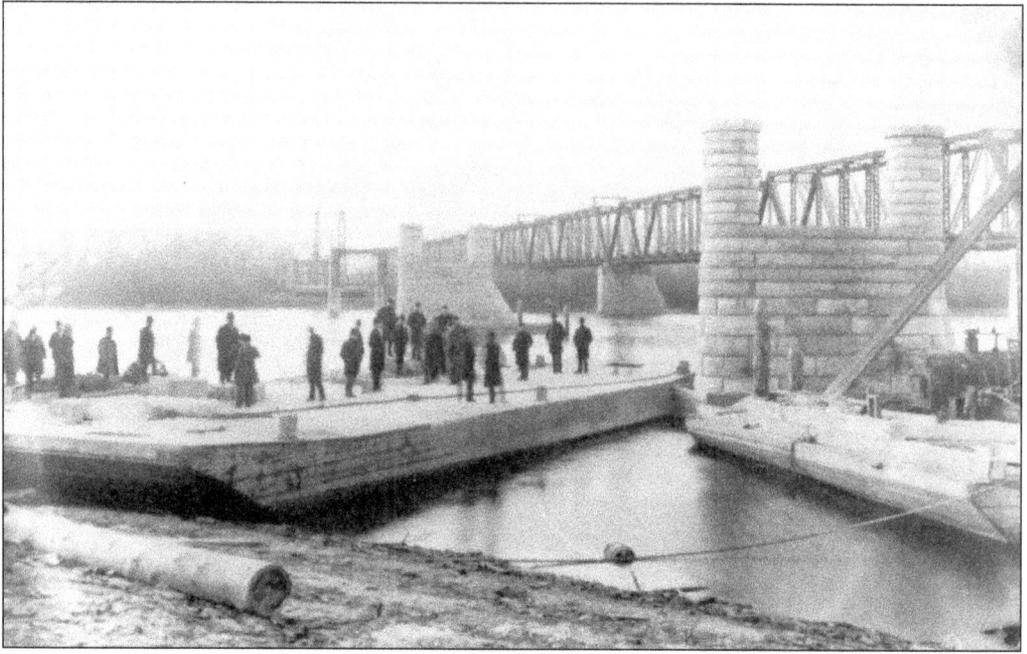

Here is an 1888 photograph of the piers that were put in to support the Wagon Bridge being built in downtown Clinton. These barges, which also held materials and construction supplies, transported workers out onto the river to do their work. (Photograph from the Clinton County Historical Society Archives.)

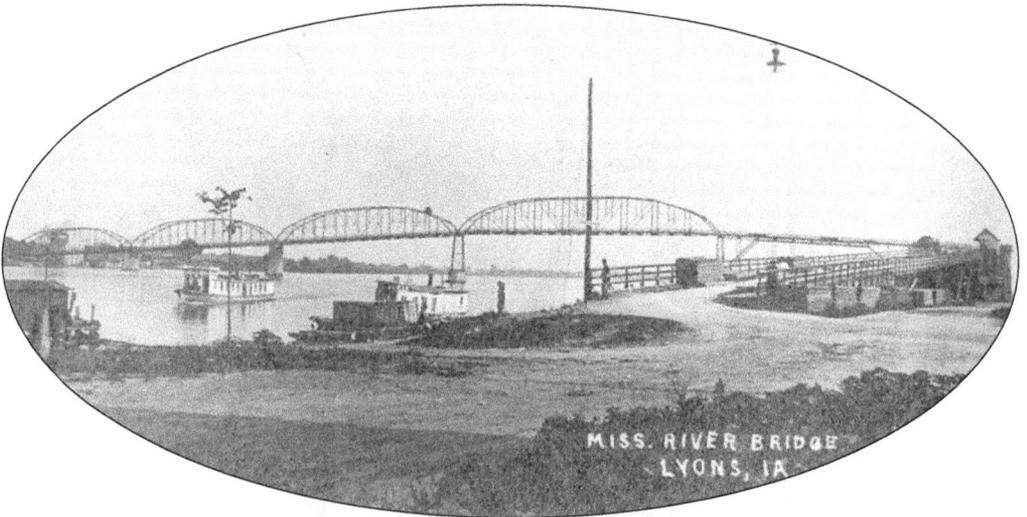

MISS. RIVER BRIDGE
LYONS, IA

The Lyons Bridge crossing the Mississippi River into Fulton, Illinois was opened to the public on July 4, 1891. It was demolished in 1975 to make room for a new bridge six blocks south into Fulton. This Main Street site was also a dock for steamboats and the Lyons Riverfront Park. As the area was developed, McEleney Motors built a car dealership at the approach to the right of the bridge. It has since closed and relocated to the western edge of the city. (Photograph from the Clinton County Historical Society Archives.)

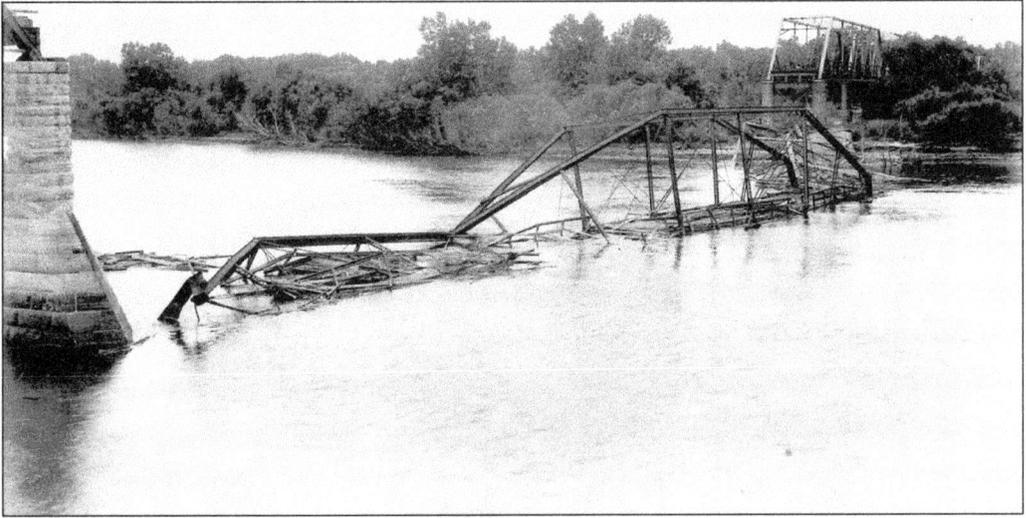

This span of the railroad bridge to cross the Mississippi River was built in 1909. In 1910, it was destroyed by a windstorm and had to be rebuilt. This photograph looks north and shows Little Rock Island in the background. (Photograph from the Clinton County Historical Society Archives.)

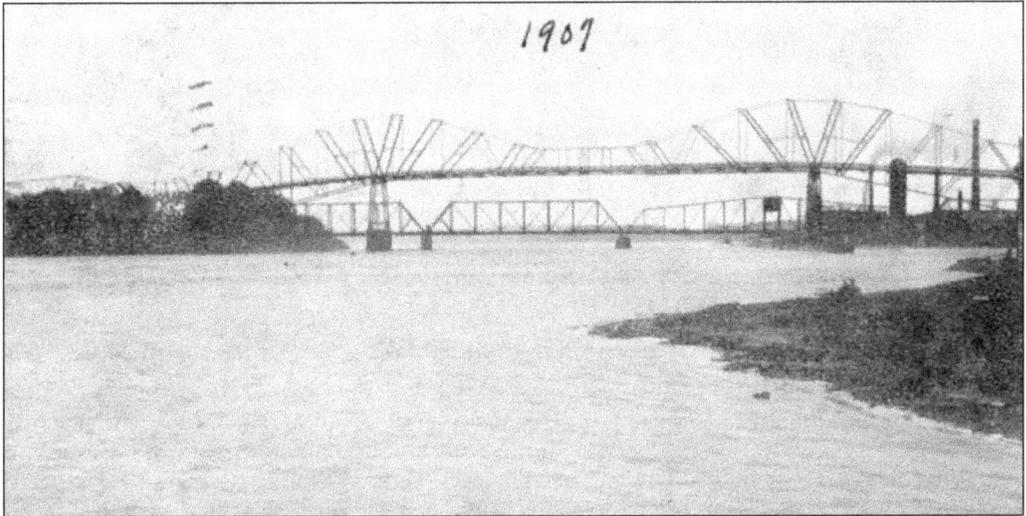

1907

A 1907 view of the "high bridge" and the C&NW railroad drawbridge taken from 6th Avenue S. in Clinton. The steamboat office was located on the right in this photo and Little Rock Island is pictured on the left. (Photograph from the Clinton County Historical Society Archives.)

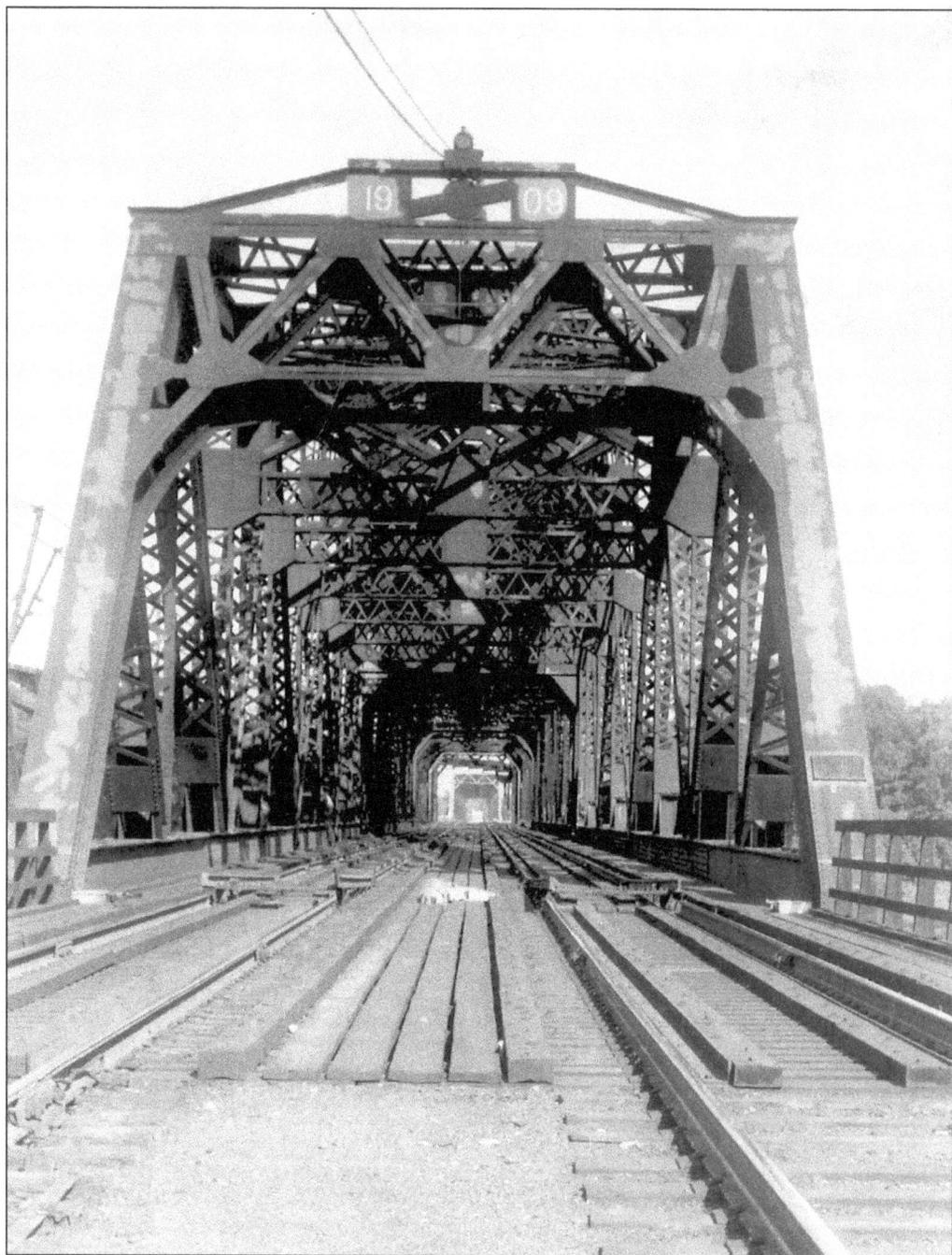

This is a view looking across the Mississippi River east from Iowa to Illinois through the C&NW drawbridge. The drawbridge was built in 1909 after the original span was taken down. A 109-pound rail was used to put the tracks of the bridge down. Derailers were installed to derail a train so it would not fall into the river when the bridge was open. In case of breakdown, most parts have to be hand-manufactured for repair. It is the only double-track drawbridge being used by the railroads to cross the river today. (Photograph from the Clinton County Historical Society Archives.)

Four

BYGONE VIEWS

The Clinton Boat Club housed a spacious combination of a dining hall and a ball room on the second floor, with a parlor and restrooms on the first floor. The second floor veranda furnished the coolest retreat in the city during the hot summer months. After opening in 1913, the Boat Club was said to be the finest on the Mississippi between St. Paul and St. Louis. It was torn down in 1999, and the site is now a grassy slope beside a children's playground. (Photograph from the Clinton County Historical Society.)

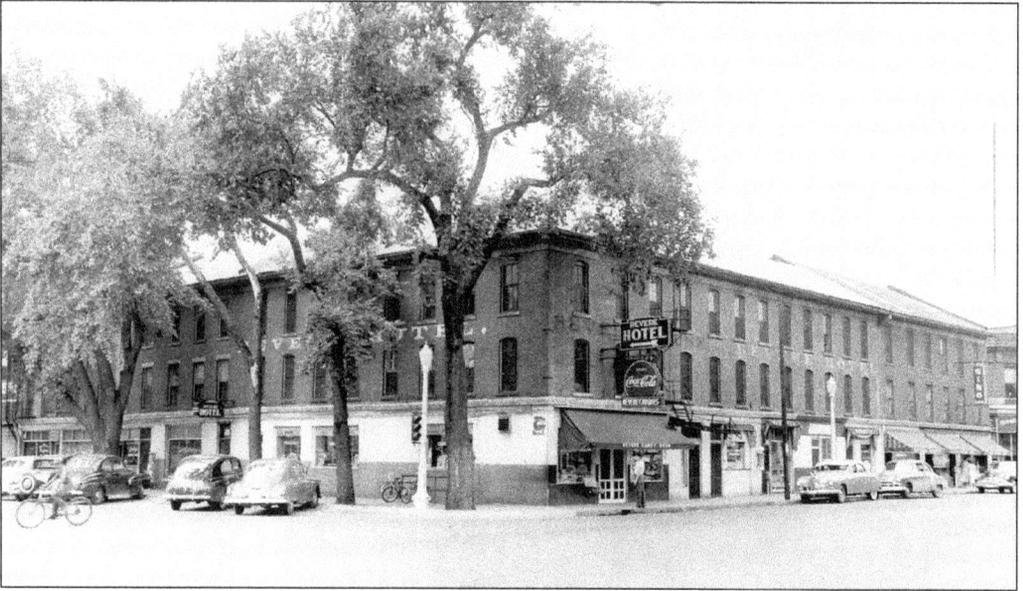

The Revere Hotel and the Revere Candy Store shared the corner of 4th Avenue S. and 2nd Street in the 1940s and '50s. At the other end of the block was one of the many Sino's Cash and Save Stores, along with McFadden's Cafe. The brick streets are now gone, and the quaint light posts have long since been replaced. (Photograph from the Clinton County Historical Society.)

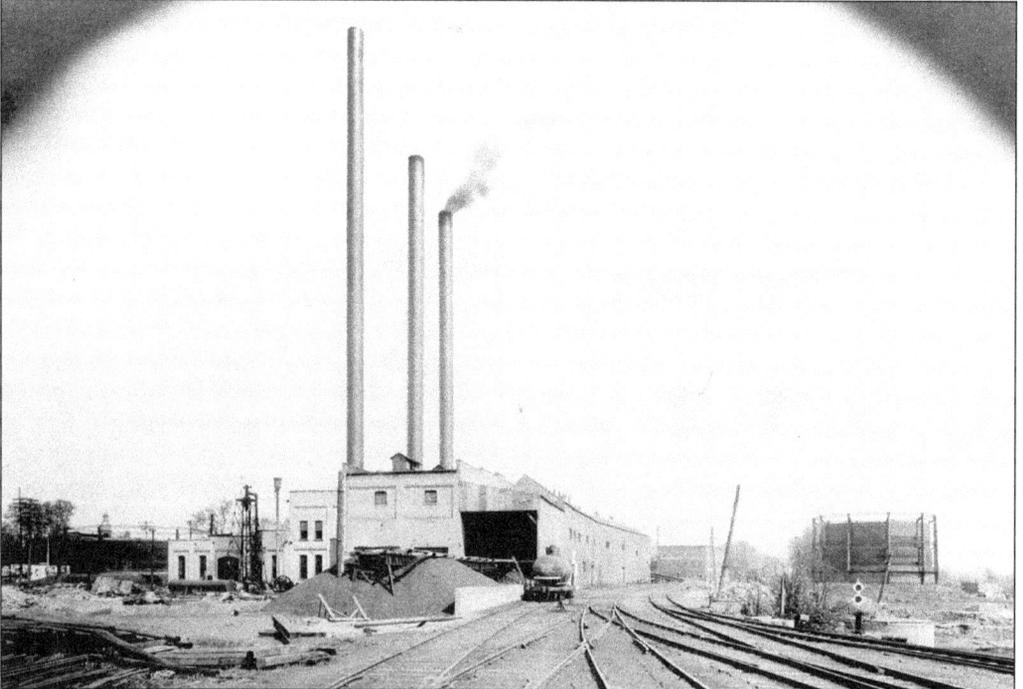

This 1925 image looks north along the railroad tracks to the Interstate Power Gas Company. The Anderson Furniture Company is located in the background, and the shack of "Dirty Bob," an unpaid caretaker of the city dump, is in the extreme right background. (Photograph from the Clinton County Historical Society Archives.)

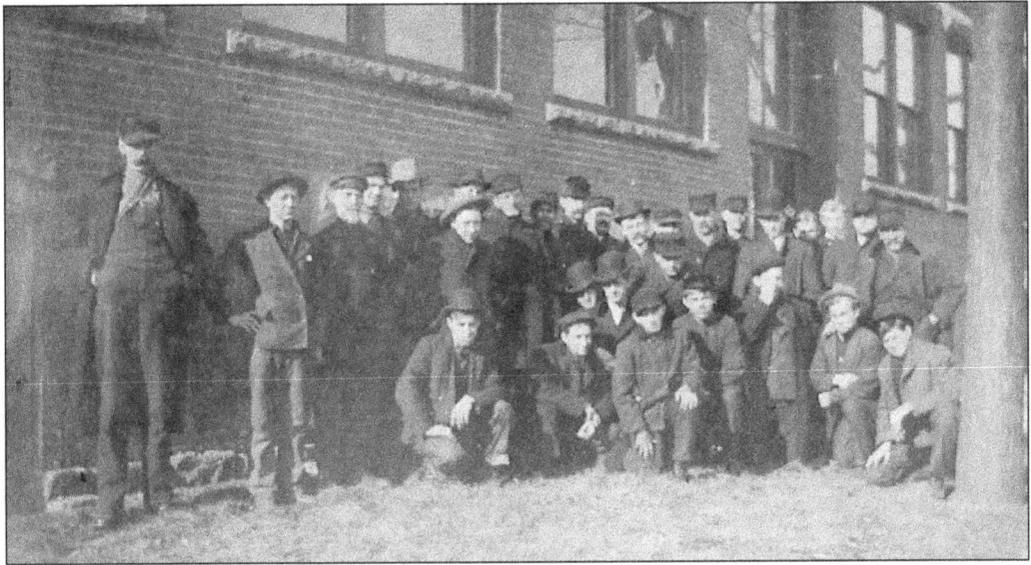

Clinton Saddlery Company was located at 902–904 S. 3rd Street and equipped everything from horses to people. Their production of harnesses, bridles, and other equipment hit its peak during World War I. The company was cited for its outstanding contribution to the war effort. When the demand for equestrian equipment slacked off, production was shifted to a line of high-quality men's dress shoes under the name of the Clinton Shoe Manufacturing Company. Because of the Great Depression and a labor strike, the company closed in 1933. (Photograph from the Clinton County Historical Society Archives.)

Everyday, truckloads of garbage were dumped in front of the Clinton Incinerator at 4th Avenue N. and River Street. Two large white garbage trucks began collecting garbage at 7:00 a.m. each morning, and the last load was dumped at 3 p.m. Clinton's first and only incinerator was built in 1931 at a cost of $40,000. By 1953, the City Engineer was concerned the incinerator was being "crowded" and something would have to be done to enlarge it. The city decided to use a landfill to bury the garbage in 1956. The incinerator was razed within a year. (Photograph from the Clinton County Historical Society Archives.)

In 1897, Clinton County had a new courthouse in the city of Clinton complete with a four-faced clock in the steeple that can still be seen from all directions. Every week the clock was manually wound by cranking the spring. Today, the clock remains an essential part of the city. However, it has long since been electrified and no longer requires someone to take the long trip up to the fourth floor of the courthouse to wind it. (Photograph from the Clinton County Historical Society Archives.)

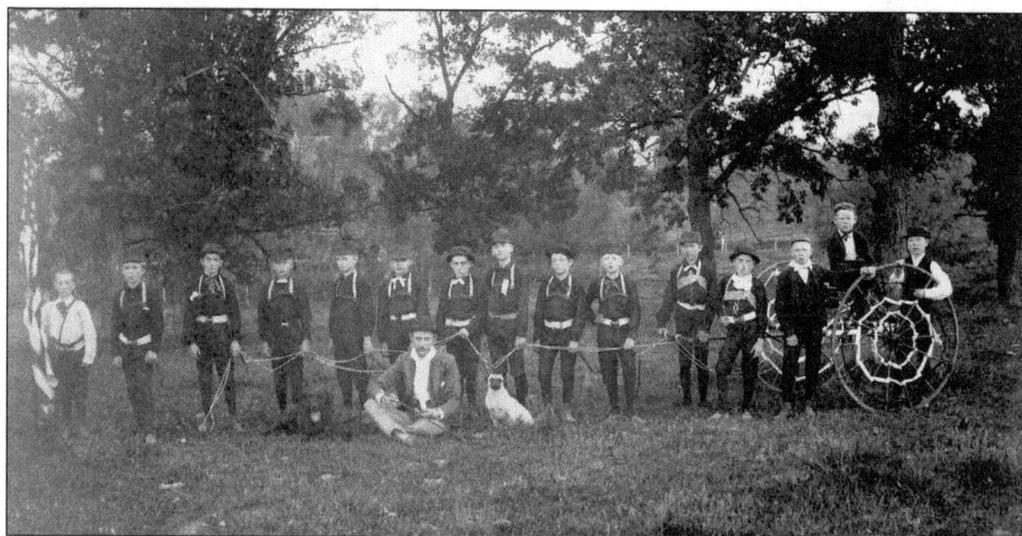

The citizens of Lyons, Iowa were proud of their prize-winning Running Fire Teams throughout the last quarter of the 19th century. A Junior Running Team is shown above with the flag bearer on the left and the team's coach and mascot in the front center. (Photograph from the Clinton County Historical Society Archives.)

52

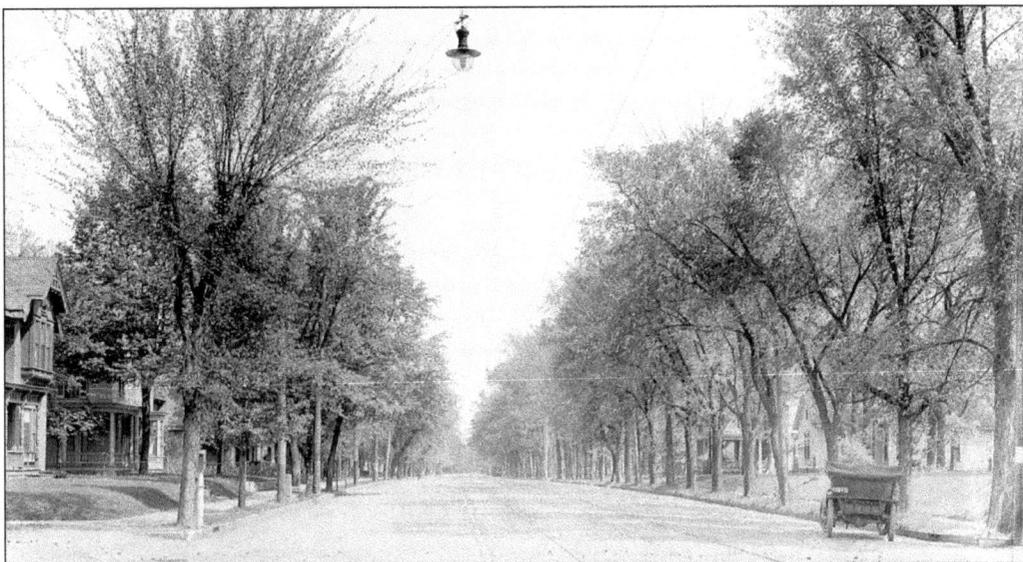

In the early 20th century, handsome houses lined N. 2nd Street while elm trees arched over the brick paving. Double streetcar tracks allowed streetcars to go in both directions, providing easy travel between Lyons and Clinton. The acetylene arc light was lowered each evening and raised again to alleviate the darkness of the night at this 10th Avenue N. intersection. Today, the street has become a major thoroughfare and is lined with commercial businesses. A few homes remain—but the elms are gone. (Photograph from the Clinton County Historical Society Archives.)

The Randall House, built in 1856, was located at 22nd Avenue and Garfield Street in Lyons. It was designed to accommodate 300 guests. A severe depression followed, and no one was found to lease and operate the hotel. In 1880, a group of Lyons investors purchased the building and traded it for land in South Dakota. The Randall House was then dismantled and transported to South Dakota by rail. (Photograph from the Clinton County Historical Society Archives.)

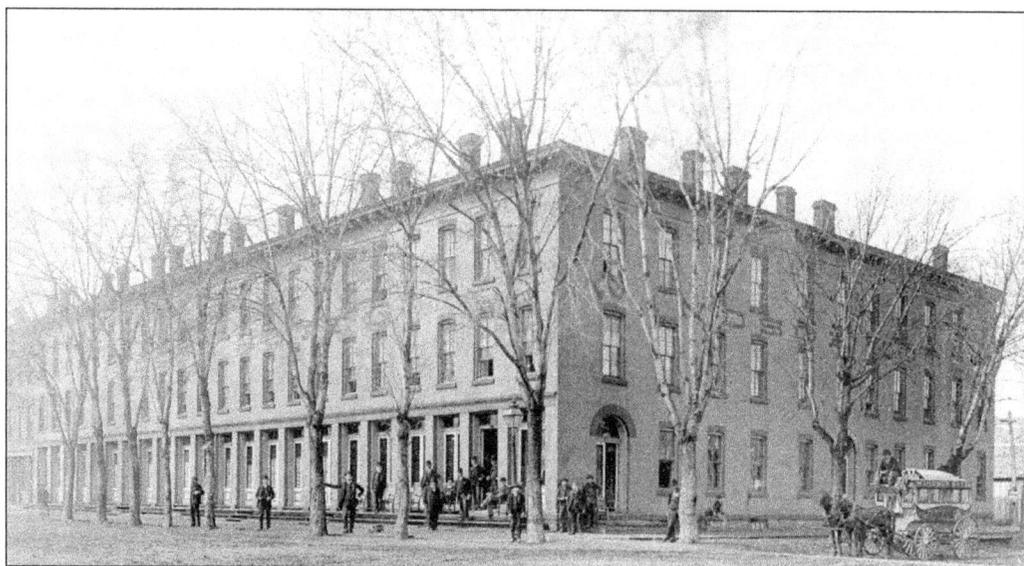

The Iowa Central Hotel was completed in 1856. The three-story brick building was located on the southeast corner of 4th Avenue and First Street. In its heyday, the hotel's spacious parlor served as the major gathering place for local society. Gourmet food was regularly served in its elegant dining room. Soon after December 18, 1878, it was renamed the Windsor Hotel, and the proprietor Charles P. Kaynor still made his home there at the turn of the century. (Photograph from the Clinton County Historical Society Archives.)

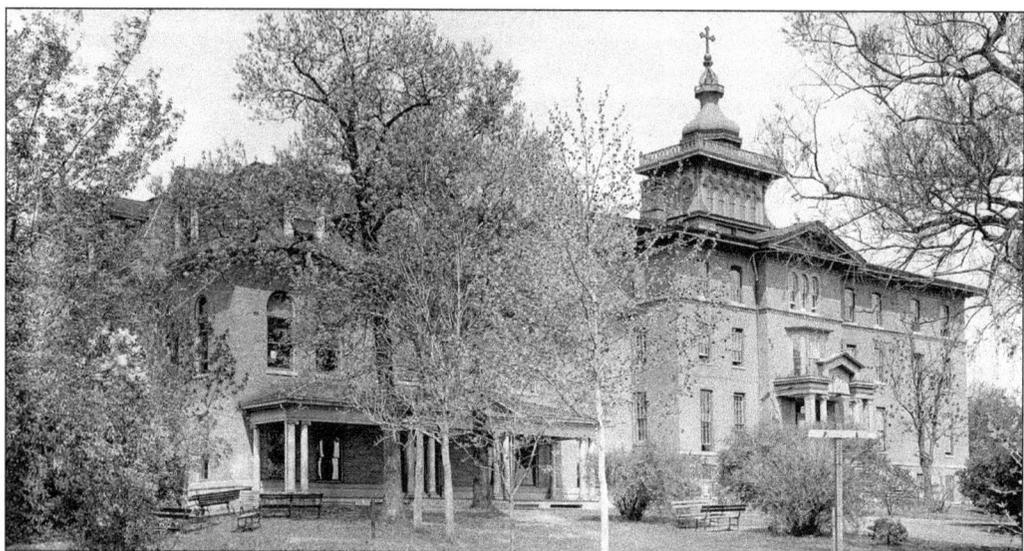

This stately structure with its large cupola was located atop the hill on N. 5th Street between 20th and 22nd Avenues. It was built in 1858 as the Lyons Female College. The new college never really got off the ground and was purchased in 1872 by the Sisters of Charity of the Blessed Virgin Mary for $100,000 and renamed Our Lady of Angels seminary. At the peak of its popularity, OLA attracted most of its boarding students from the Chicago area. By 1965, with the number of students dwindling and the burden of maintaining a 100-year-old building, the sisters closed the school. The halls of the building stood empty until it was razed in 1969. (Photograph from the Clinton County Historical Society Archives.)

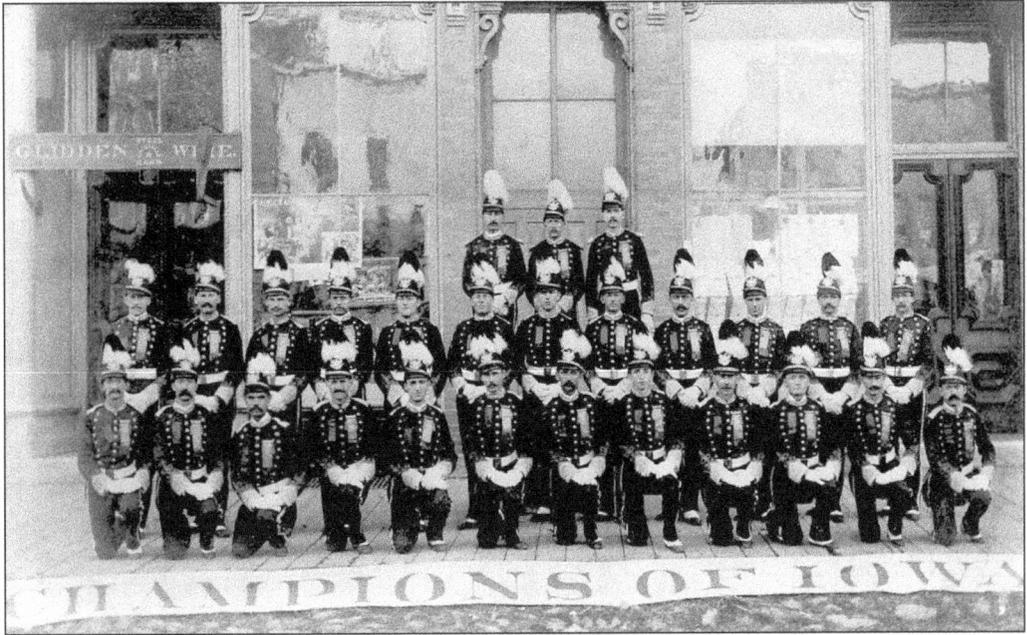

The surname of Root has been associated with the Lyons business community since 1854. It represents the oldest, continuously-family-owned firm in Clinton County. C.L. Root organized the Root Drill Team Corps, which won the Iowa State Championship in 1889, 1890, and 1891. This group was selected to officially escort the governor of Iowa on his tour of the World's Fair in 1893, and they were in demand for appearances throughout the Midwest. (Photograph from the Clinton County Historical Society Archives.)

On January 8, 1968, a 17-year-old male student set the Clinton High School on fire. Firemen fought the two-million-dollar blaze, which destroyed the main building in nine degrees below zero weather. On Christmas holiday when the fire occurred, the 1,156 students were out of school for two weeks and then returned to classes in other facilities around the city. The school was rebuilt, and students reconvened in 1970. (Photograph from the Clinton County Historical Society Archives.)

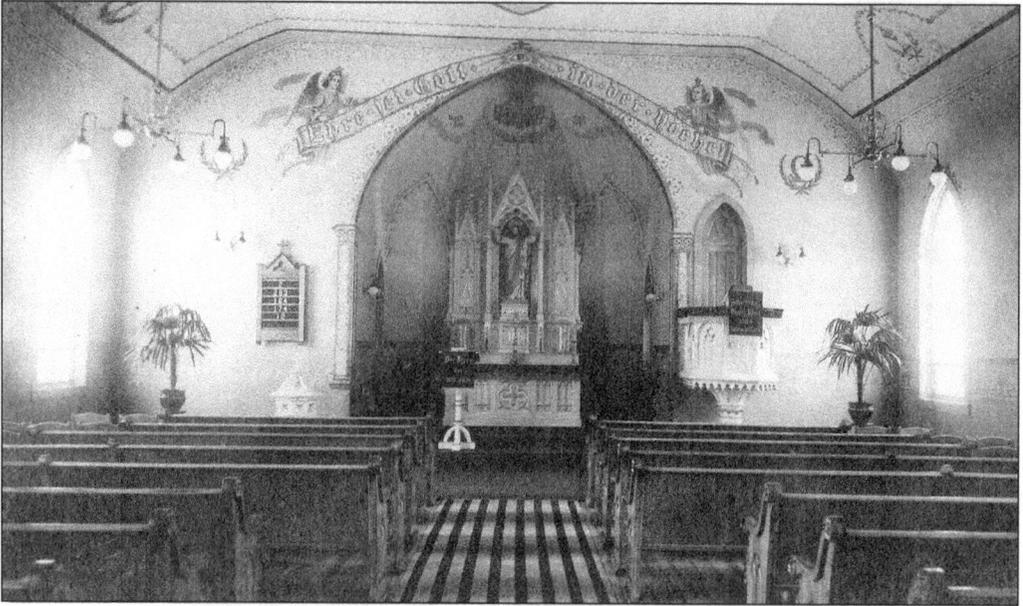

The interior of the second St. John's Lutheran Church, located on N. 5th Street between Main and Buell Avenues in Lyons, was noted for its beauty and simplicity. The pulpit is shown on the right of the altar with a small baptismal font on the left. The frame white building was destroyed by fire on February 27, 1939. In 1940, the congregation replaced their church at the site of the former Western Union Brewery, a short distance away. Portions of the beer cellar still exist to the rear of the present church parsonage. (Photograph from the Clinton County Historical Society Archives.)

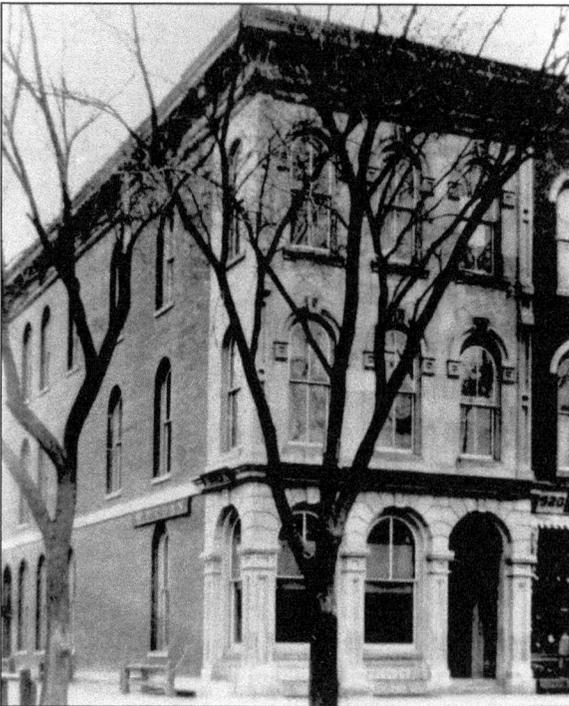

Established in the early 1860s, the first Clinton National Bank building was a majestic structure located on the corner of 6th Avenue S. and 2nd Street. For many years, the building was occupied by McLane Office Equipment and then by O'Leary's Irish Pub. The building was destroyed by fire in 1998, and the site is now a downtown parking lot. (Photograph from the Clinton County Historical Society Archives.)

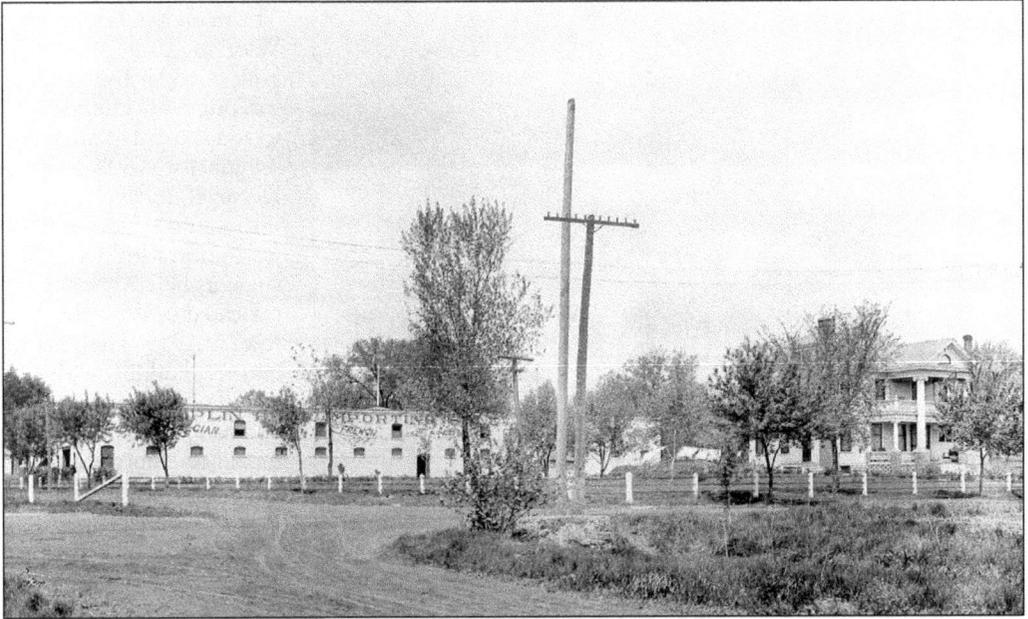

In 1902, the firm of the Champlin Brothers opened a livery barn in the 100 block of 5th Avenue S. in Clinton and made the decision to import their stock of horses from France, Belgium, England, and Germany. After a fire destroyed the original stable, they rebuilt their livery business on the corner of 4th Street and 13th Avenue N. Their horses were known for winning prizes in state fair show rings and livestock exposition horse shows. The company liquidated their stock in 1925; however, the large white house still stands. (Photograph from the Clinton County Historical Society Archives.)

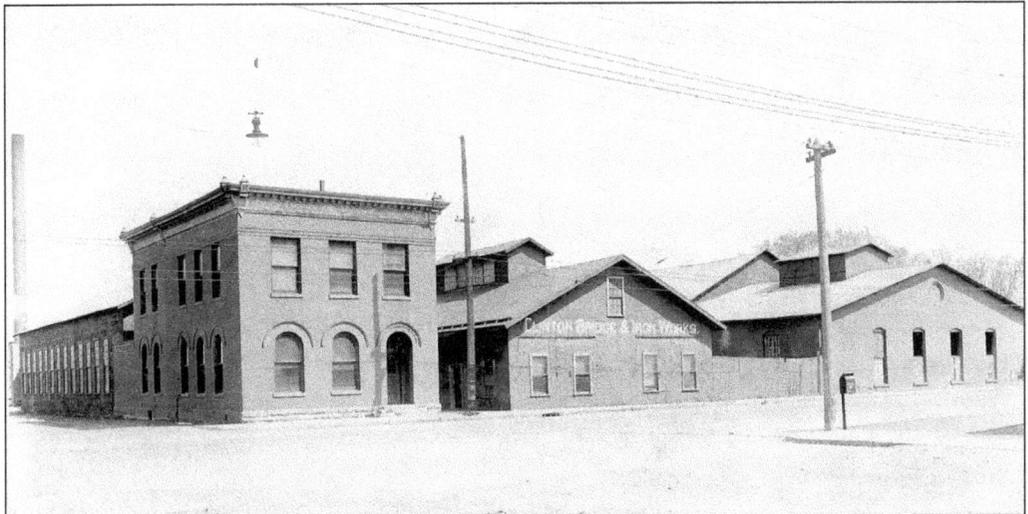

The Iron Works Plant, located on 2nd Street between First and 2nd Avenues, opened in Clinton in 1868 and was in continuous operation for over 115 years with several name changes. Known in 1892 as the Clinton Bridge Company, the George Wilson family purchased it and renamed it the Clinton Bridge and Iron Works. In 1928, the company's name was shortened to the Clinton Bridge Works, until it ceased operations in 1984. (Photograph from the Clinton County Historical Society Archives.)

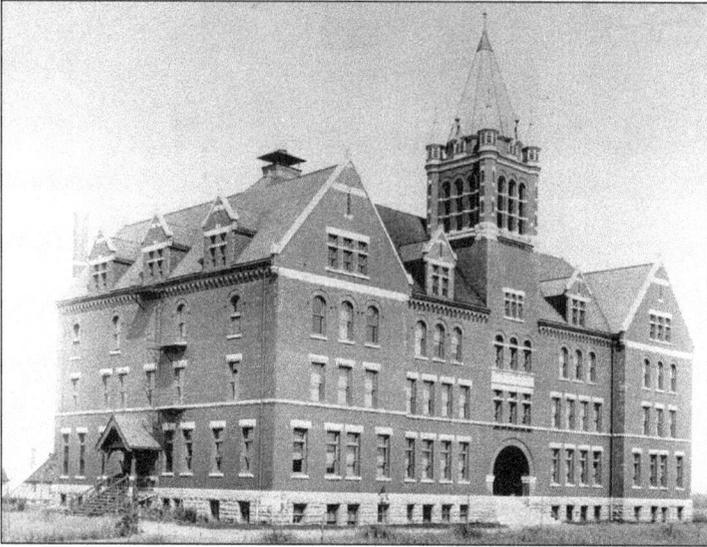

The main building of Wartburg College was built in 1893–1894 and was originally intended to educate only Lutheran seminary students. However, it developed into a co-educational institution with over 250 students before it was relocated to Waverly, Iowa in 1935. The majestic building with its tall tower was a noted Clinton landmark and remained empty until the early years of World War II, when it was converted into apartments to cope with the acute housing shortage. In 1998, this once proud hall of advanced education was demolished. (Photograph from the Clinton County Historical Society Archives.)

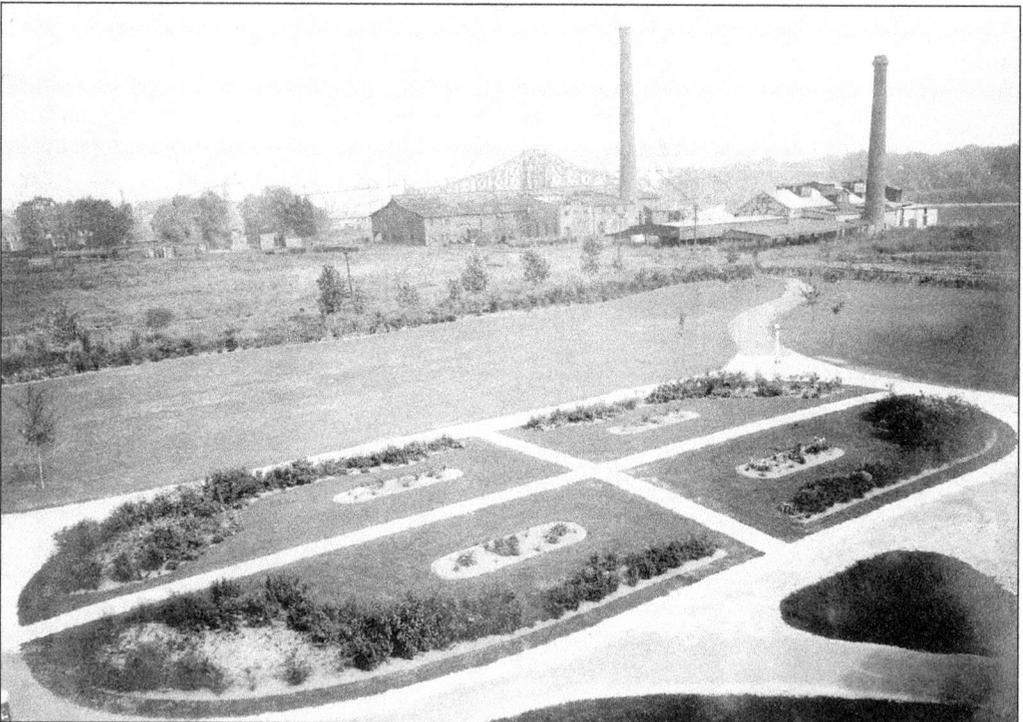

Formal gardens were part of the landscape at the Curtis Companies office located at 114 12th Avenue S. in Clinton. The abandoned Upper Mill of the W.J. Young Company and the Stone Mill of the C. Lamb & Sons Company are shown in the background of this 1920 photograph. The Curtis Company opened as a molding, sash, door, and window factory in 1866 and stayed in business for over 100 years. After closing, the gardens were no longer cared for and faded away. (Photograph from the Clinton County Historical Society Archives.)

On the southwest corner of Chancy Park, this once proud building housed the Chancy Park Community House. Looking over the manicured lawn of Chancy Park, the building was used by Chancy residents for many events and functions. By 1950, when this photograph was taken, age had taken its toll and the building was soon demolished. (Photograph from the Clinton County Historical Society Archives.)

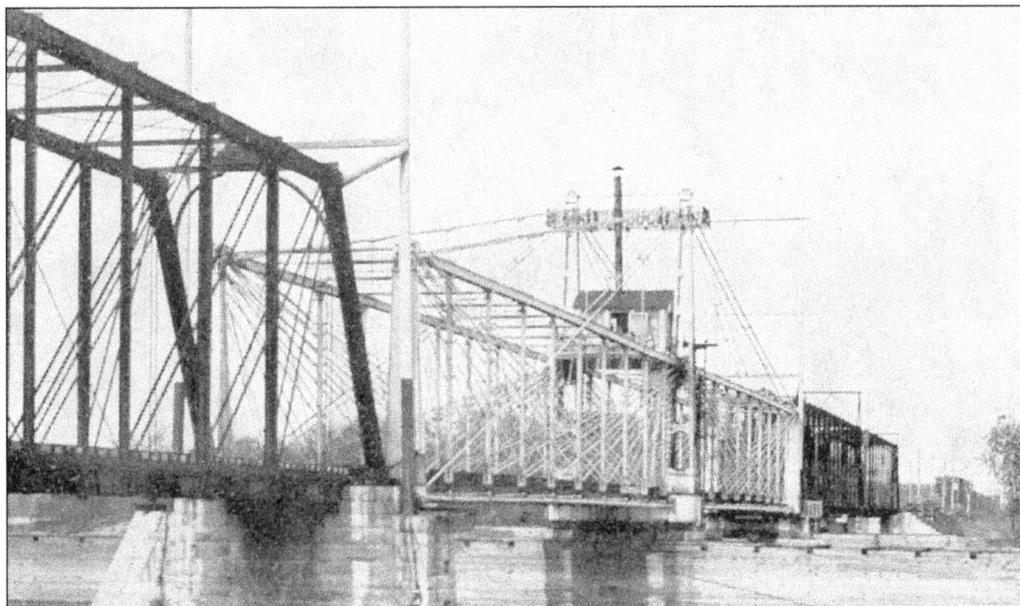

Shown here is a view of the first railroad bridge, built in 1856, across the Mississippi River connecting downtown Clinton to the Illinois shore. It was torn down in 1909 to make room for a new railroad drawbridge, which would become the first double track bridge to cross the river and is still in operation today. (Photograph from the Clinton County Historical Society Archives.)

The small acreage atop the bluffs at First Avenue and Bluff Road didn't appear to have much of a future. However, during World War II, more than 100 Italian war prisoners were housed in a camp there. On Sunday evenings, the young POWs would recall their homeland with song. Many music lovers would park along Bluff Boulevard to hear the lively and haunting music. Though the building pictured on the right served as the mess hall, the barracks are now gone. (Photograph from the Clinton County Historical Society Archives.)

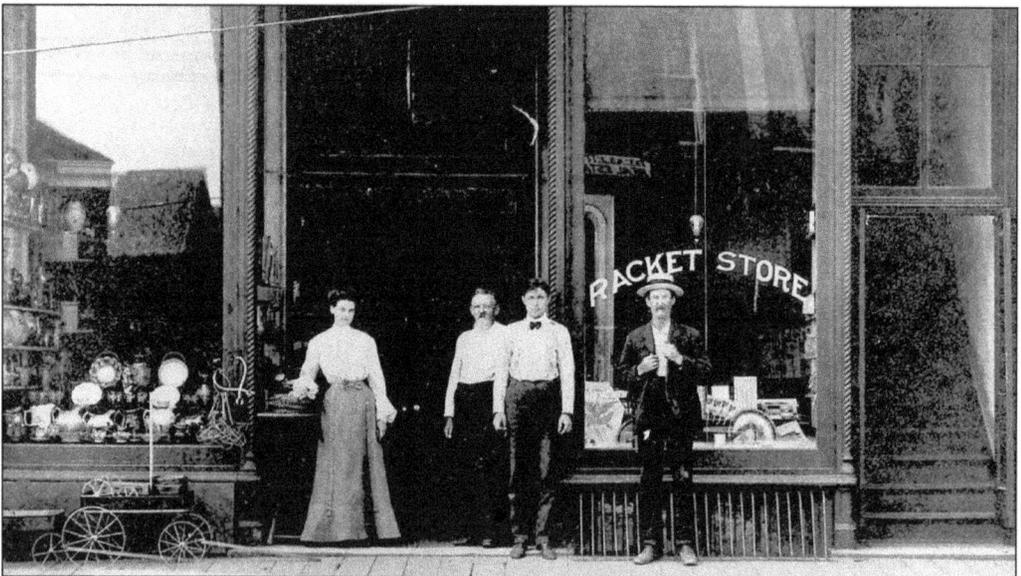

Hobein's was one of the most desirable stores in Lyons in the 1880s. It was called a "Racket Store" because it offered a wide selection of items, including fine china, cut glass, thread, toys, and almost anything needed or wanted. The wire-wheeled wagons along with a wire-wheeled scooter are prominently displayed on the wooden sidewalk in front of the store. (Photograph from the Clinton County Historical Society Archives.)

The Highway Park is a pleasant oasis on the corner of Bluff Boulevard and 7th Avenue S., at the junction of two of the city's busiest streets. In 1940, these majestic white columns led the way through a covered, shady arbor to the gazebo. It was well-used by families for gatherings and celebrations. The gazebo remains; however, the columns have long since been removed. (Photograph courtesy of Lucille Wharff.)

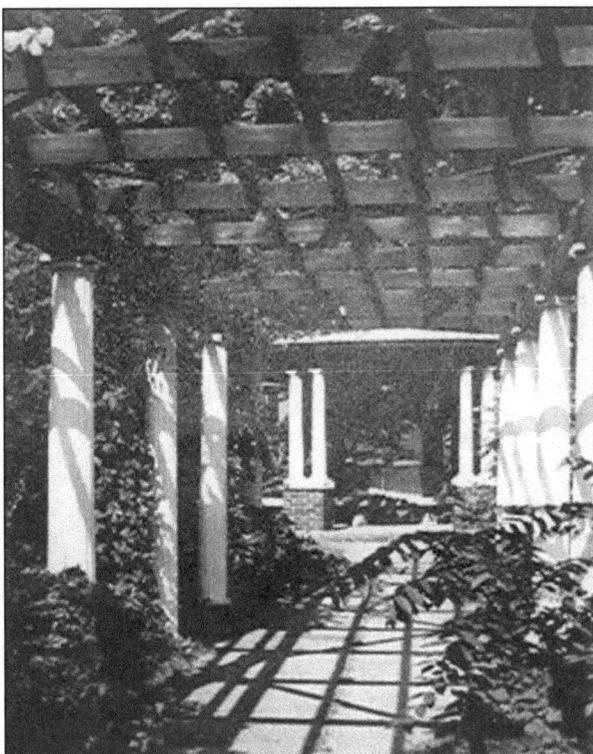

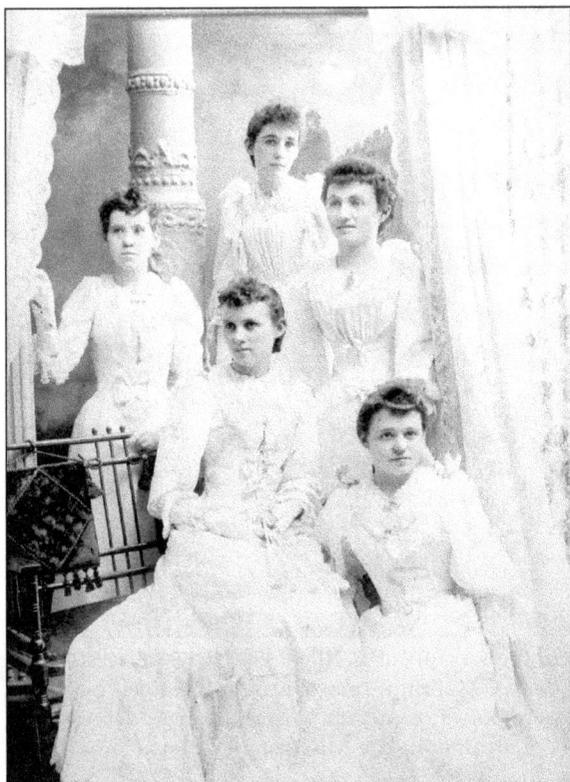

The five lovely young ladies pictured here are from the 1892 graduating class of St. Mary's High School in Clinton. At a later date, the names of the entire graduating class of seven were written on the back of the photograph: Winnie Gibbons, Katherine (Dalton) Gickhorn, Minnie (Welsh) Ohern, Sister Mary Edwardine (Bernadette Tierney), Nellie (Foley) McDonald, Mascell (Tierney) Homer, and Helen Roeder. (Photograph from the Clinton County Historical Society Archives.)

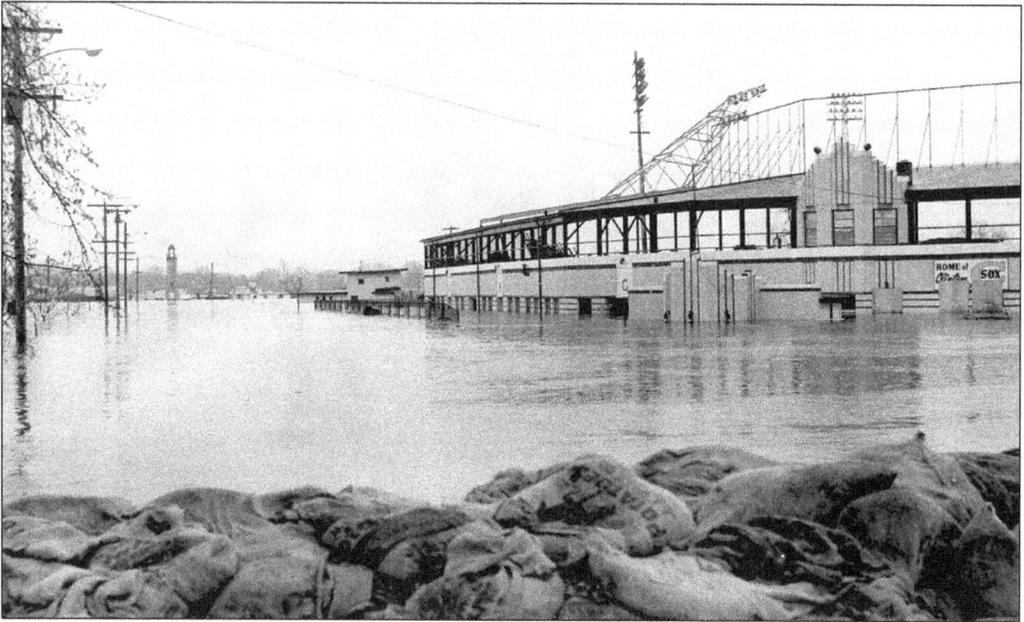

Flood levels on the Mississippi River were recorded many times in the history of Clinton County, however, none as high as the 24.85 foot level on April 28, 1965. Citizens of all ages worked tirelessly in a massive effort to protect the city from the ravages of the "Mighty Mississippi" by sand bagging and constructing dikes. (Photograph from the Clinton County Historical Society Archives.)

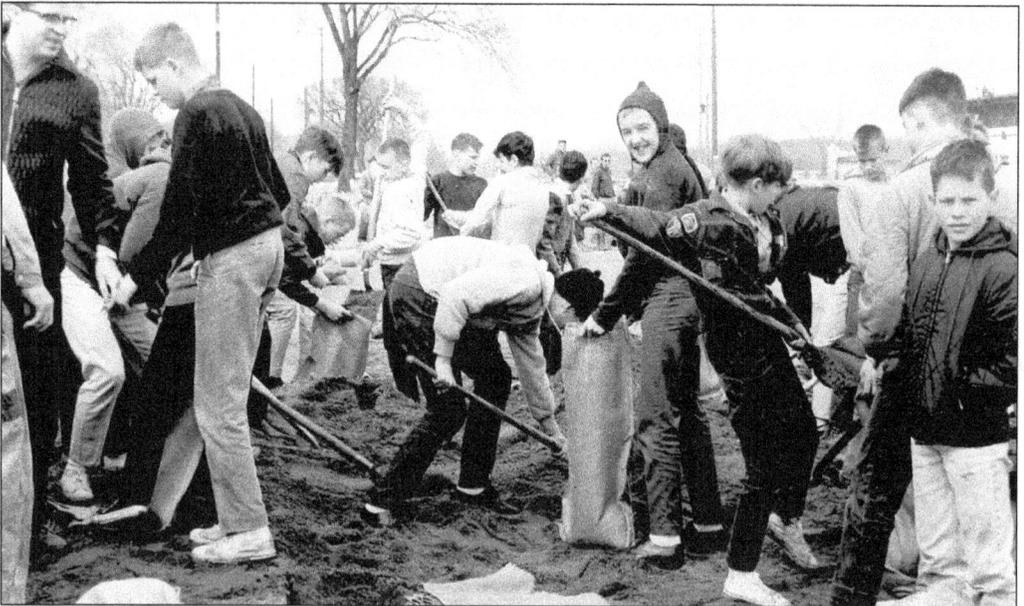

Schools and industries were closed as volunteers of all ages filled sand bags alongside the National Guard and the Civil Defense. Over 1,000 Clinton homes were surrounded by water, and 36 businesses and 16 industrial plants were out of operation. Historians now describe the flood of 1965 as one of the greatest disasters of all time in the Mississippi Valley. (Photograph from the Clinton County Historical Society Archives.)

Five

STREET SCENES

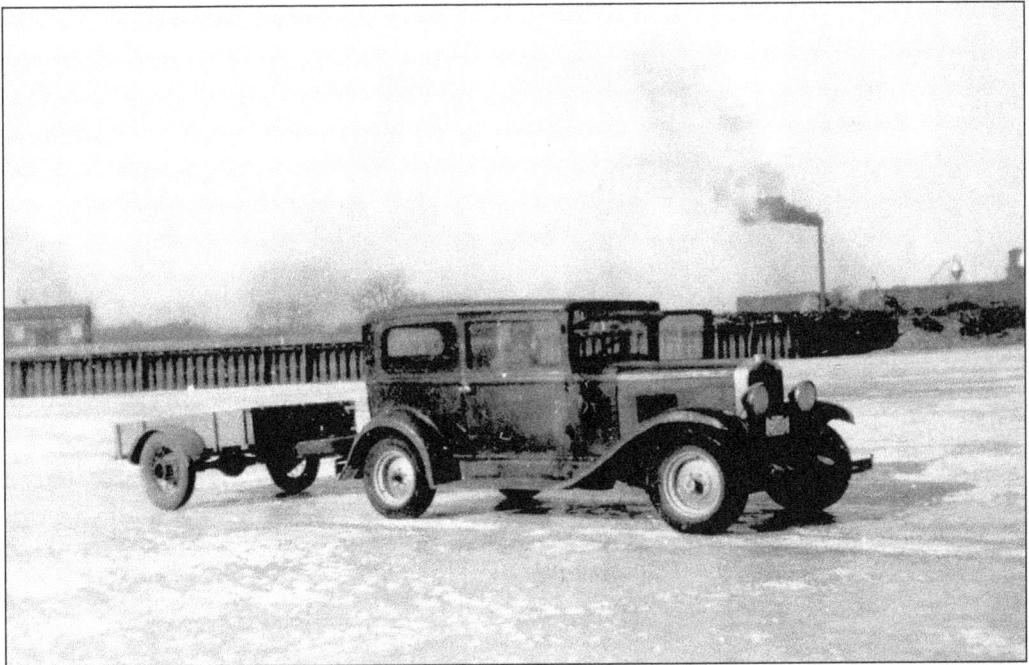

Dr. Herbert Carson's 1930 Chevy is shown crossing Beaver Slough from 2nd Street to Beaver Island. This was a common way to quickly get across the Mississippi River and its backwater sloughs once the thick ice set in. The Curtis Company is shown in the background. (Photograph from the Clinton County Historical Society Archives.)

This August 1, 1912 photograph shows Van Allen's corner and looks west. The open site on 5th Avenue was being cleared for the construction of the Wilson Building. (Photograph from the Clinton County Historical Society Archives.)

This photograph, taken in 1914, again shows Van Allen's corner looking west on 5th Avenue, this time including the completed six-story Wilson Building. (Photograph from the Clinton County Historical Society Archives.)

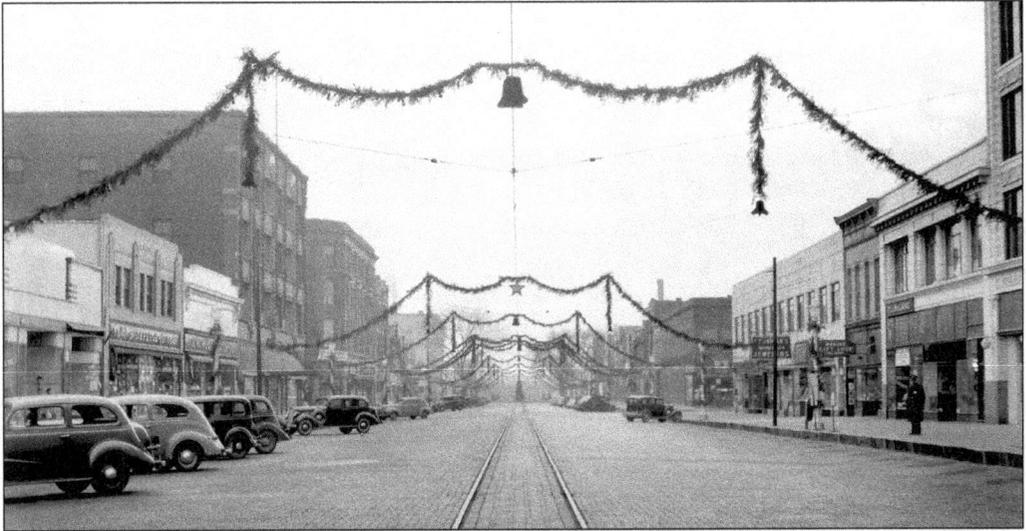

This image faces east from 3rd Street, down 5th Avenue S., toward the Community Christmas tree in early December in the 1930s. The Van Allen Building is the first four-story building on the left. It is presently being renovated for commercial and residential use. The Woolworth Building shown to the west of the Van Allen Building is now a parking lot. (Photograph from the Clinton County Historical Society Archives.)

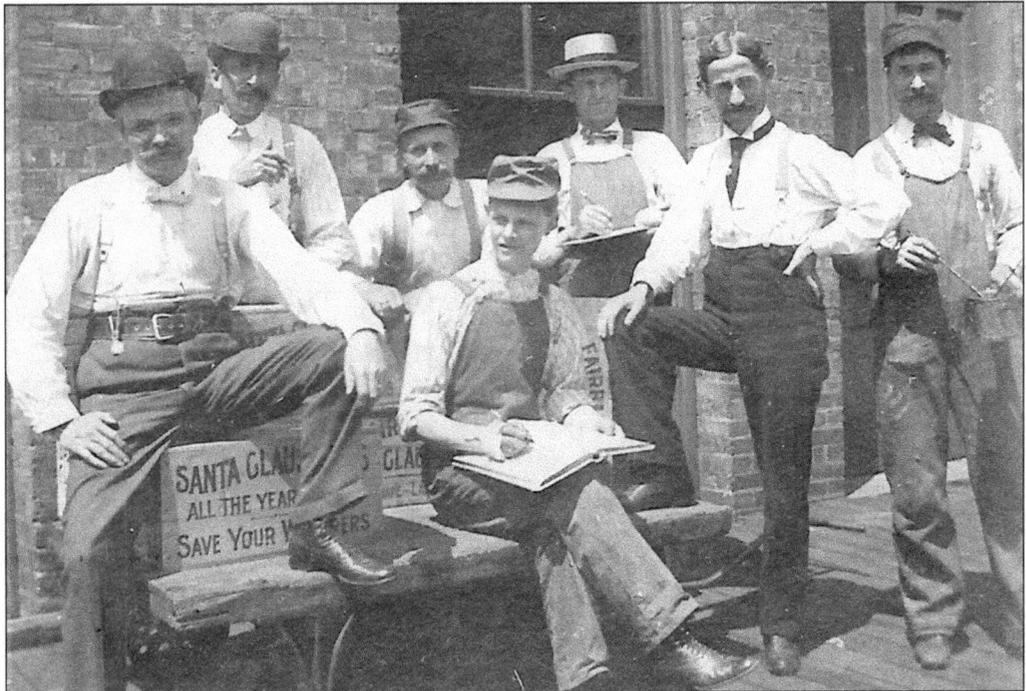

This c. 1890 photo pictures employees of the T.M. Gobble Company, Wholesale Grocer, outside their workplace at 119 5th Avenue. The business was founded in 1883, and the original building burned in 1915. Within six months of the fire, a new building was completed. The T.M. Gobble Co. remained in business until 1957. (Photograph from the Clinton County Historical Society Archives.)

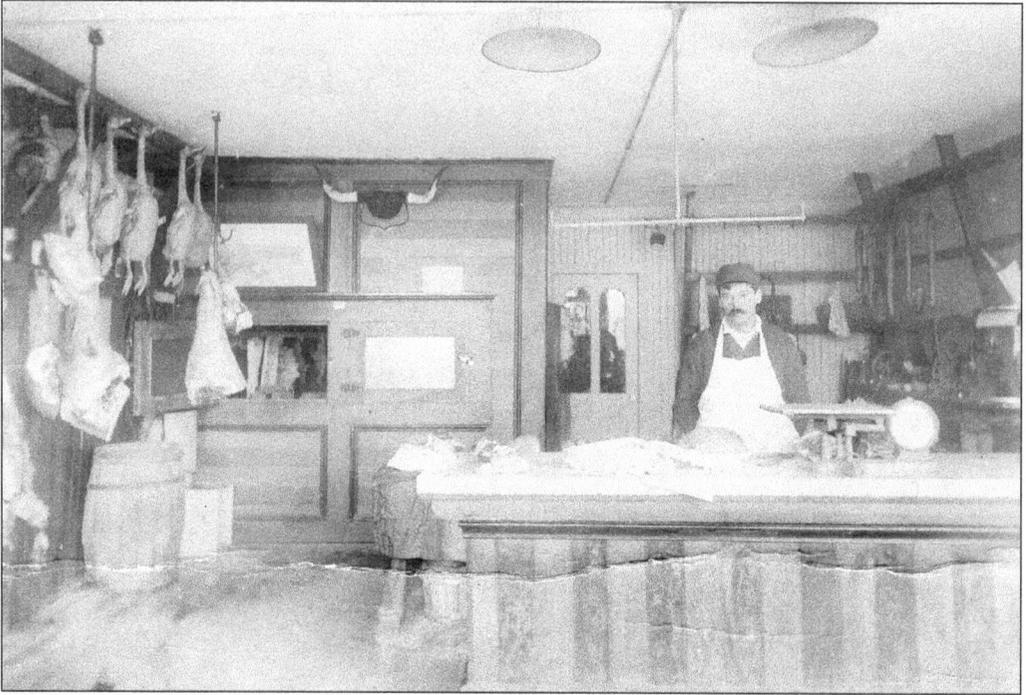

This is one of the many Lyons' meat markets that flourished at the end of the 19th century. Note the lack of packaging and refrigeration that we consider a necessity today. (Photograph from the Clinton County Historical Society Archives.)

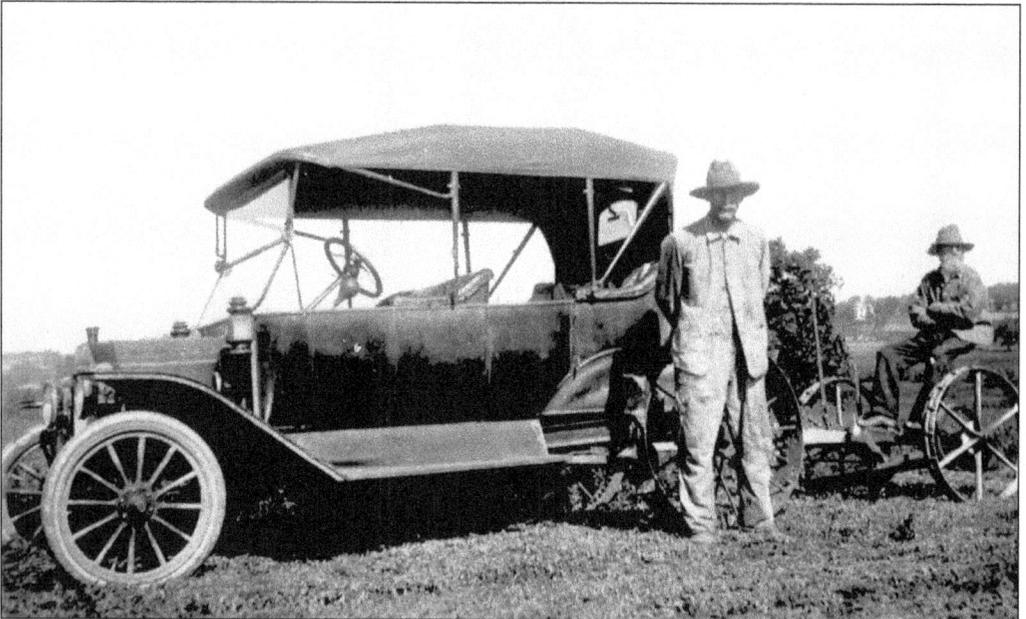

Noble Vosburg stands at 1400 S. 10th Street in 1914 with his Model-T Ford, which has been converted into a homemade tractor. The automobile was transformed into a tractor from a kit that was widely sold for that purpose. The gentleman sitting in back is not identified. (Photograph from the Clinton County Historical Society Archives.)

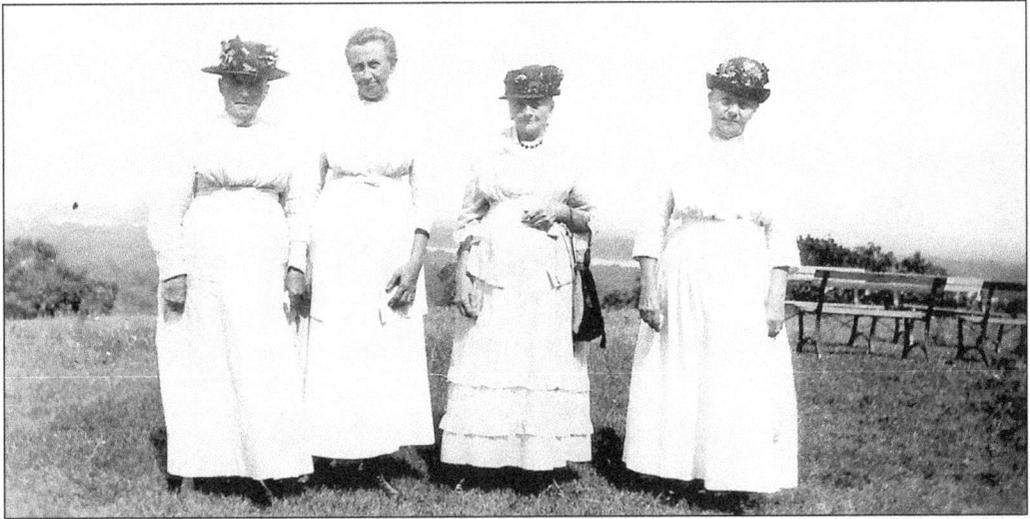

Pictured on a sunny afternoon in 1917 is "The Tuesday Afternoon Meeting of the Wednesday Sewing Club which usually meets on Fridays." (Photograph from the Clinton County Historical Society Archives.)

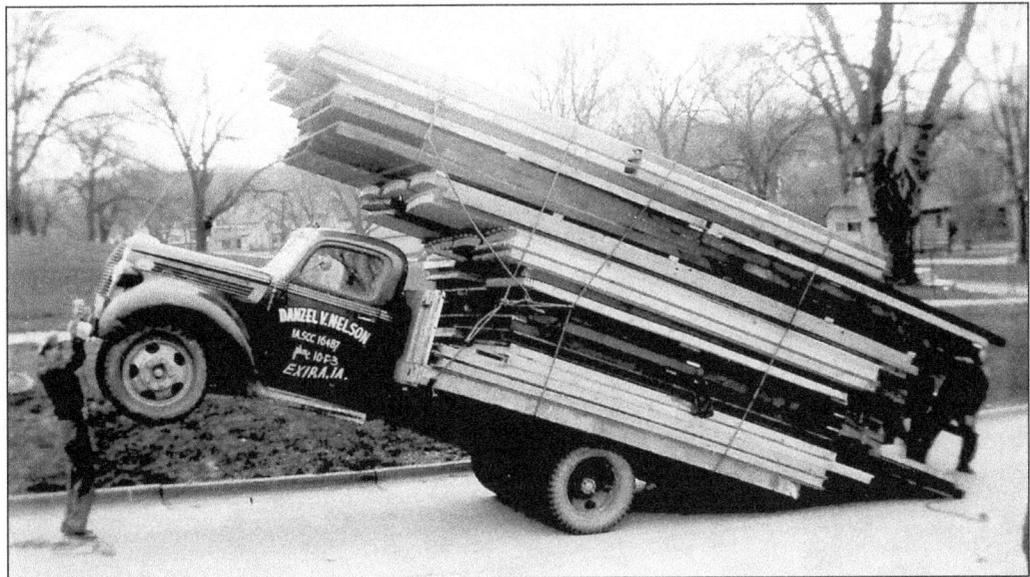

Oops! Going up the hill on 19th Avenue N. just past 3rd Street near Foy's Hatcheries proved to be a disaster for the delivery of wooden pallets by the Danzel V. Nelson Company of Exira, Iowa in 1942. (Photograph from the Clinton County Historical Society Archives.)

Oakland Cemetery in Lyons was the site of many Decoration Day ceremonies, as pictured in 1900. Elijah Buell, along with most early Lyons settlers, is buried at Oakland, making it a unique place related to the history of Clinton. (Photograph from the Clinton County Historical Society Archives.)

In the late 19th century, baseball was truly a national pastime. The game was considered a "gentleman's sport," as evidenced by the C.J. Calnan baseball team, pictured here in an 1899 photo. (Photograph from the Clinton County Historical Society Archives.)

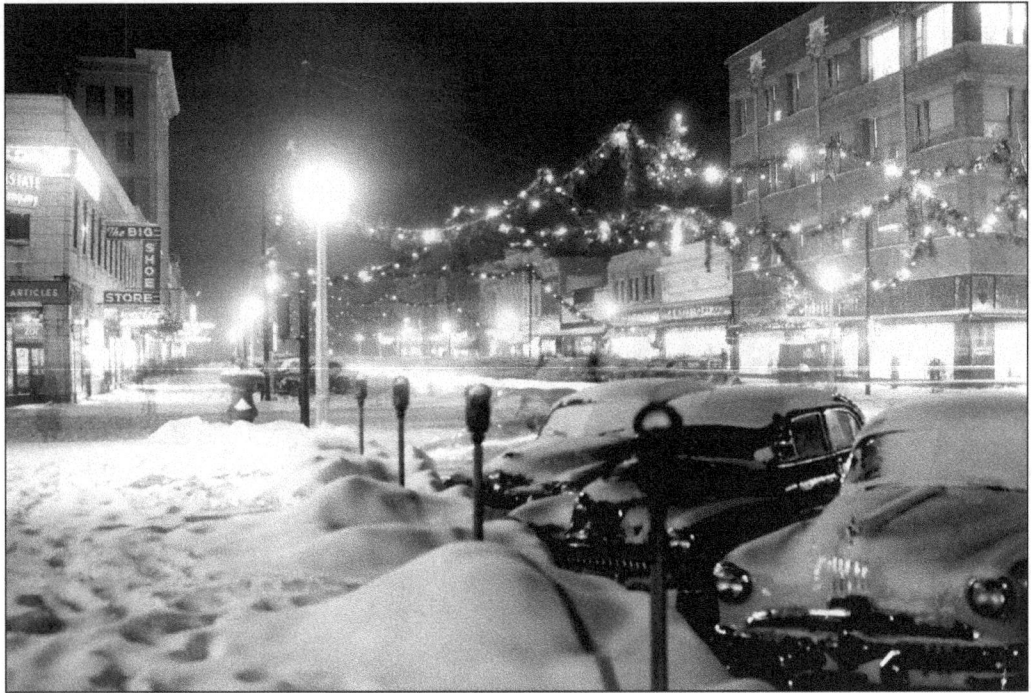

Looking west on 5th Avenue S. in downtown Clinton, after a fresh December snow in the 1950s is the Van Allen Building on the right and the Big Shoe Store across the street on the left. (Photograph from the Clinton County Historical Society Archives.)

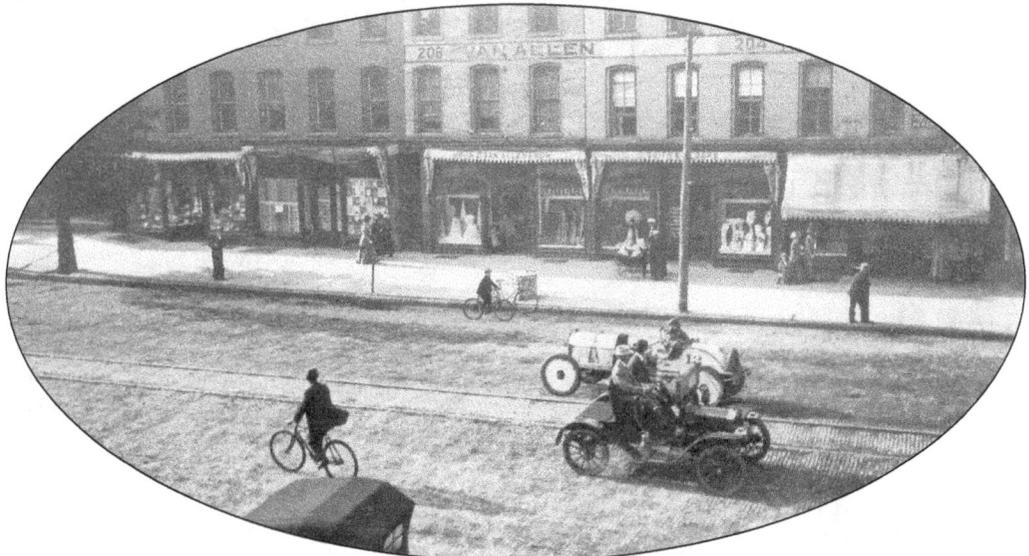

Before 1896, the John D. Van Allen & Son Company was in business as Van Allen & Rixen, north of the present Van Allen Building, advertising Dry Goods and Cloaks on the awning of the building. By 1896, Rixen was no longer in the partnership, and the name Rixen had been painted out of the sign on the front of the building. By 1912, John D. Van Allen had enlisted the services of the architect Louis Sullivan to build his world-famous Van Allen Department Store. (Photograph from the Clinton County Historical Society Archives.)

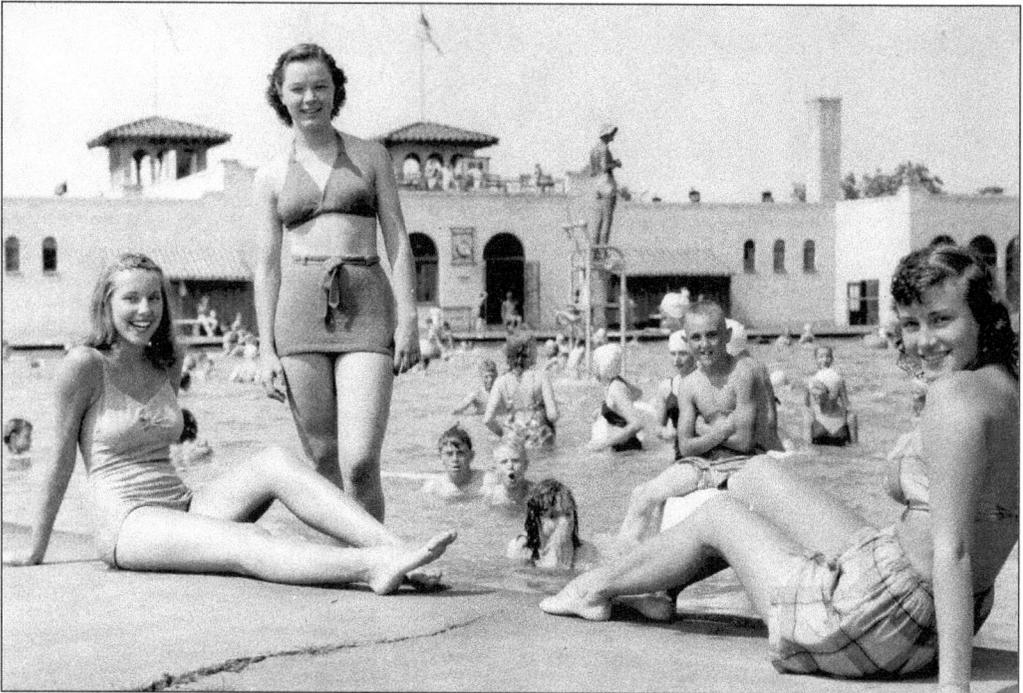

The Clinton Municipal Swimming Pool, located along River Drive, delighted swimmers with its handsome bath house and unique round pool when it opened in the 1930s. Bathing beauties from each decade thru the mid-1990s (when it was replaced) took in sunshine and glances from the boys. The pool boasted a 15-foot diving tower in the center and was considered one of the finest in the country. (Photograph from the Clinton County Historical Society Archives.)

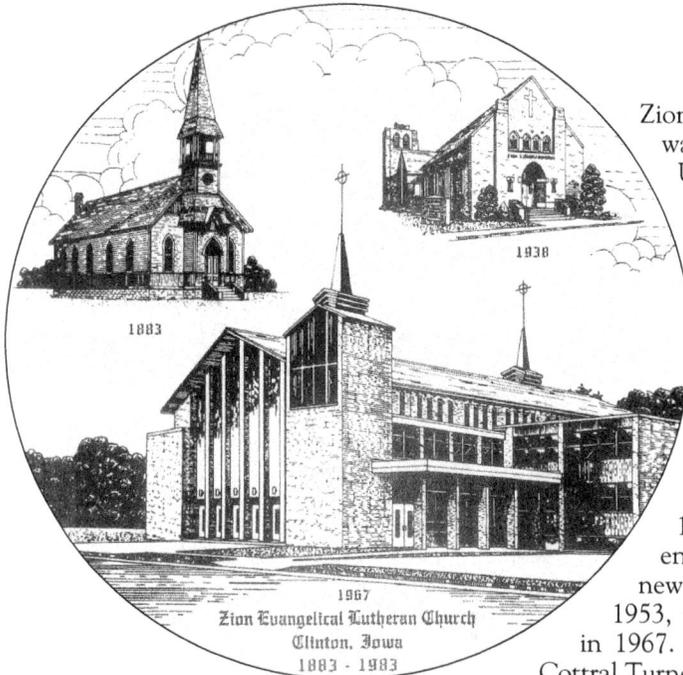

Zion Evangelical Lutheran Church was organized on March 4, 1883. Until that time, bi-weekly services were held on Sunday afternoons in the Danish Lutheran Church, with teachers or students from the theological seminary in charge of the service. The Zion congregation was founded by 32 men, and a lot on the corner of 3rd Avenue S. and 5th Street was purchased in August of 1883. The original church was enlarged several times, and a new parish hall was dedicated in 1953, while a new church was built in 1967. (Photograph courtesy of Joan Cottral Turner.)

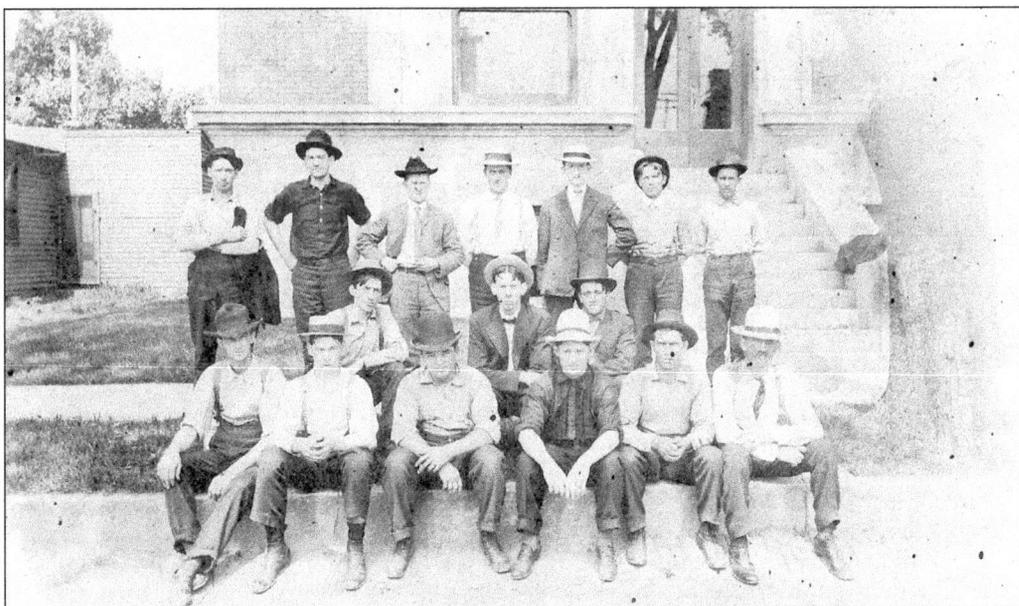

In 1858, the Lamb & Sons Company got the first telephone in Clinton. The first exchange office began in 1880 and was located at 212 5th Avenue. By 1883, the Iowa Union Telephone and Telegraph Company purchased the local telephone company, and by 1886, long distance was available to 100 towns. These telephone company employees are shown outside the company office at the turn of the 20th century. (Photograph from the Clinton County Historical Society Archives.)

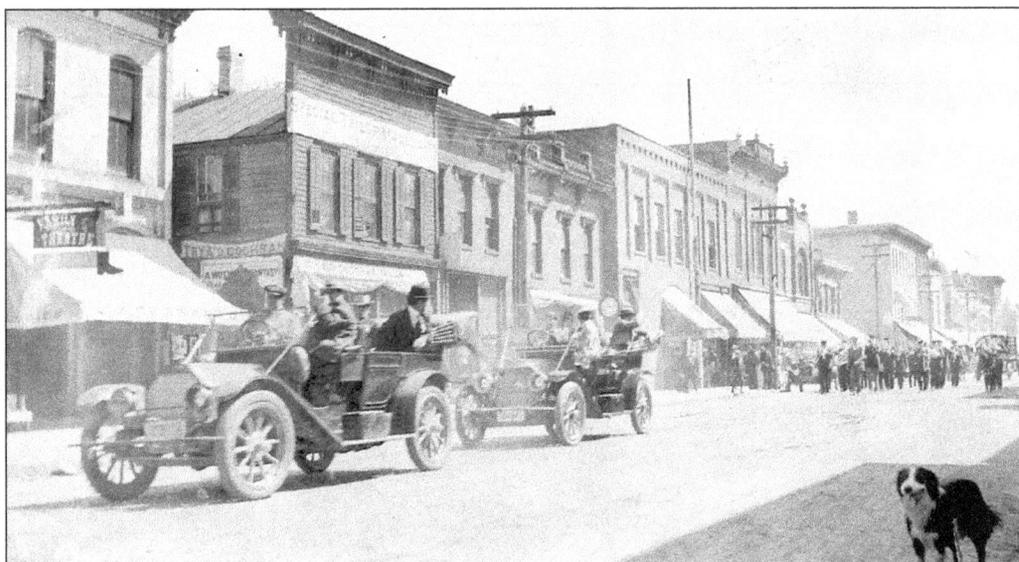

The Family Theater, the first building shown on the left in this 1915 photograph, was located at 411 2nd Street. The theater operated during the vaudeville era and imported "headliners" from the east. It offered three shows daily. When Emil Flindt first came to Clinton, he found employment at the Family Theater. A.D. Cochran, a tailor, owned the second building on the left. His slogan was "Try A.D. Cochran." It was later renamed the Clinton Tailor Shop. (Photograph from the Clinton County Historical Society Archives.)

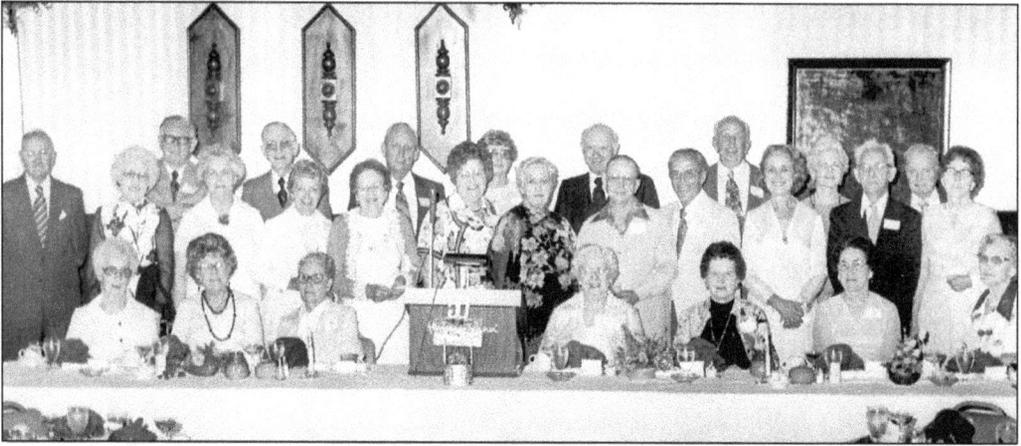

The Lyons High School graduating class of 1927 held their 50th reunion on June 18, 1977. Pictured from left to right are the following: (front row) Louise Goettsch Rimmer, Ella Christiansen Backer, Lorene Bough Box, Viola Rathje Nicolaysen, Mary Lanaghan Clancy, Alice Everhart Mills, and Thelma Baker; (middle row) Valeria Briggs Harper, Jessine Duuck, Hazel Cottral Reynolds, Edna Scribner Mertz, Venita Rickoff Wilcox, Hazel Guignon Winter, Lee Everson, Jim Corbett, Anzonette Asmussen Hall, Lyle Cottral, and Alfrieda Hansen Tolson; (back row) Bob Ebensberger, John Lanaghan, Ralph Kross, Bob Burke, Anna Ketelsen Brandenberger, Melvin Shetler, Bill Roeh, Winifred Owens, and Tom Crawley. (Photograph courtesy of Joan Cottral Turner.)

Let it snow! Let it snow! Let it snow! The winter of 1935–1936 proved to be one of the snowiest on record. You can bet the old car traveling through the drifts isn't a four-wheel drive vehicle of today. (Photograph from the Clinton County Historical Society Archives.)

72

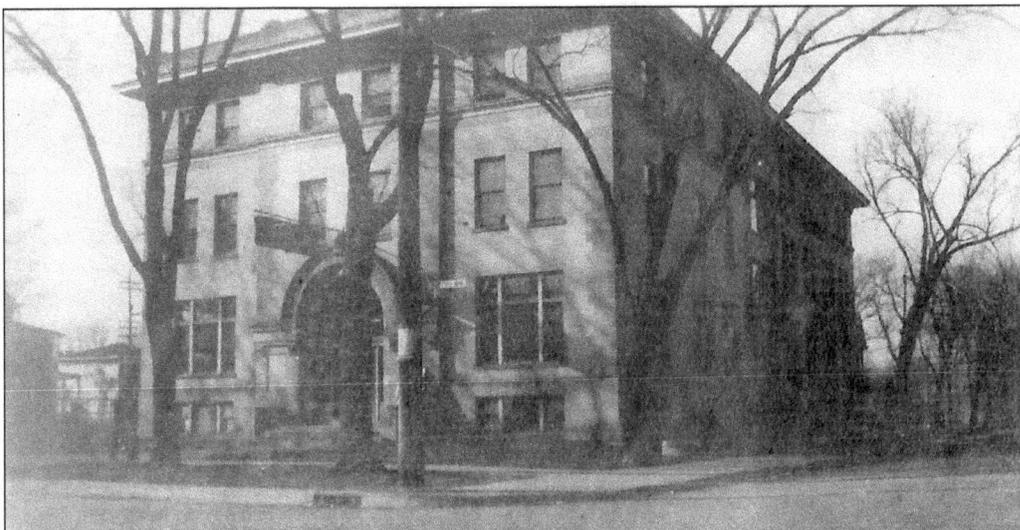

The YMCA, located at 5th Avenue S. and 3rd Street, was originally organized in 1891 in the A.P. Hosford home. The home, which was purchased to be used as a YMCA, was donated to the organization by W.J. Young. In 1904, the home was razed. A new building was erected, with the cornerstone laid on August 6, 1905. That building is still in use today as part of the YMCA complex. (Photograph from the Clinton County Historical Society Archives.)

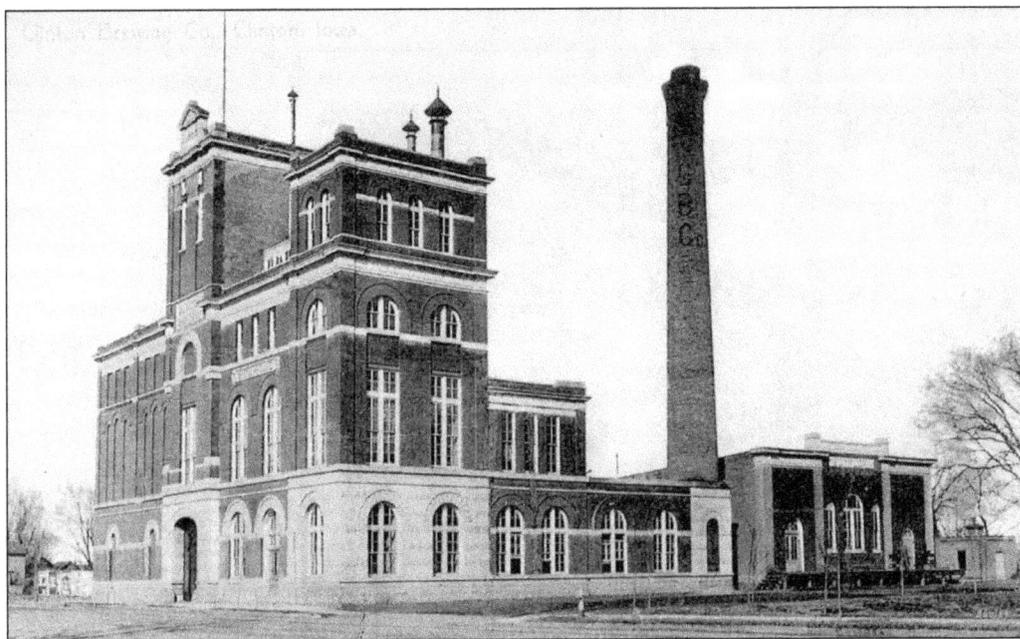

The Clinton Brewery Company was the largest brewer in the city's history and considered one of the finest in the Midwest. Pointer Beer was its first product, and its trademark, the Pointer Dog, was well known. With the arrival of prohibition in 1916, the brewery closed; however, it opened again when prohibition was repealed, under the ownership of the Gateway Brewing Company. Financial difficulties in the late 1930s caused production to cease. It was again re-opened in 1942 to produce industrial alcohol for the war effort. In 1958, this beautiful building was razed to build the Jewel-Osco store. (Photograph from the Clinton County Historical Society Archives.)

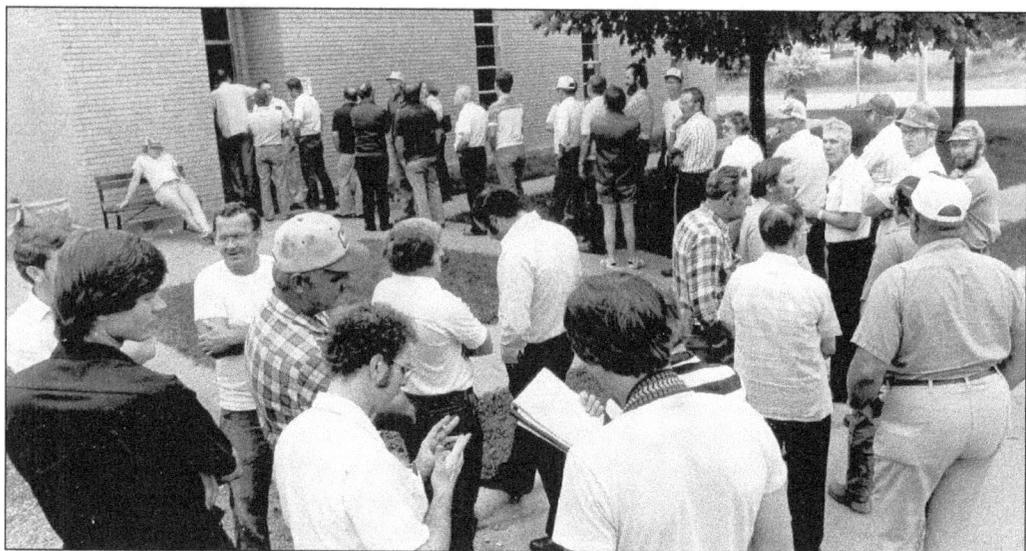

The Grain Millers' strike against the Clinton Corn Processing Company began August 1, 1979. Local 6 of the American Federation of Grain Millers, shown above, voted for what was expected to be a short work stoppage. The company immediately advertised and hired permanent replacement workers. It was an act of war to the strikers, who vowed to remain on the picket line until all workers had returned to their jobs. (Photograph from the Clinton County Historical Society Archives.)

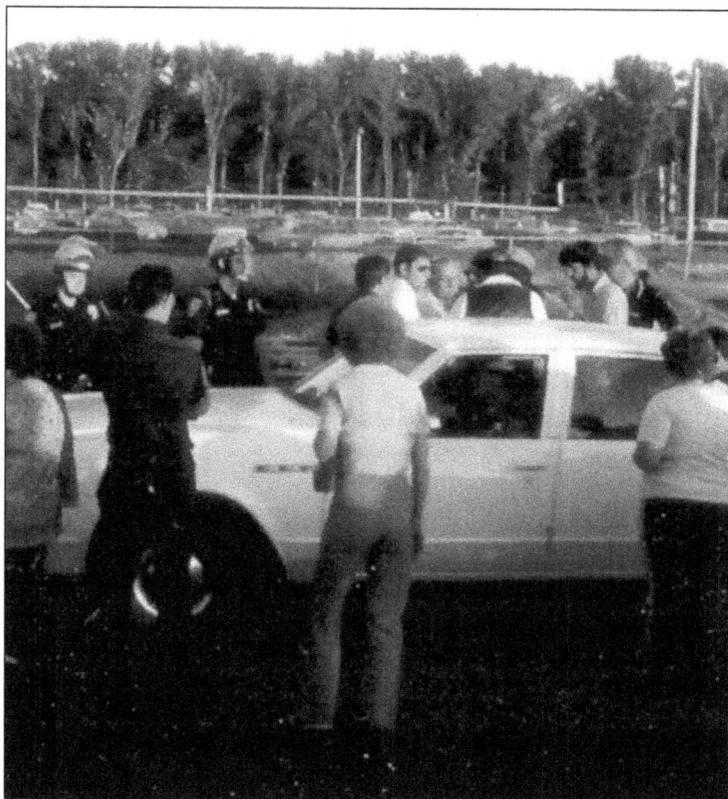

On-again and off-again negotiations made little headway during the Clinton Corn strike as more replacement workers filled the strikers' jobs. The walk-out turned ugly as the strikers accused the police of harassment, and the police denied the allegations, instead claiming that union supporters had attacked them. Although no picket signs are in the streets of Clinton today, the struggle still continues. Many people claim that today's economic problems in Clinton are a direct result of that strike. (Photograph courtesy of Dave and Pat Nichols.)

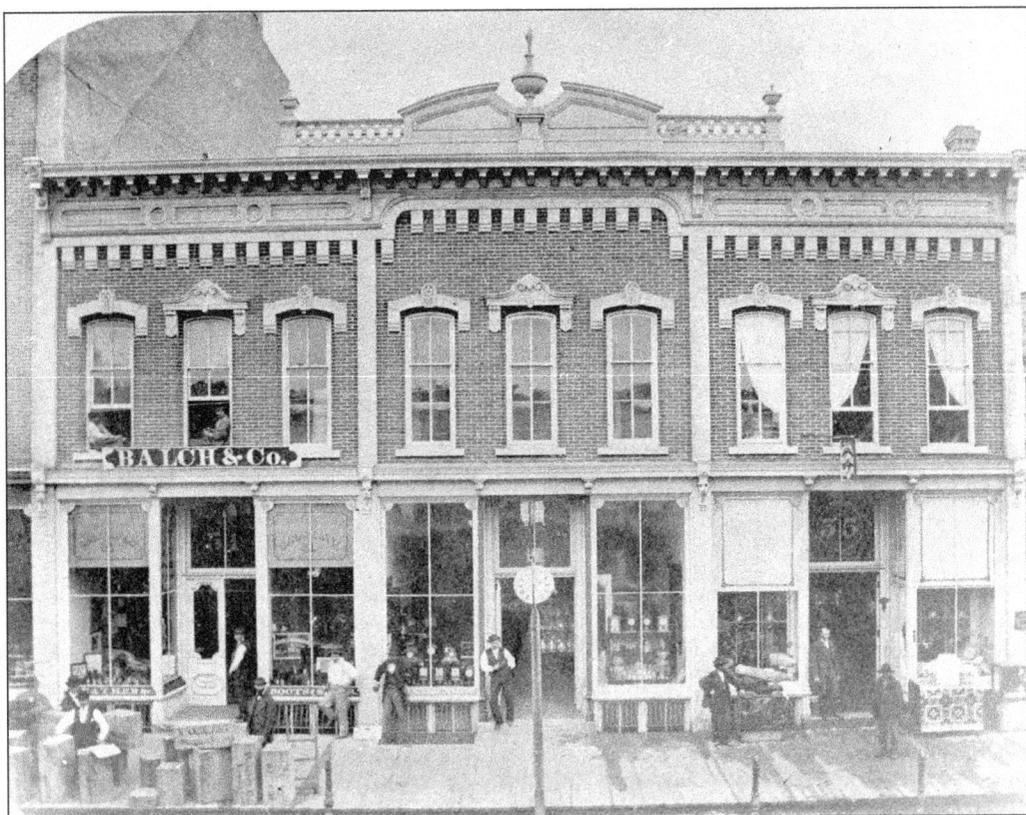

On Main Avenue in Lyons, shopping could be easily accomplished within a short distance. On the left, Balch & Co. were manufacturers and wholesale dealers in boots and shoes. Mr. Balch came to Clinton County in 1858 and started his business with his brother, John. A large work force of shoe makers made Army shoes for Balch & Co. for its sales during the Civil War. In the center, J.H. Potts, a store that opened in 1854, was a dealer in watches and jewelry. The store remained in business for over a century. On the right, Earles & Lund were dealers in fancy and staple dry goods. The business prospered. In 1873, Mr. Earles sold his share of the store and stock of goods to Mr. Lund. (Photograph from the Clinton County Historical Society Archives.)

Constructed in 1912, the Lincoln Highway was the first highway to completely cross the United States. It crossed into Lyons and went straight west through all of Clinton County. In 1920, this monument on the Lincoln Highway was dedicated to W.J. Coan, founder and the first president of the Clinton National Bank and the first consul for the state of Iowa, for the effort he put forth in establishing the Lincoln Highway. (Photograph from the Clinton County Historical Society Archives.)

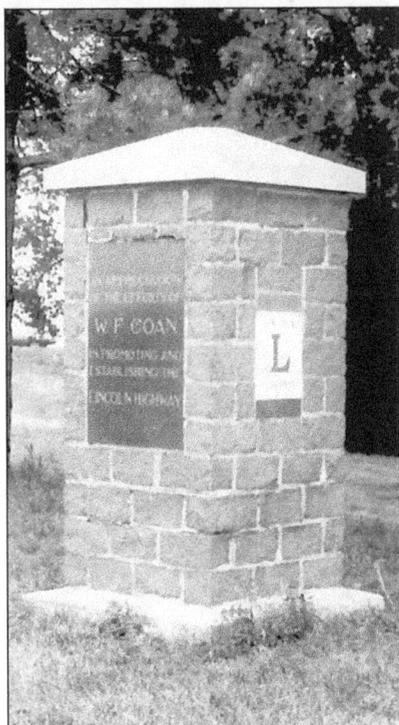

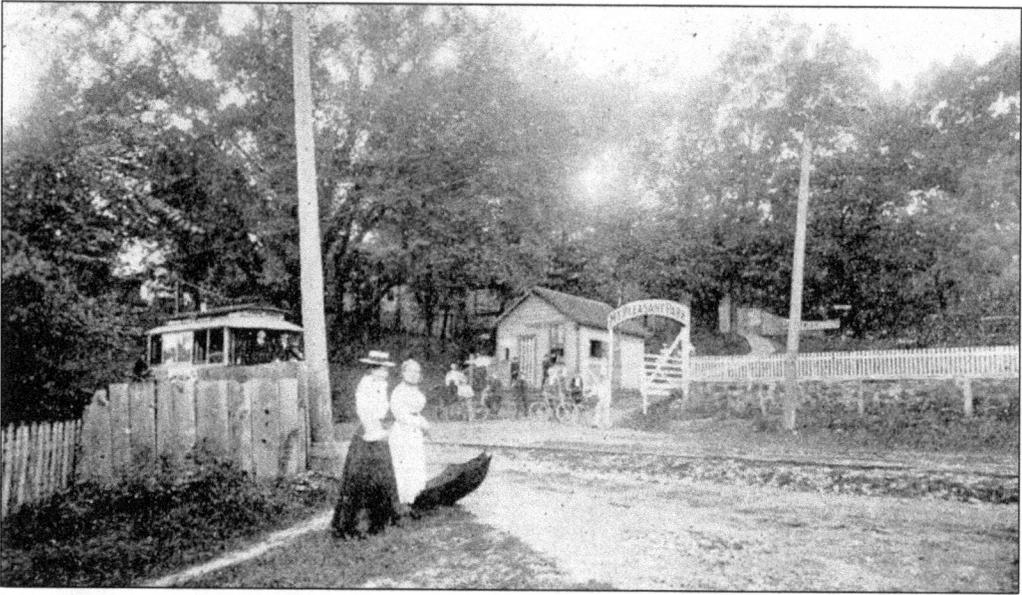

The Mt. Pleasant Park Stock Company was incorporated in 1884 with the goal of purchasing a 20-acre site of wooded land on Bluff Boulevard at the corner of 2nd Avenue S. Some spiritualist meetings had been previously held at that location, and it was acceptable to the members. In 1885, the name was changed to the Mississippi Valley Spiritualist Association and remains under that name today. (Photograph from the Clinton County Historical Society Archives.)

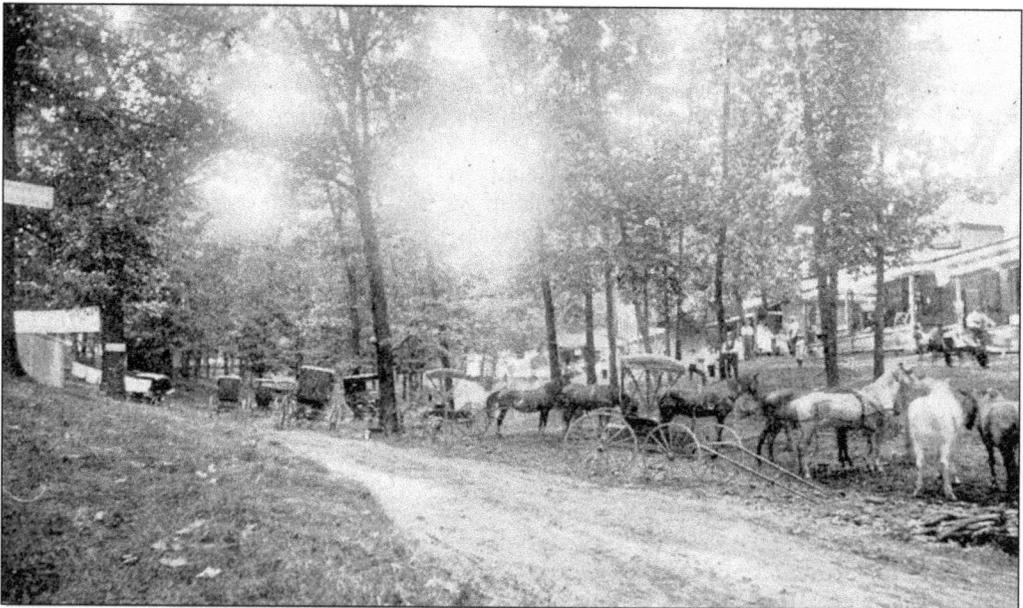

By the turn of the century, there were 40 privately-owned cottages as well as an auditorium for lectures, a hotel, and a restaurant in the park. The buildings were illuminated by gasoline lamps, and scores of tents housed summer visitors. The city of Clinton's first swimming pool was built in the park in the 1920s by the Spiritualist Association. It was closed in the 1930s when the new Riverview Park swimming pool opened. A program of weekly services in the chapel are still held today. (Clinton County Historical Society Archives.)

Six
HAPPENINGS

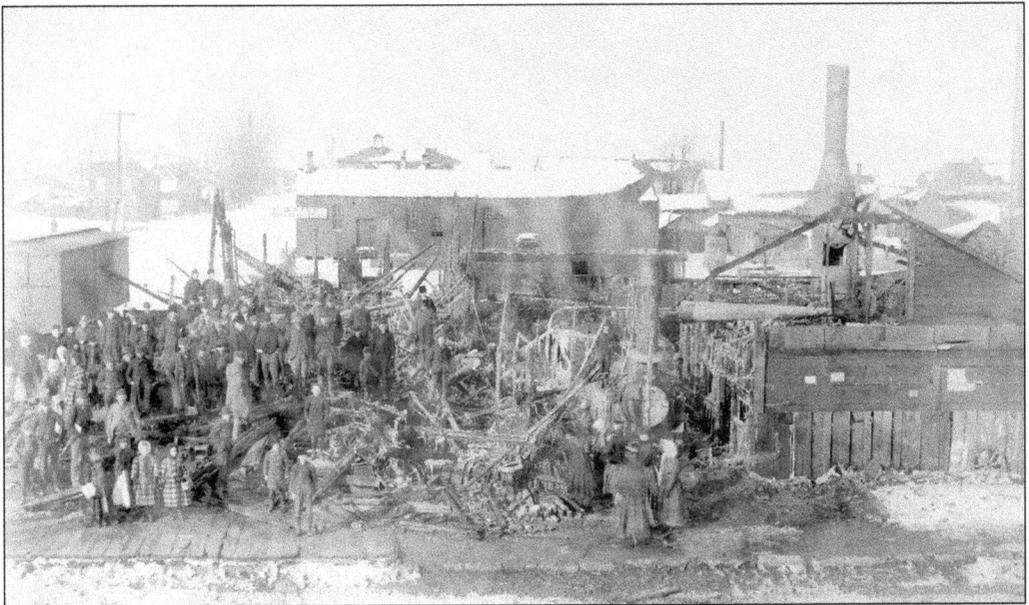

The Moesinger Machine Shop and Foundry fire occurred in the late 1880s at the corner of Main and Grant Streets in Lyons. Looking north, the building behind the ruins bears the sign: "H. Gates, Coal, Grain & Stock." (Photograph from the Clinton County Historical Society Archives.)

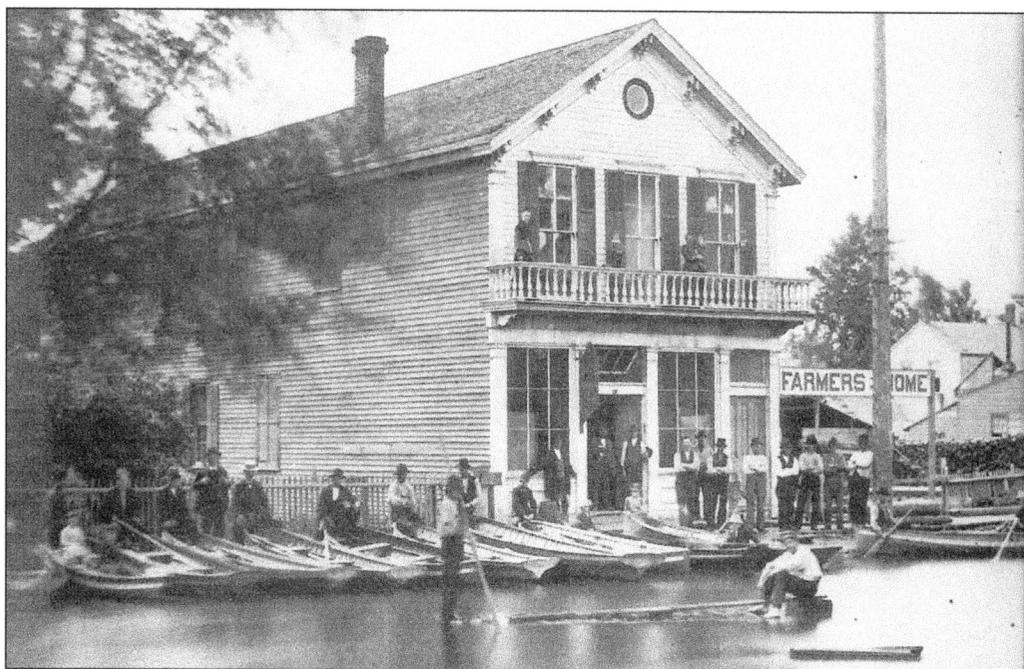

During the 1888 Mississippi River flood, boat transportation was all that was available for the residents and neighbors of the Farmers Home (hotel). The hotel was located on the west side of First Street between 6th and 7th Avenues S., presently the site of the Clinton Police Department parking lot. (Photograph from the Clinton County Historical Society Archives.)

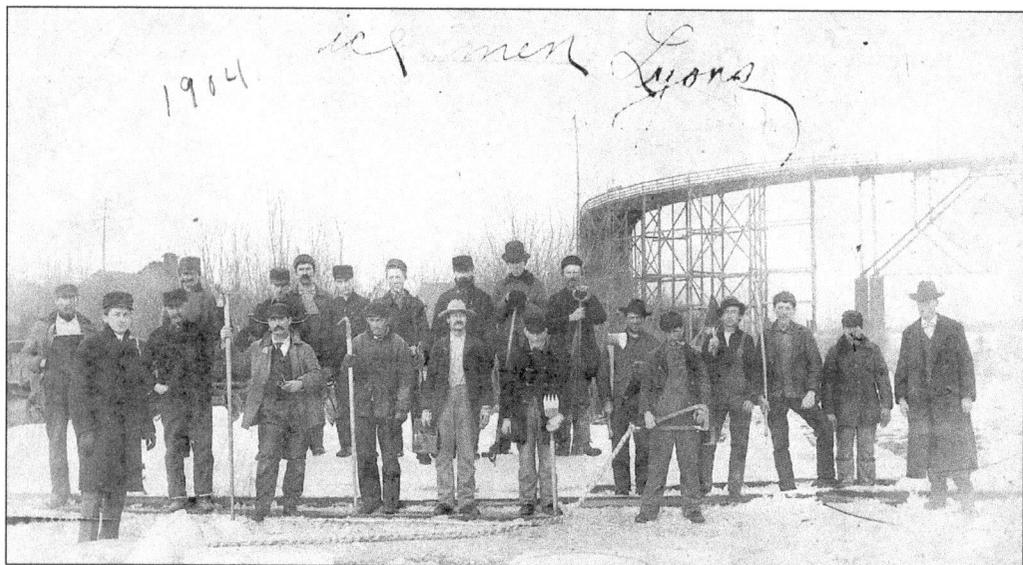

South of the Lyons Bridge, men of the Wilke Coal and Ice Company posed while putting up ice in 1914. The ice was stored in sawdust and kept in warehouses for summer use. Home deliveries of the ice were made by wagon and later by truck. Customers placed a card in their window signaling if they wanted ice and how many pounds. Many Clinton youths were happy to see the iceman with a chunk of ice on his shoulder, as a raid on the truck for a chip of ice was a summer treat. (Photograph from the Clinton County Historical Society Archives.)

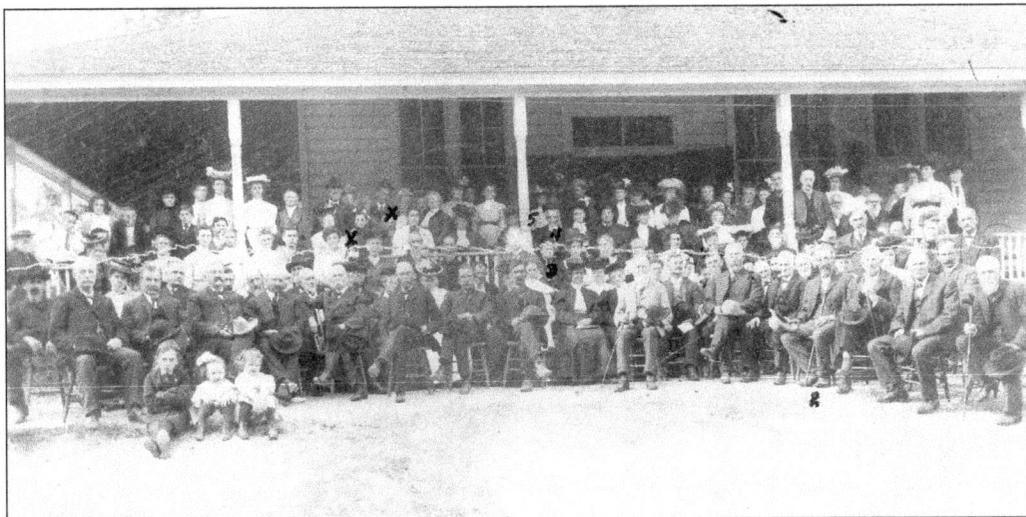

An Old Settler's Reunion was held at the Joyce Park Pavilion, now Eagle Point Park, in 1906. The pavilion was later taken down, and a new building was constructed as a WPA project during the 1930s. Identified by markings in the picture are the following: (x) Marcus and Cornelia Phillips Lillie, (2) Ebenezer Betsinger, (3) (right of post) Prentiss Holmes, Lt. U.S. Army (Ret.), (4) Emma Betsinger, and (5) May Betsinger. The Old Settler's Association required a member to have been a resident of Clinton County by 1866; this was later changed to 1875. (Photograph from the Clinton County Historical Society Archives.)

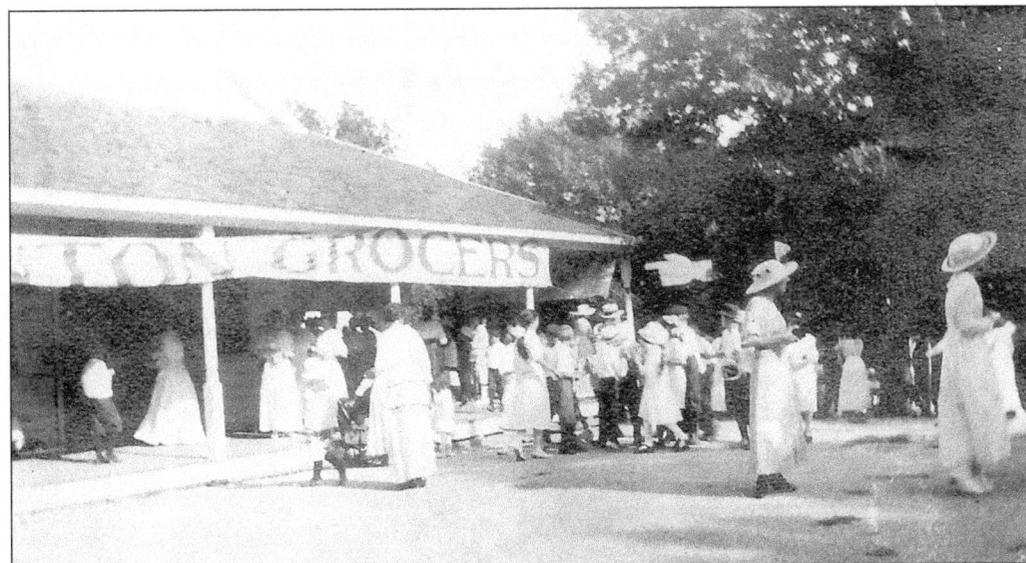

Clinton's Eagle Point Park has traditionally been used for summer celebrations. The Clinton Grocers used the lodge in the park during the summer of 1917 for their picnic. This is the original structure of the lodge, which was re-built as a WPA project during the 1930s, and serves as the lodge used today. (Photograph from the Clinton County Historical Society Archives.)

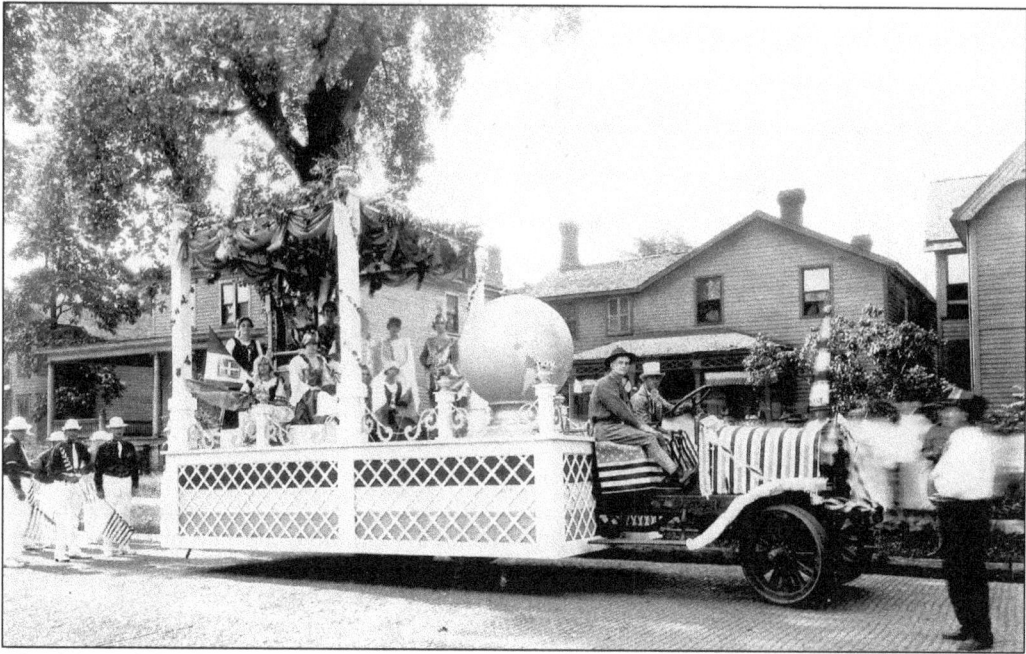

The driver of this float is dressed as "Uncle Sam," accompanied by a World War I garbed "soldier" in a Clinton patriotic parade held in either 1917 or 1918. The large globe on the front of the float, along with the young women in Swiss dress, appear to emphasize peace in the world. Note the brick paved streets. (Photograph from the Clinton County Historical Society Archives.)

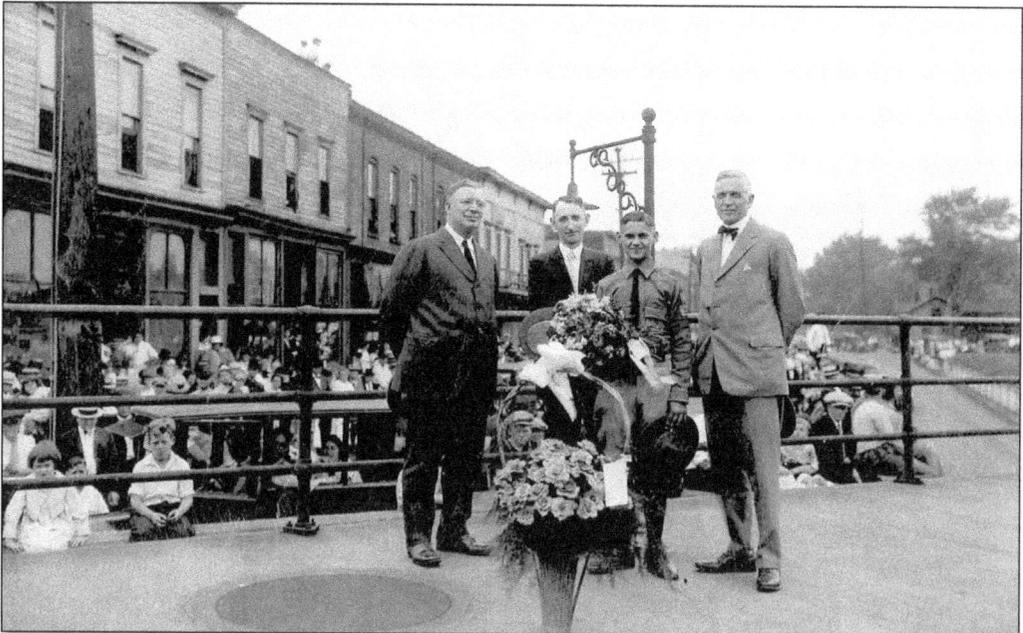

Shown waiting for President Harding's funeral train to arrive, Clinton's memorial service for President Harding was held on the top of the 4th Street viaduct in August of 1923. Pictured left to right are King Slocum, Mayor Towles, Art Rohwer, and Milo Gabriel. Boy Scout Art Rohwer presented the flowers. (Photograph from the Clinton County Historical Society Archives.)

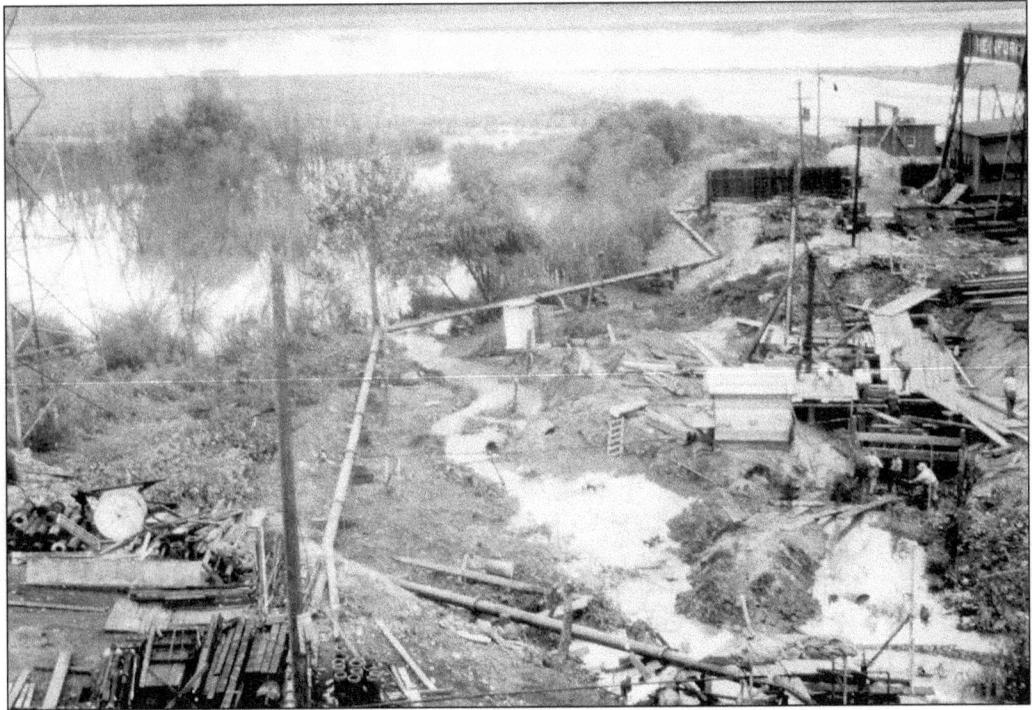

This view shows sewer construction at First Avenue and the Mississippi River in 1925, near where the Clinton Bridge Works was built. After the Bridge Works Company was constructed, the sewer ran under that building. (Photograph from the Clinton County Historical Society Archives.)

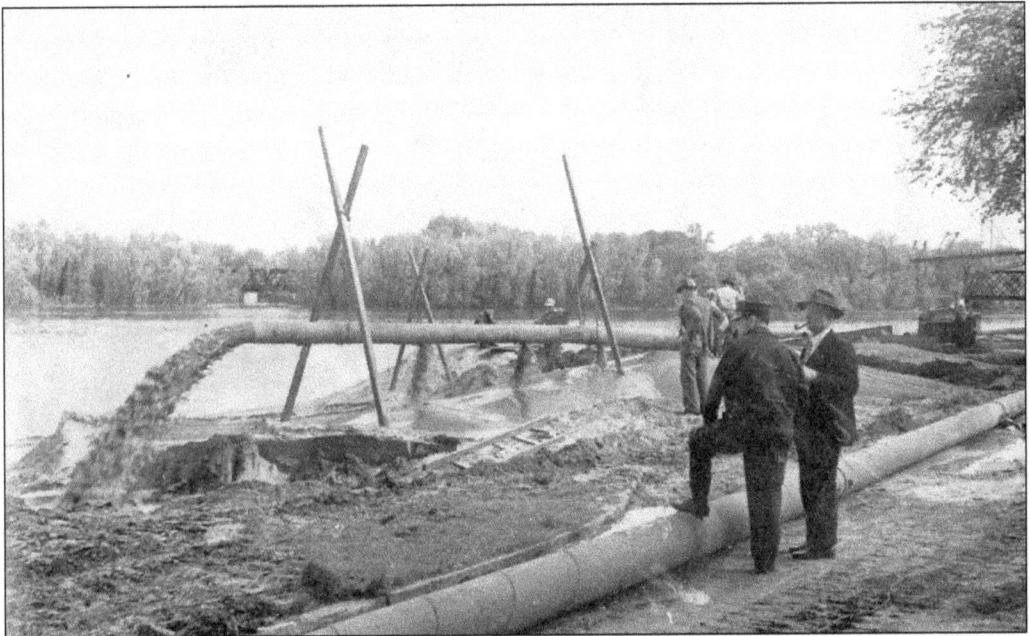

This photograph depicts the construction of River View Park in the 1930s at 4th Avenue S. Workers are pumping in sand for fill. The railroad bridge can be seen to the right and through the trees on the left. (Photograph from the Clinton County Historical Society Archives.)

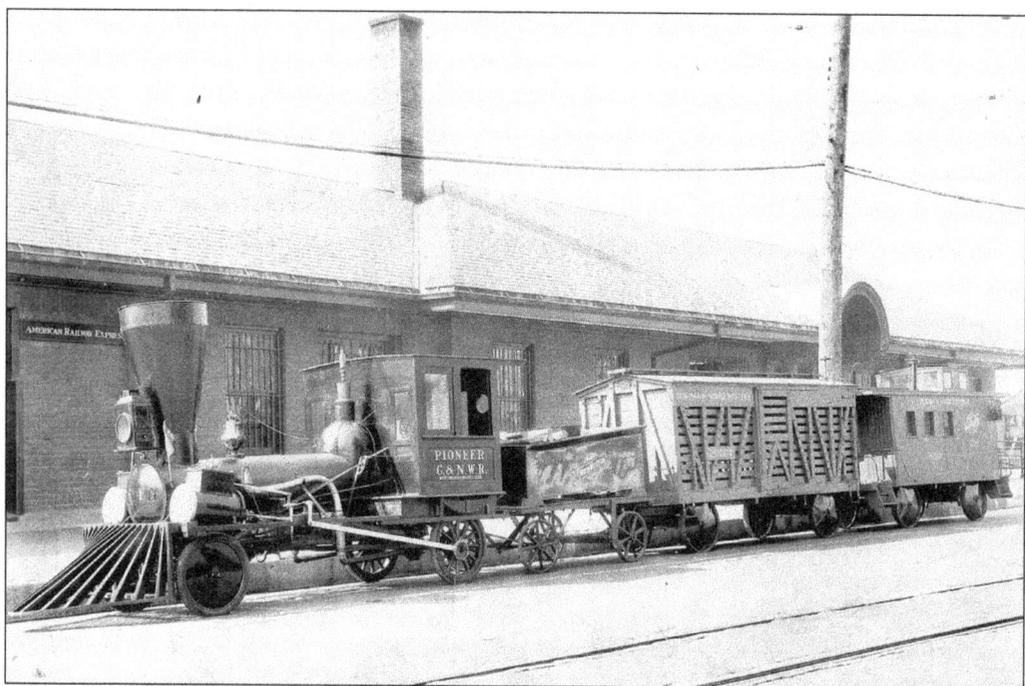

A replica of the "Pioneer" at Clinton's Chicago & Northwestern Railroad depot is pictured in 1930. The original "Pioneer" was the first railroad engine to cross the Mississippi River in 1848. The crossing was accomplished by ferry since the railroad bridge had not yet been built. (Photograph from the Clinton County Historical Society Archives.)

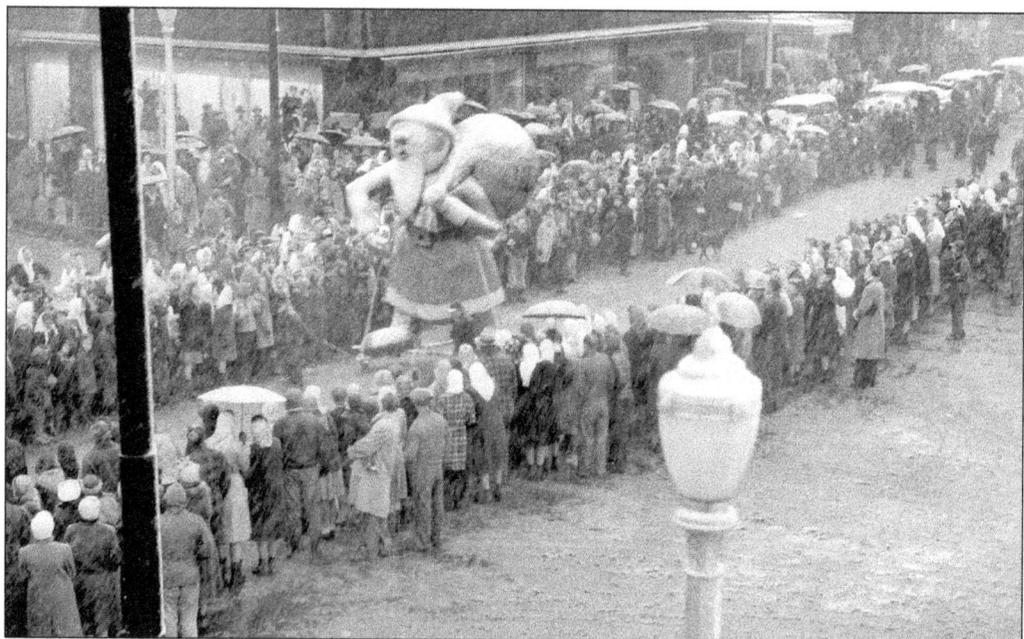

This is a snowy afternoon Christmas parade, c. 1930, going south on 2nd Street past 5th Avenue S. It looks like Santa has his bag full of goodies for the happy spectators along the route. (Photograph from the Clinton County Historical Society Archives.)

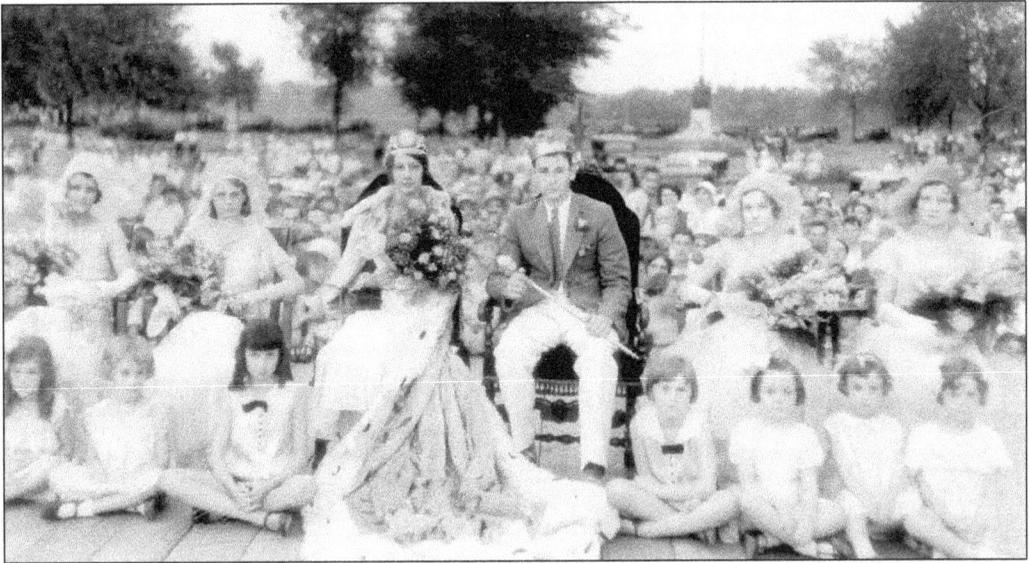

Attired in an ermine-trimmed robe, wearing a jeweled crown and carrying a jeweled scepter, Miss Donna Wulf (later Mrs. Karl Sporman) was crowned Queen of Clinton's Diamond Jubilee celebration on July 30, 1931. Marvin Whalen was named King. The royal court pictured from left to right are as follows: Elayne Paley and Virginia Carstensen, maids of honor; Queen Donna Wulf; King Marvin Whalen; and Helen Bronenkant and Grace Helferich, maids of honor. Pages and trainbearers included DeMerle Little, Joan Ladehoff, Beverly Warren, Rosemary Kleeberger, Mary Jean Christiansen, Evelyn Raun, and Maxine Mauck. (Photograph from the Clinton County Historical Society Archives.)

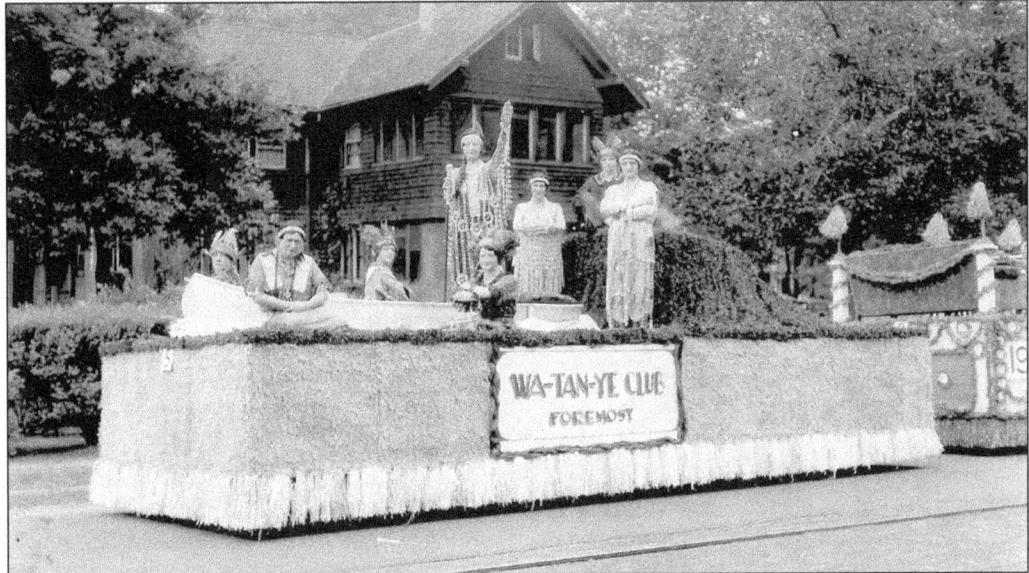

These are members of the "Wa Tan Ye" organization on their float in the 1931 Diamond Jubilee celebration during Clinton's 75th anniversary parade. "Wa Tan Ye" (an Indian term meaning "foremost") was organized in 1921 in Mason City, Iowa and established in Clinton in 1924. Wa Tan Ye members are still active in the community today. (Photograph from the Clinton County Historical Society Archives.)

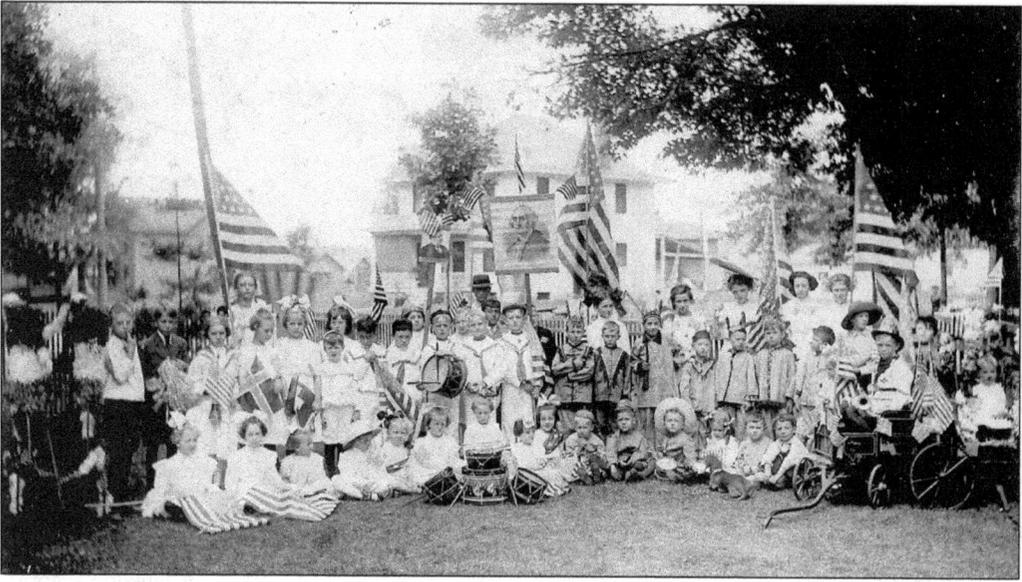

Parades have always been a tradition in Clinton's history. These young children are no exception and are ready to march off with placards honoring both George Washington and Teddy Roosevelt. The photograph dates from c. 1910. (Photograph from the Clinton County Historical Society Archives.)

The Friendship Train, from France, stopped in Clinton in February of 1948 with Drew Pearson as the welcoming speaker. The cars were filled with museum pieces and sent to Iowans in gratitude for the food and clothing sent to France during World War II. One item was a beautiful wedding dress and veil. It was loaned by H.A. Sino, of Clinton, (who served as State Chairman of Reception Arrangements for the train) to Miss Mary Lou Sullivan, now Mrs. Mary Lou Hinricksen, for her wedding. The Clinton County Historical Society now has the "Merci" gown in its collection. (Photograph from the Clinton County Historical Society Archives.)

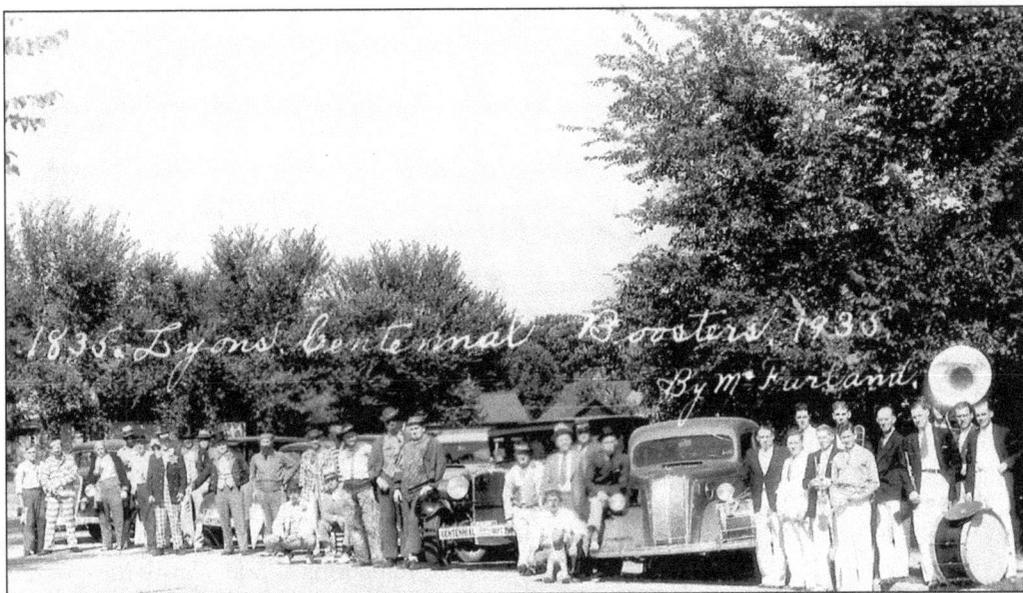

In 1935, the citizens of Lyons celebrated their 100th year with seven blocks of fun-filled activities on Main Avenue from 3rd Street to the river. Pictured are the Lyons Centennial Boosters. On the left, the boosters are dressed as clowns and on the right is the band. The last "centennial" celebration was held in 1958 due to a notice from the Iowa Department of Transportation that Main Avenue was a portion of a highway and could no longer be closed for the occasion. (Photograph from the Clinton County Historical Society Archives.)

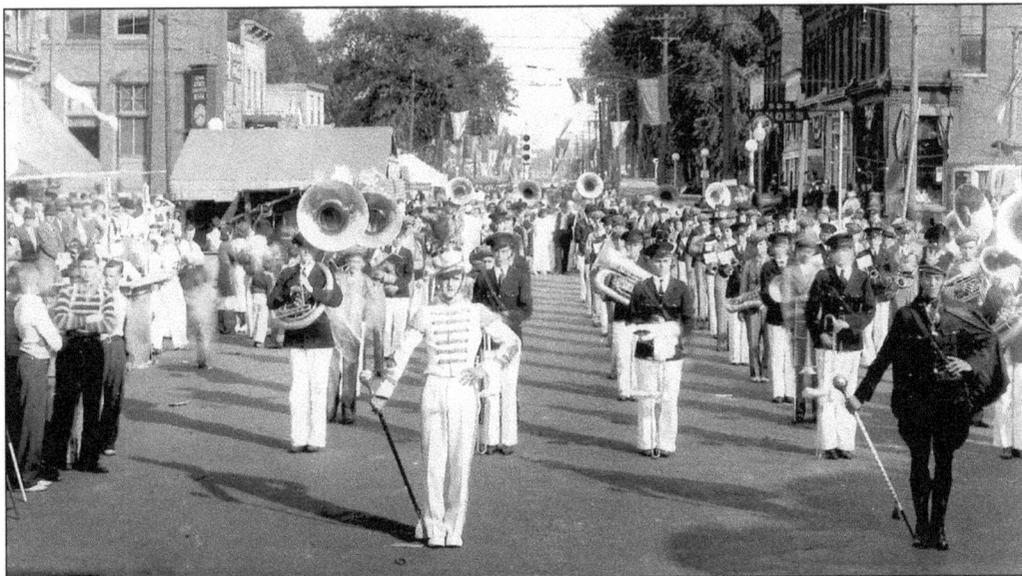

The city of Lyons kicked off the centennial celebration in 1935 with a combined 80-piece band from both Lyons and Clinton High Schools, led by Lyons High School drum major, Marvin "Muffy" Zastrow. The band is facing west on Main Avenue at the intersection of N. 2nd Street. Everyone in Lyons could hear the sounds of the calliope calling them to come to the centennial and enjoy the rides, vendors, shows, food, and friendship from noon to midnight for the three-day weekend. (Photograph from the Clinton County Historical Society Archives.)

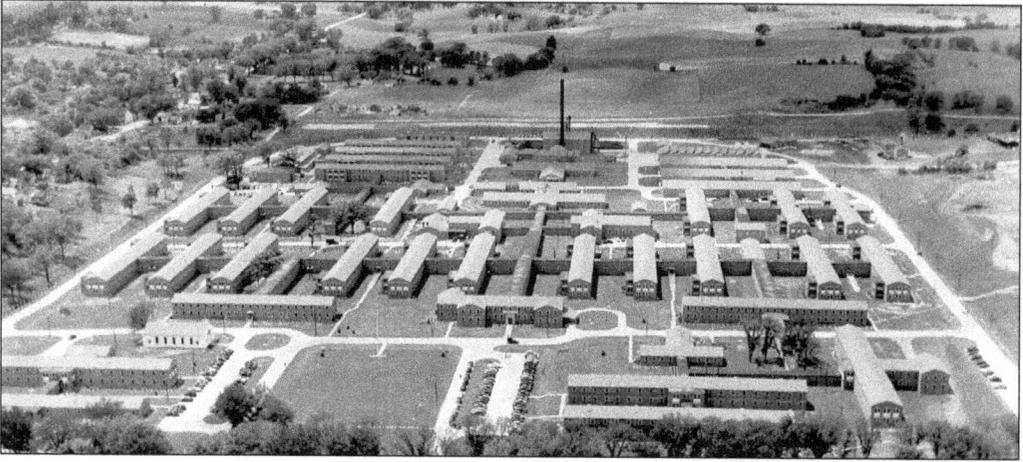

Schick General Hospital was built on the previous site of Root Park in Lyons at a cost of $1,717,980. The first patient was admitted March 2, 1943, and the official dedication was held on October 7, 1943. With 95 pink-red buildings on 160 acres and over 1,700 beds, many of the nation's wounded military came to this Clinton hospital during World War II. Most of the buildings still stand, but have had many different uses since the hospital was closed on March 1, 1946. It is presently the site of a nursing home and a private apartment complex. (Photograph from the Clinton County Historical Society Archives.)

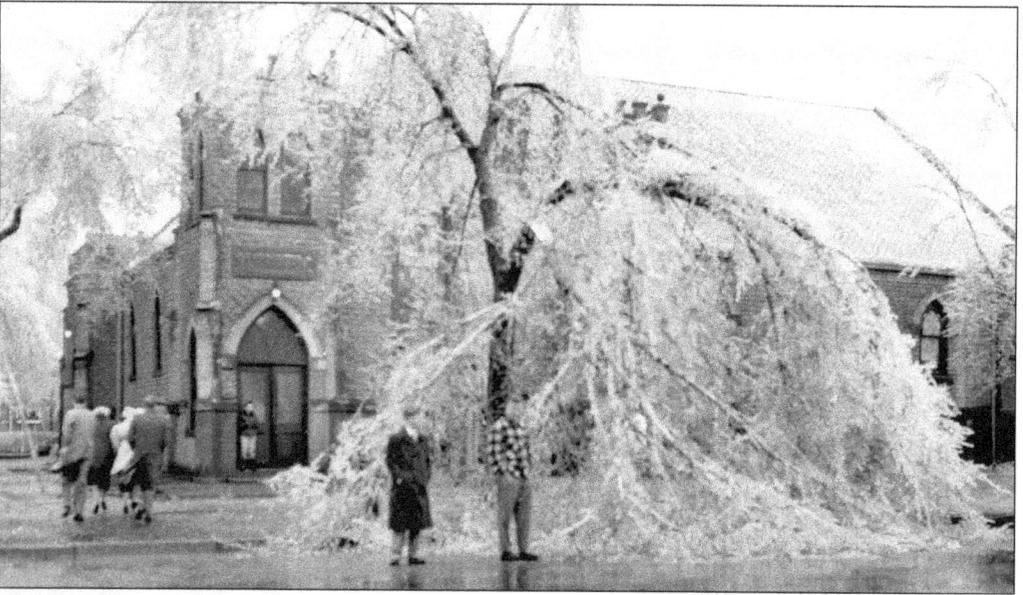

The worst ice storm in our history left Clinton staggered and isolated with close to a million dollars in damage. It was not really an "ice storm," but a disastrous combination of steady rain that began at 3 a.m. on Easter morning April 9, 1950 and below-freezing temperatures. The ice coatings on wires and branches built up to one-half inch, and the sound of cracking tree limbs and the loss of electricity was widespread throughout the area. Ham radio operators and the National Guard came to the rescue. Within six days, electricity was restored to the area, but the clean up took many weeks. In this photo, ice glistens on a downed tree on 8th Avenue S. and 3rd Street, and St. Paul's Lutheran Church sits the background. (Photograph from the Clinton County Historical Society Archives.)

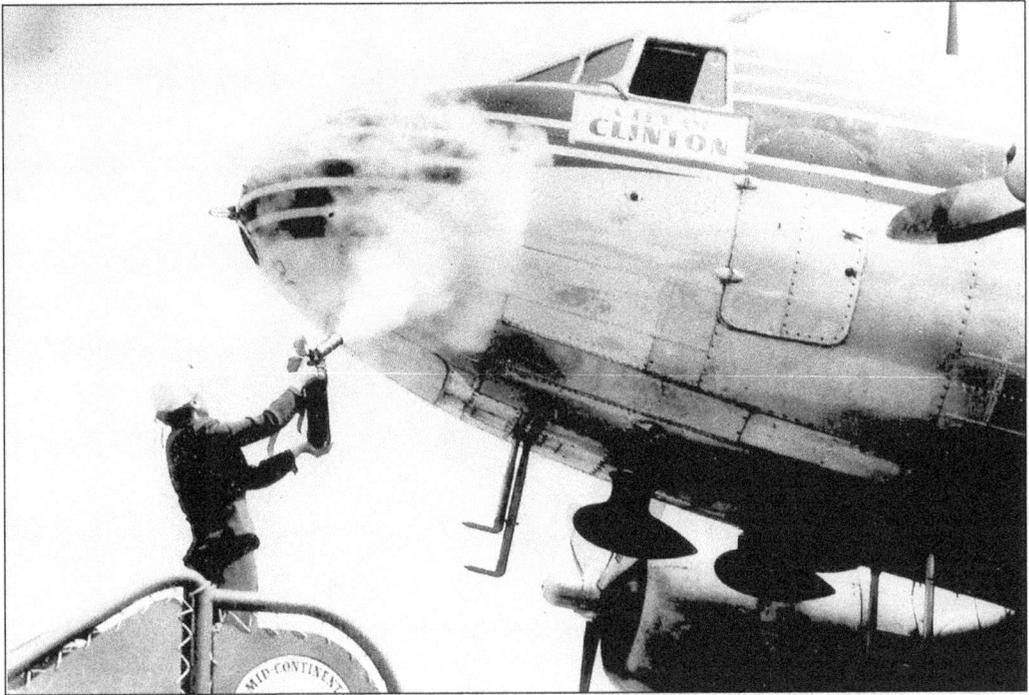

Mrs. Homer I. Smith, wife of the Clinton Airport Commission Chairman, christens the Mid-Continent Airlines' *City of Clinton* with a fire extinguisher at an airport ceremony on May 2, 1952. In the spring of 1952, Air Mail Service commenced at the Clinton Airport. (Photograph from the Clinton County Historical Society Archives.)

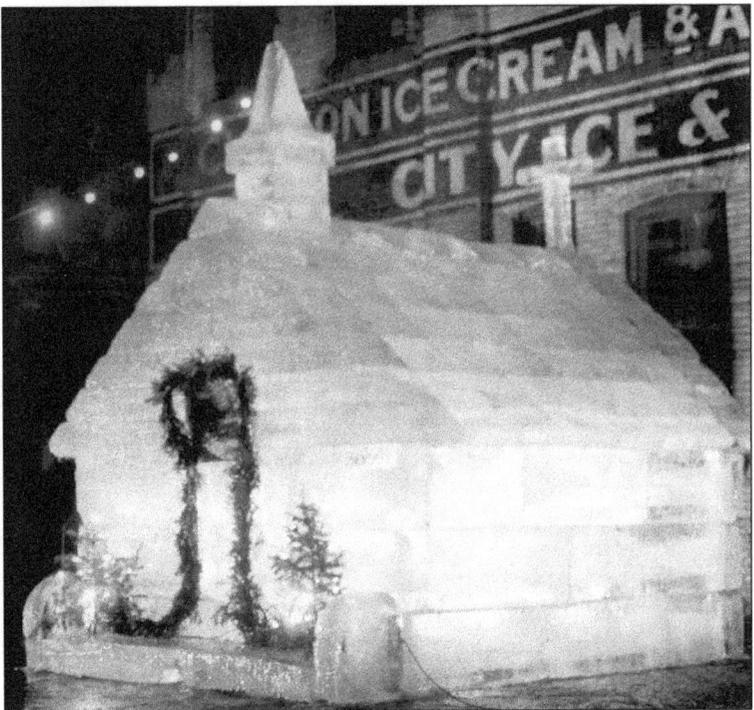

This lighted block ice house was part of the city's Christmas decorations in the 1950s. The location was the City Ice and Fuel Company at 7th Avenue S. and First Street. (Photograph from the Clinton County Historical Society Archives.)

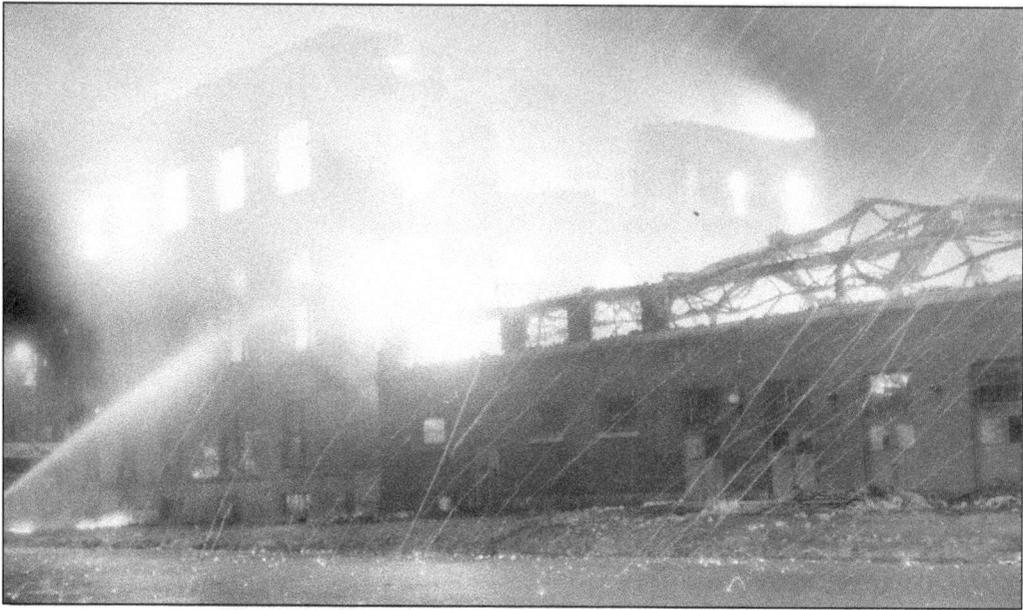

The Coliseum was built as an armory in 1914, largely through the efforts of the Clinton Chamber of Commerce. Construction costs were $110,000. It served as the city's convention center and housed the Modernistic Ball Room. Taking your girl to the "Mod" to dance to the music of one of the big bands, after having dinner in the building's Legionnaire Restaurant, was a popular date in the 1940s and 1950s. The building, located at 4th Avenue S. and First Street, was destroyed by fire on December 24, 1958 along with the Masonic Temple just south of the Coliseum. (Photograph from the Clinton County Historical Society Archives.)

The World War I monument located at 5th Avenue S. between First Street and the Mississippi River was erected to commemorate the service of the people of the county, the victory that has been won in World War I, and the young men of the county who made the supreme sacrifice of their lives. The Daughters of the American Revolution raised the funds for the monument through its Cook Book Committee and Quartet Entertainment Committee. The flag pole, 80 feet tall, was designed as a ship's mast and brought on three railroad cars from Idaho. (Photograph from the Clinton County Historical Society Archives.)

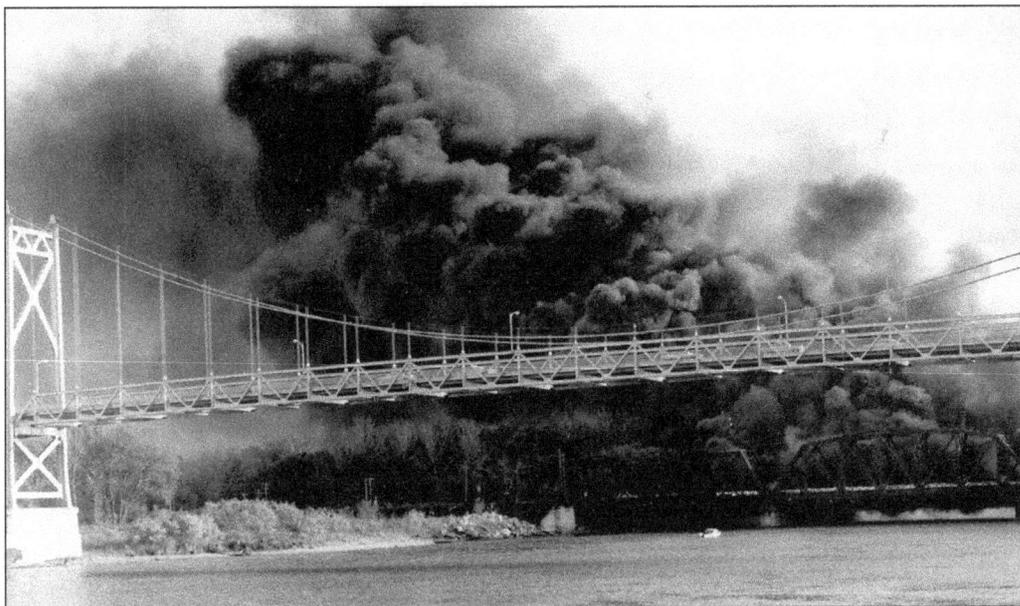

On October 24, 1958, a fire started from an acetylene welding torch when workmen were repairing earlier damage to the swing span of the railroad bridge over the Mississippi River. The bridge was severely damaged and out of operation for a week. The Coast Guard closed the river to navigation. Tows and barges stacked up waiting to head downriver, with only a few weeks left in the navigation season. Railroad crews of over 100 men worked around the clock to repair the bridge and bring it back into service. (Photograph from the Clinton County Historical Society Archives.)

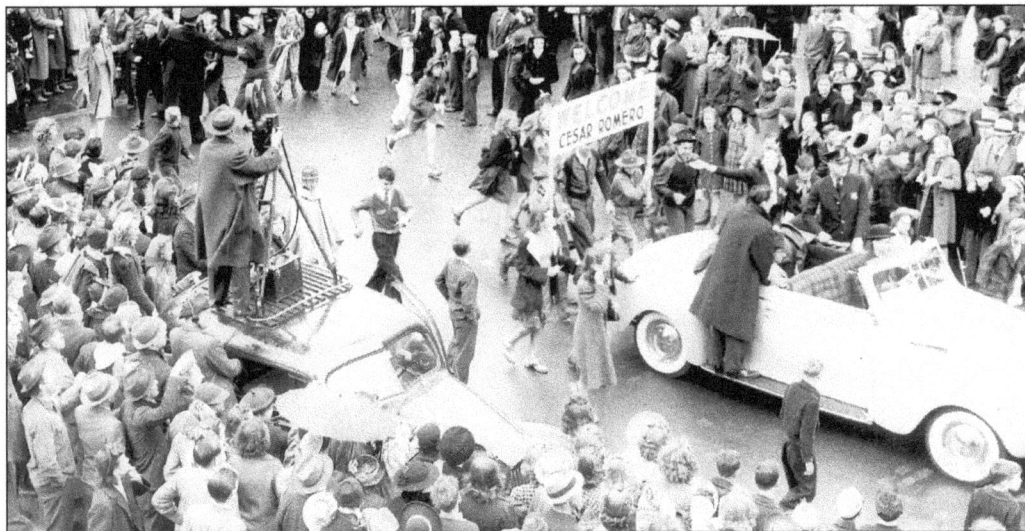

In May 1940, Clinton hosted a three-day celebration for the world premiere of the film about the life of native-born Lillian Russell. Film stars Don Ameche and Cesar Romero, along with starlets Arleen Wheland and Mary Healy, attended the premiere. Large crowds filled the streets for the many events, which included a giant parade, dedication of the C&NW's new streamliner, *Treasure Island*, street dances, free acts, and the dedication of a plaque that was placed in Riverview Park in Lillian Russell's name. (Photograph from the Clinton County Historical Society Archives.)

Westward Ho! Making the 2,600-mile trip to Yellowstone National Park were 216 Clinton area Boy Scouts, leaders, and drivers in 57 Model T Fords. The trip was intended to boost publicity for Clinton, and the scouts would receive instructions in nature that was to be equal to one full year's schooling. The entourage left Clinton on June 20, 1921 and returned on July 26. (Photograph from the Clinton County Historical Society Archives.)

A 50-year reunion was held for all the participants on the 1921 Boy Scout Yellowstone National Park trip. Each member of the group had paid $25 for the opportunity, a precious amount of money in 1921. Today, memories are still shared among the descendants of the original group. (Photograph from the Clinton County Historical Society Archives.)

Seven

PEOPLE

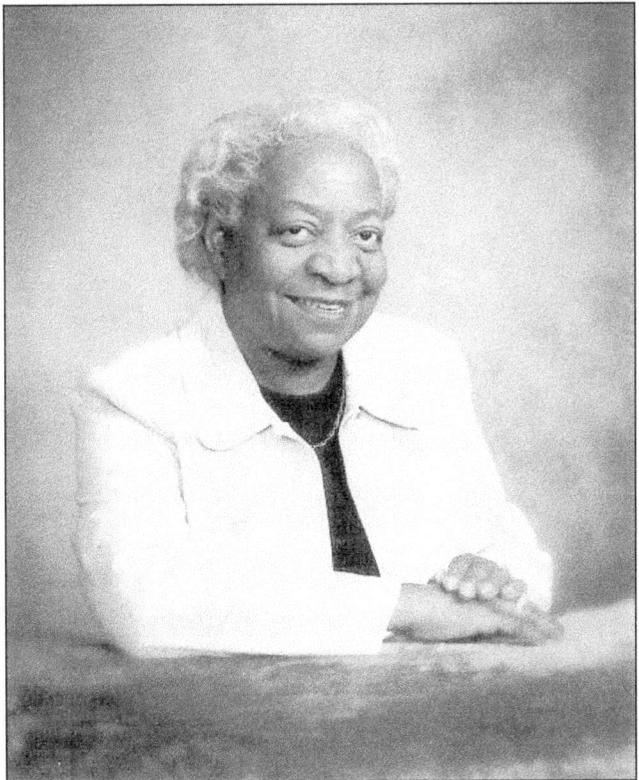

Clinton's mayor, LaMetta Wynn, is the only black female mayor in the state of Iowa. A registered nurse, Mayor Wynn is a widow and the mother of 10 children: nine daughters and one son. She has received many honors for her civic work and was inducted into the Iowa African American Hall of Fame in 2001. (Photograph courtesy of Mayor Wynn.)

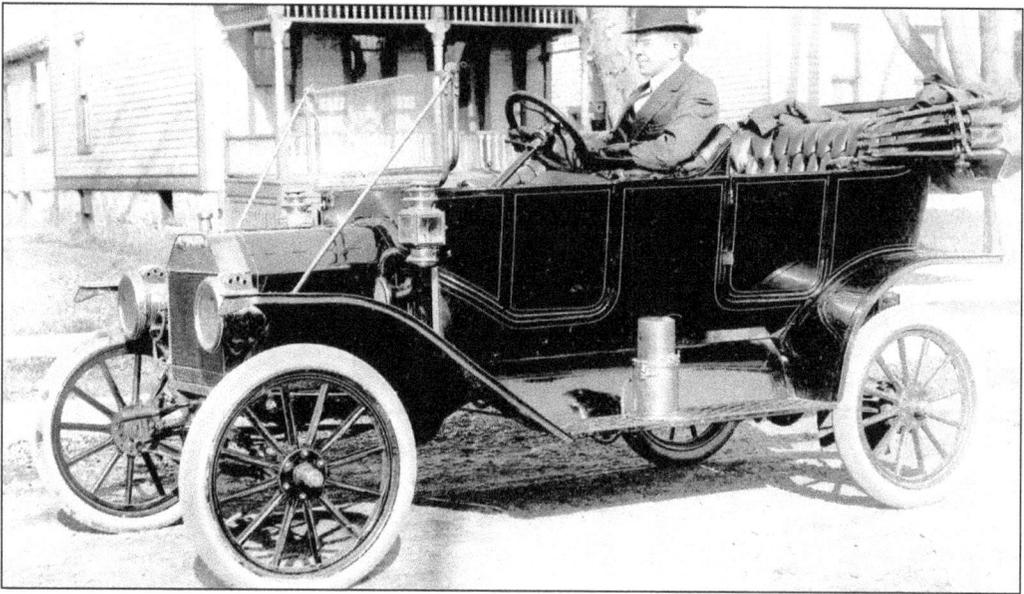

Leo Rosenberger is pictured here driving his 1912–1913 Ford. He was born in 1891 and worked at the *Clinton Herald* as the Mechanical Superintendent for $53^1/_2$ years. (Photograph from the Clinton County Historical Society Archives.)

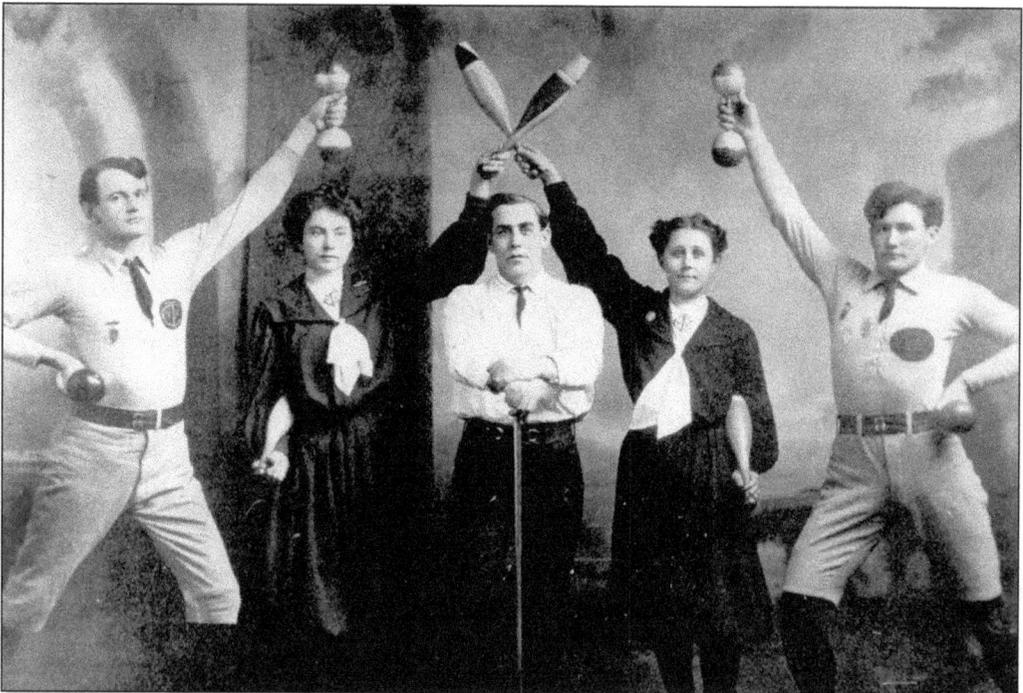

The Clinton Turn Verein (Turner Club) was formed in 1877 for the purpose of promoting physical education and fitness. The first Turner Hall was built on the corner of 3rd Avenue and 4th Street. Pictured from left to right are: Otto Bark; Lena Petersen; John Edens, Instructor; Emma Edens Johannsen; and Emery Thompson. (Photograph from the Clinton County Historical Society Archives.)

Lt. John Burke, a native Clintonian, graduated from Lyons High School as valedictorian in 1935. While serving as a pilot in World War II, he lived through many missions including D-Day; however, his plane was shot down on September 17, 1944 over Holland. During the summer of 2003, a memorial was established in Endhaven, Holland for Lt. Burke and the rest of the air crew. (Photograph courtesy of William Burke.)

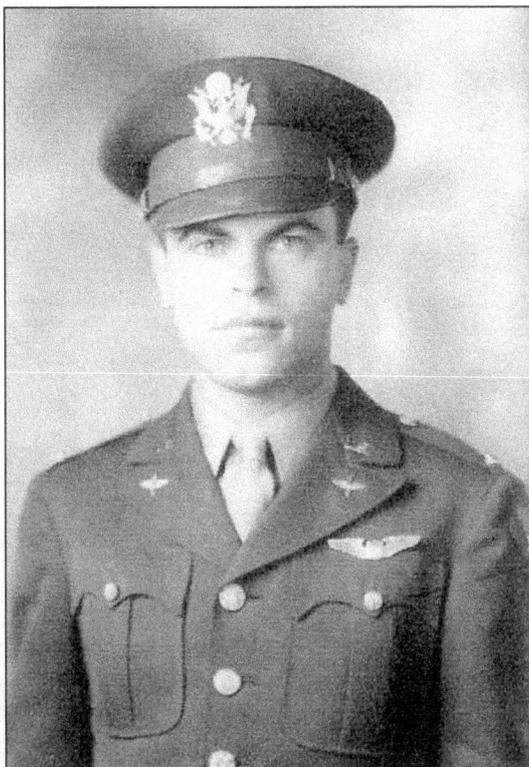

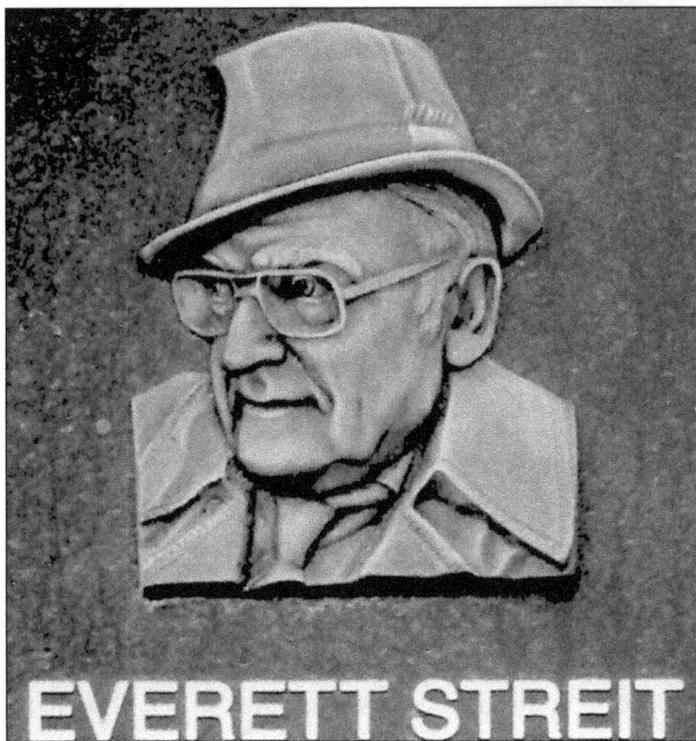

EVERETT STREIT

Everett Streit was beloved by the citizens of Clinton. He was employed with the *Clinton Herald* for 64 years, serving as editor for 35 of those years. "Ev" served on many city boards, commissions, and in leadership positions that made Clinton a better place for all of us. (Photograph from the Clinton County Historical Society Archives.)

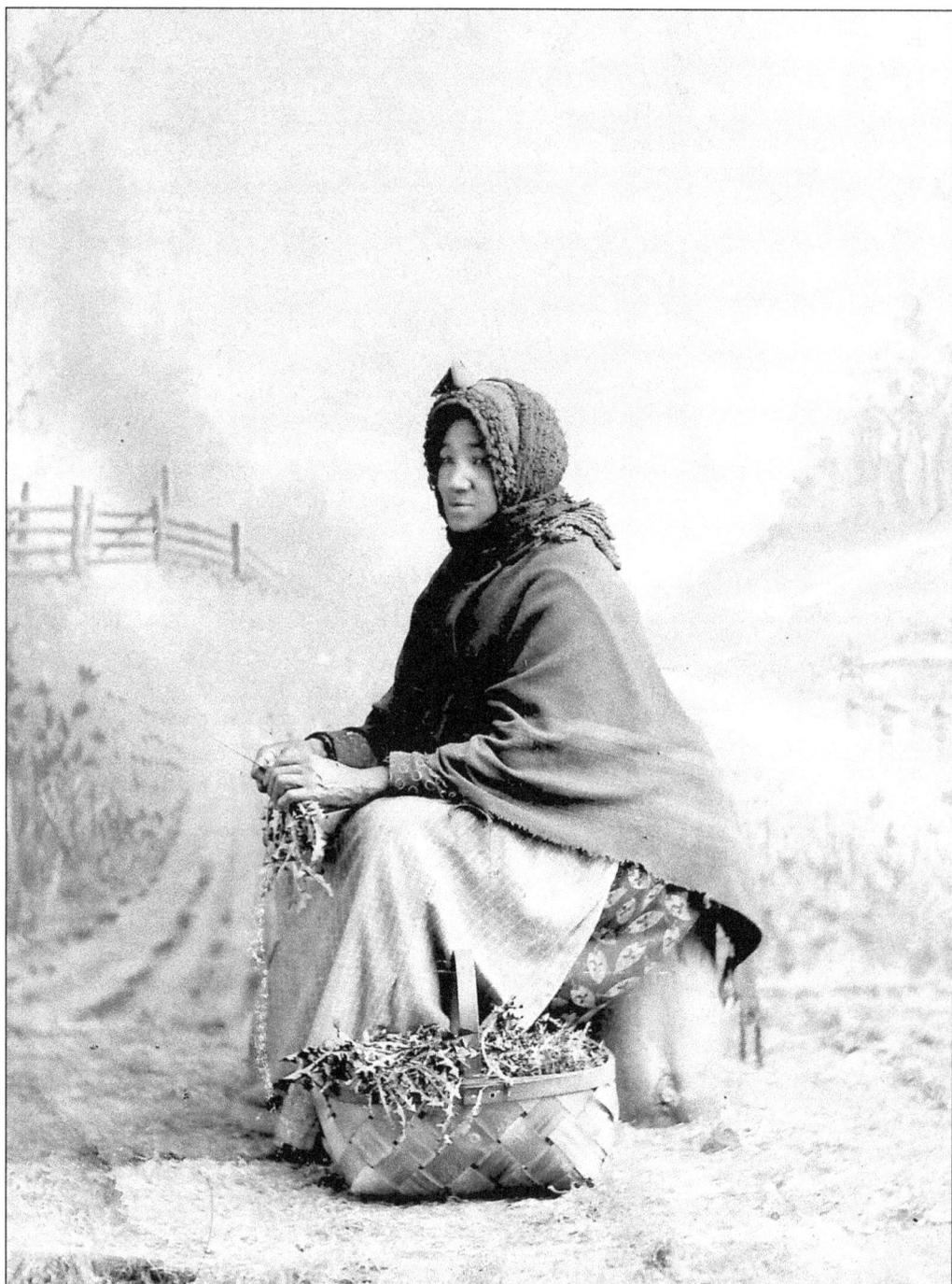

Elizabeth Fairfax (locally known as Aunt Liz) was born a slave and served as a scout and a nurse during the Civil War. After the war, she adopted Clinton as her home. By her industry and economy, she bought a little homestead and raised two children. Toward the end of her life, Clinton businessmen set up a donation fund and sent Aunt Liz to take part in the Grand Army of the Republic's national encampment in Boston, where she was known as "Mammy" to her old regiment. (Photograph from the Clinton County Historical Society Archives.)

Frederick Wayman (Duke) Slater enrolled in Clinton High School in 1913. As a budding athlete, he was anxious to try out for football in spite of his father's disapproval. The family was unable to afford the $10 needed to buy both the required shoes and helmet. He chose the shoes and became so accustomed to going without a helmet that he never wore one during his high school or college careers. (Photograph from the Clinton County Historical Society Archives.)

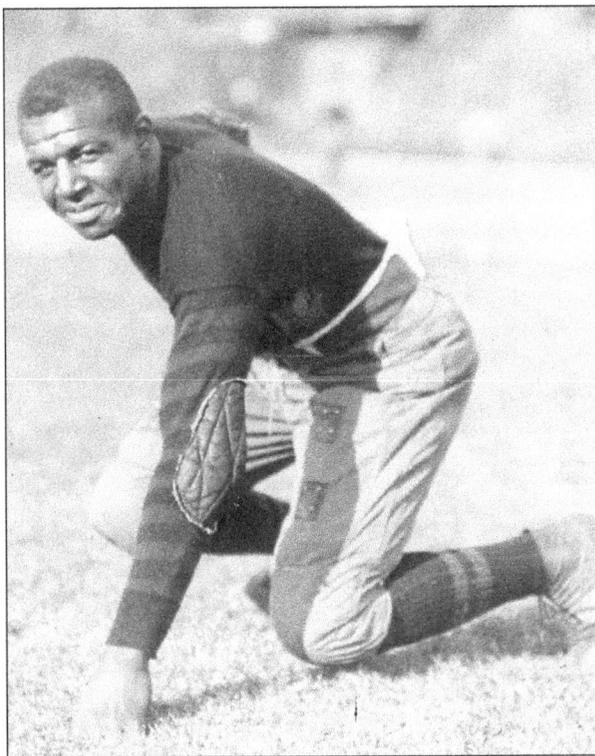

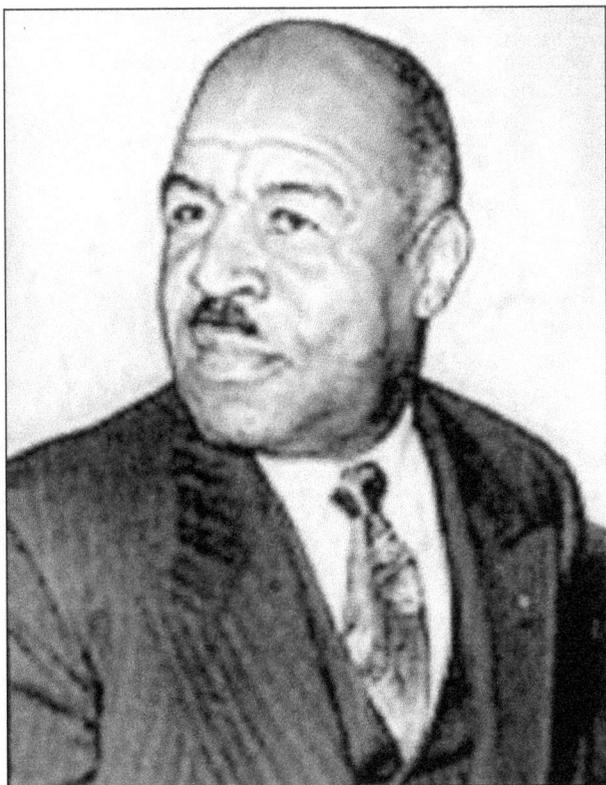

After playing every game during his University of Iowa football career, Duke Slater went on to play professional football for nine years. The great athlete went on to earn a law degree in 1929 and served as a judge in the Illinois Circuit Court from 1960 until his death in Chicago in 1966. (Photograph from the Clinton County Historical Society Archives.)

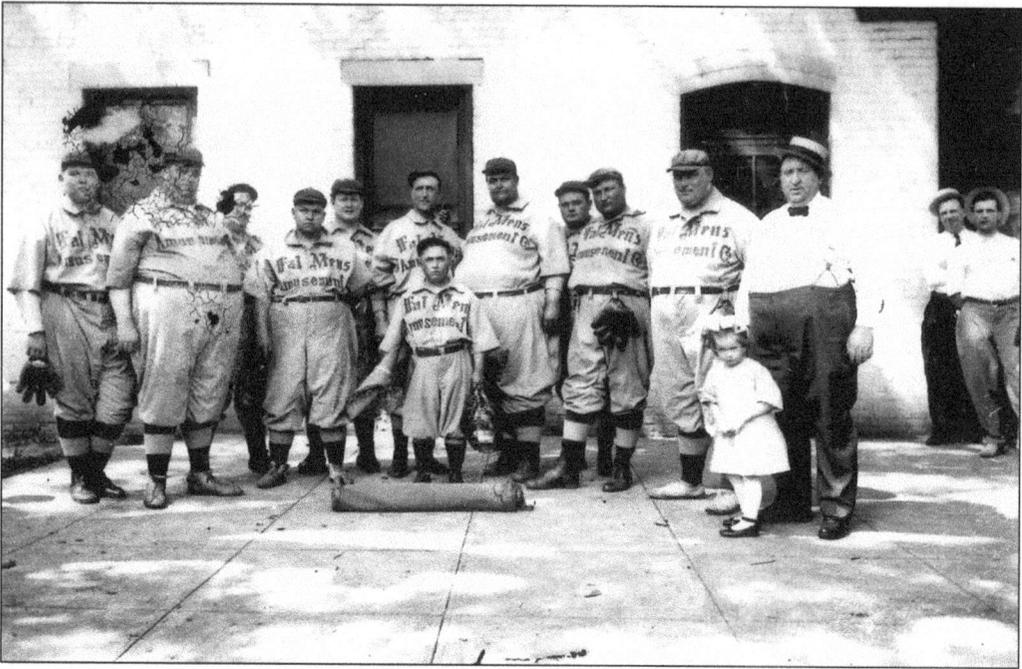

The Fat Men's Amusement Company baseball team was a traveling team that visited towns throughout the Midwest. They came to Clinton many times, playing baseball with local clubs and entertaining at celebrations and participating in parades. Both photos date from *c.* 1910. (Photographs from the Clinton County Historical Society Archives.)

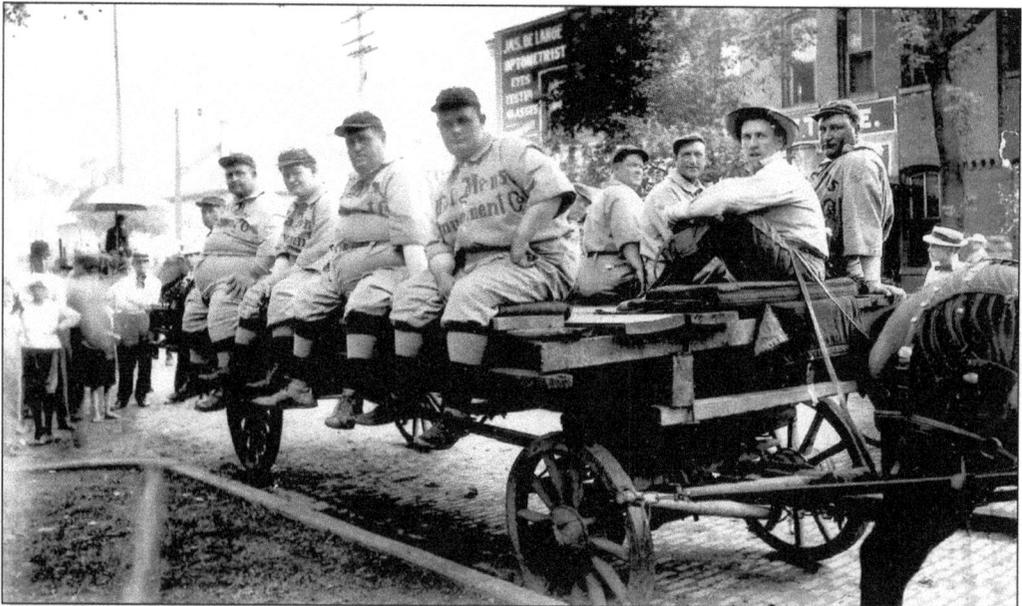

Frank Ellis, a local attorney at the turn of the 20th century, and his wife had one child, Jane, born in 1900. The playhouse they built for Jane in their yard at 318 6th Avenue S. equaled many homes of the era. It was large enough that it has been used as a home for many families throughout the years. During 1917, it was used as a servicemen's canteen. The little house was moved to 208 25th Avenue N. and remains there today. (Photograph from the Clinton County Historical Society Archives.)

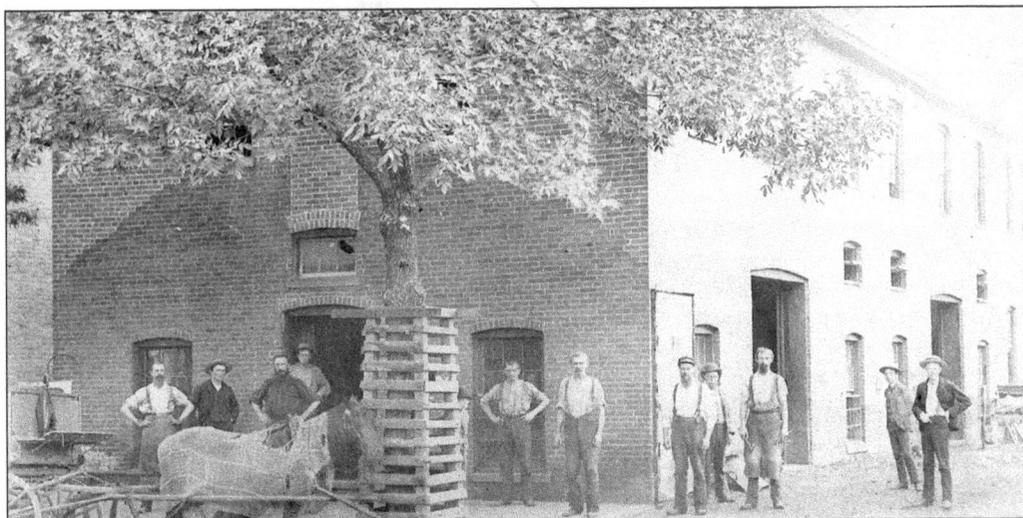

The old blacksmith shop, shown here in 1888, was erected in the 1860s around the time Lillian Russell was a child in Clinton. The building occupied the site of what is now 411 S. 2nd Street. Pictured from left to right are the following: Mose Harding, John Stewart, Chris Christiansen, unidentified, Frank Wythe, unidentified, George Bryant, unidentified, and Frank Mangold, head blacksmith. The last two men are unidentified. (Photograph from the Clinton County Historical Society Archives.)

Ruby Bell Rickoff, known to the American public as Madame Coretta, was born in Clinton in 1899. At four years old, she was 25 inches tall and weighed 15 pounds. Her family reluctantly consented to let her go into show business at the age of five, and she entertained for four seasons with the Ringling Brothers Circus. While with the Mazeppa Carnival at age 13, Ruby Bell was buggy riding with her manager when the horse bolted, and she fell to her death. At the time of her death, she was 30 inches tall and weighed 19 pounds. (Photograph from the Clinton County Historical Society Archives.)

William H.D. Koerner, born in Germany in 1898, came to Clinton as a child and was educated in the Clinton public school system. During his early years, he was a student with the John M. Stitch Art Studio. Mr. Koerner started his career as a staff artist with the *Chicago Tribune* and went on to many national magazine assignments, including covers for the *Saturday Evening Post*. While a painter of many subjects, his favorites were of the Old West. The Cowboy Hall of Fame holds a special showing of his work. (Photograph from the Clinton County Historical Society Archives.)

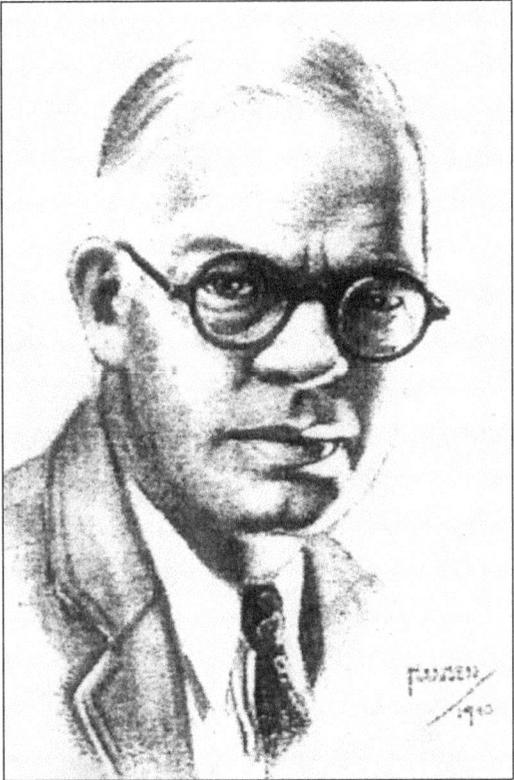

Robert German, M.D., a local dermatologist practicing in Clinton for over 30 years, has held many state medical offices, including President of the Iowa Dermatological Society, while also being active in his church. Over the years, two women from Clinton have held the office of the President of the Iowa State Society of Medicine: Dr. Mary A. Coveny in 1907 and Dr. Maryelda Rockwell in 1950. (Photograph courtesy of Dr. Robert German.)

Dan Winget is pictured here with Buffalo Bill around the turn of the 20th century. Mr. Winget published the *Merry War*, a social commentary newspaper of the 1890s. He had earlier been a Pony Express rider and was a friend of Buffalo Bill, the famous Pony Express rider. Many times the two men led Clinton's picturesque parades, especially those held on Memorial Day, winding their way to Springdale Cemetery to honor the veterans taking their final rest. (Photograph from the Clinton County Historical Society Archives.)

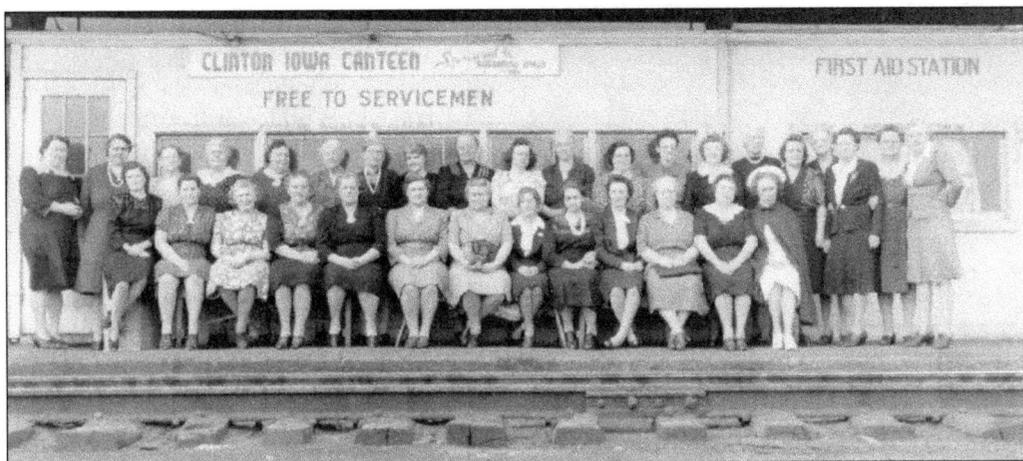

The Sustaining Wings were a group of local women who, with help from their husbands in 1943, formed a "free canteen" at the Clinton Depot for the many servicemen and women who were traveling through the city on trains during World War II. They originally met the trains with lunch baskets filled with food and used the express hand trucks as serving tables. Soon, more women joined the effort, and they expanded into a dining car loaned to them by the Northwestern Railroad. Plans to build a wooden shelter and first aid station brought many benefits from area businessmen and civic and church groups, and the women began to meet every train from 7 a.m. until midnight. When the canteen closed on March 03, 1946, over 2,136,000 military personnel had enjoyed the hospitality. (Photograph from the Clinton County Historical Society Archives.)

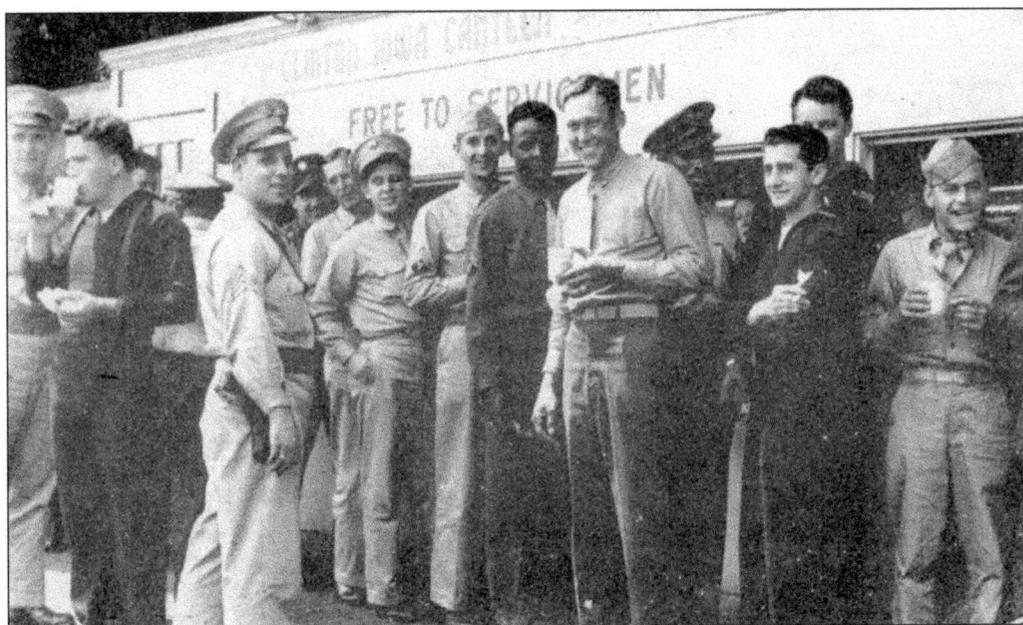

Stanley Reeves was born in 1914 and while teaching in Cedar Falls, Iowa, was drafted into the Army Air Force in World War II. After his military service, he came to Lyons to be principal of the Lyons Junior High School. He was also a principal and a teacher at North, South, East, and West schools in Lyons and was principal of Horace Mann School from 1953 until his retirement in 1980. Mr. Reeves was dedicated to the education of the city's students and received many awards for his service. (Photograph from the Clinton County Historical Society Archives.)

Marquis W. Childs, 1903–1990, Pulitzer Prize winner, was a Clinton native and a graduate of Lyons High School. Mr. Childs, who garnered national fame and recognition as a Washington correspondent for the *St. Louis Post-Dispatch*, wrote the book entitled *Mighty Mississippi*. No stranger to controversy, Mr. Childs wrote a 1932 article for *Harper's* magazine that caused an uproar among the surviving relatives of the families most prominent during the lumbering era. He stated about Clinton, "On Saturday pay-day night, no good woman stirred out of the house without a strong man at her side. . . ." (Photograph from the Clinton County Historical Society Archives.)

Felix Adler, known to the world as "Funny Felix," is a Clinton native and began his career in vaudeville. As a most amusing entertainer, he was considered "The King of the Clowns." Felix's first love was entertaining children, and he spent many holidays in his hometown bringing delight to the children of the city. (Photograph courtesy of Theo Smith and the Discovery Center.)

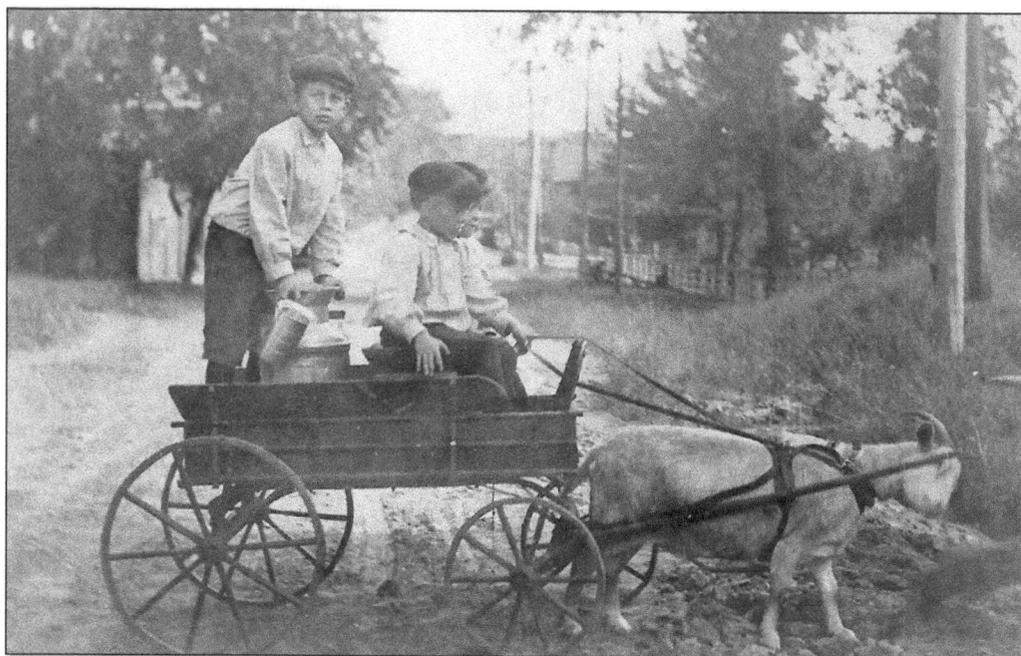

Ray, Art, and Ed Gideonsen are pictured in a goat cart in 1915. They were the sons of John and Fena Gideonsen, owners of the Oak Grove Dairy on Harrison (now 22nd Place), across from Chancy Park. Oak Grove was the original name of Chancy Park. (Photograph from the Clinton County Historical Society Archives.)

On August 14, 1976, the 1926 Clinton High School graduating class held their 50-year class reunion. CHS had 175 graduates in that class. After 50 years, they still look like a great group of happy folks. (Photograph from the Clinton County Historical Society Archives.)

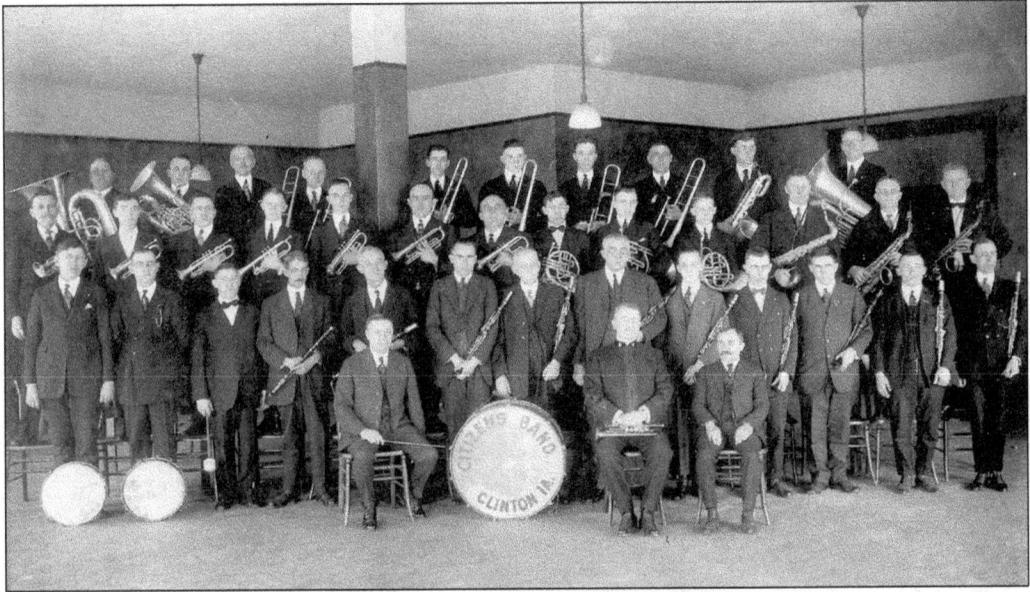

Emil Flindt came to Clinton in 1912 as a musician at the Family Theater, where he directed the Clinton Citizen's Band as well as his own orchestra. In 1916, Flindt wrote "I'm Proud to Call Them My Boys" when the 1st Iowa Field Artillery was sent to war on the Mexican border. He also led the 126th Field Artillery Band during World War I. (Photograph from the Clinton County Historical Society Archives.)

While in France during World War I, Emil Flindt wrote a melody known as "The Truck Driver's Dream," which he later introduced as "The Waltz of the Poppies." Wayne King, an aspiring musician from Savanna, Illinois, first heard the song while living at the YMCA in Clinton. Mr. King later renamed the song "The Waltz You Saved for Me" and after writing new lyrics for it, used it as his theme song. (Photograph from the Clinton County Historical Society Archives.)

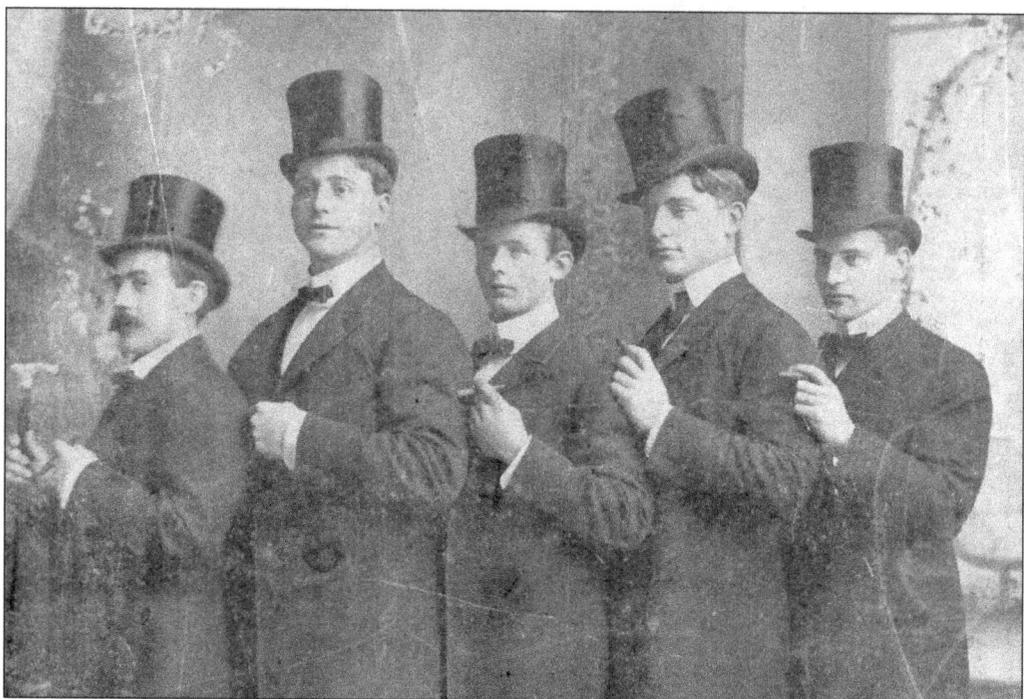

The Jolly Five were cigar makers in the city of Clinton during the 1880s. This photograph appeared inside the lid of their cedar cigar boxes, which held 25 to 50 smokes. They entertained throughout the area while plugging their own hand-made cigars. Pictured from left to right are the following: John Edens, John Maxheim, Hans Petersen, Frank Maxheim, and Alfred Hansen. (Photograph from the Clinton County Historical Society Archives.)

Frederick E. Schoenbaum was born on January 8, 1906 in Denver, Iowa. He has a Master of Music degree from Sherwood Music School in Chicago and was head of the music department at Wartburg College in Clinton from 1929 until 1935, when it was relocated to Waverly, Iowa. He graduated from Wartburg Seminary in 1929. He served as pastor at Zion Lutheran Church in Elvira, Iowa from 1935 until January 1945, when he was called to Zion Lutheran Church in Clinton, Iowa. He served there until 1952 and later returned in 1982 as visitation pastor. In 1931, he organized the Apollo Choral Society in Clinton, which has presented Handel's *Messiah* during the Christmas season each year since. (Photograph courtesy of the Schoenbaum family.)

Harold Kelly spent much of his life entertaining people of all ages and making them smile with his magic. Starting as a 10-year old-child entertaining his friends, Harold Kelly's first paying magic show was in the 1930s at the local Eagle's Club. During the Depression, Harold Kelly, as the magician, and his friend, Felix Adler, as the clown, put on a show together at the old German Theater, now the Odeon Club. All proceeds were given to help keep the soup kitchens going. This photograph shows Mr. Kelly in his 80s, the last time he performed magic tricks for his family; however, he lived to be 94 years old. (Photograph courtesy of Mr. Kelly's family.)

Reuben Henry Beil, known as "Mr. Camera," a local photographer of hometown people and scenes, was born in Clinton in 1885. At age 16, he purchased his first camera, and four years later, he had advanced to home portraits and commercial photography using his parents' home as his studio. In 1912, upon opening the first Beil Studio, he worked to perfect a formula of chemicals that would obtain a satisfactory emulsion. He soon discovered that magic "mix," and his early photographs are well preserved to this day. Many generations are grateful to him for recording Clinton history in his over 50 years of service. (Photograph courtesy of the Beil family.)

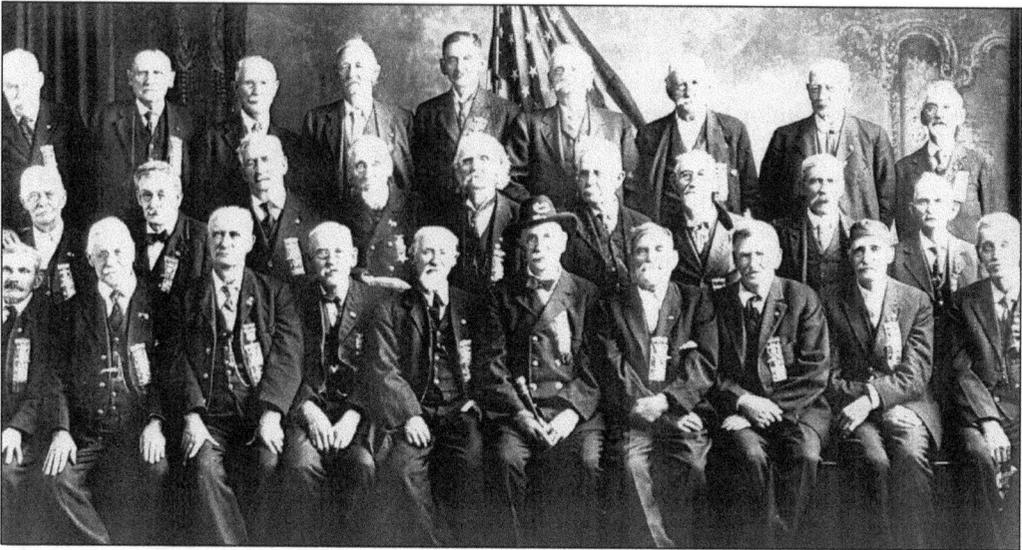

The General N.B. Baker G.A.R. Post No. 88 in Clinton was named after Nathaniel Bradley Baker, a New Hampshire native, who made Clinton his home and earned the respect of his fellow man leading troops in the Civil War. After organizing, the men of the post began holding assemblies and were known for their picturesque parades leading to Springdale Cemetery, where a section had been set aside for the veterans of the War of the Rebellion. Pictured from left to right are the following: (top row) S. Brooks, E.D. Wells, G.W. Barker, William McCune, Thomas Wheeler, Spencer M. Lecky, J.A. Platt, Thomas J. Brown, and T.M. Rinebarger; (middle row) J.H. Dunmore, J.H. Davison, B.F. Mattison, R.S. Rathbun, William F. Nixon, G.W. Davis, Geo. D. Dalrymple, H.C. O'Dell, and Isaac Strom; (bottom row) Theo. Kleppien, W.H. Easterly, R.C. Young, J.M. Wheeler, J.C. Bartow, C.F. Kellogg, B.B. Baldwin, A.R. Hart, Warren Turner, and Joseph A. Reece. (Photograph from the Clinton County Historical Society Archives.)

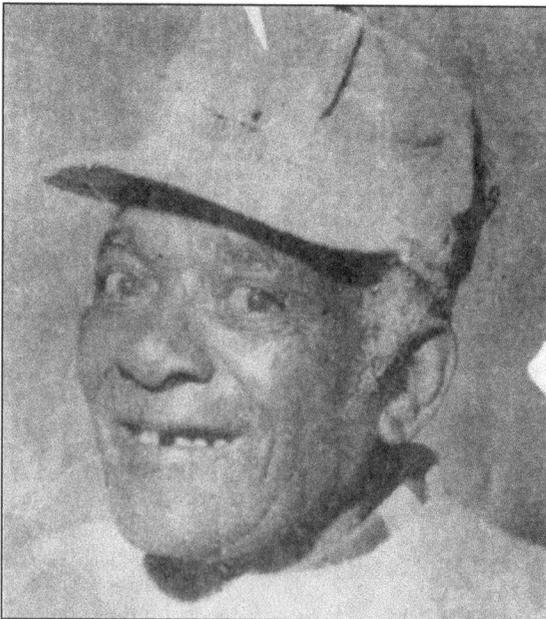

In the early 1920s, Money Harris was passing through Clinton and he liked the sound and feel of it, so decided to make it his home. For many years, Money did odd jobs around town. In the 1930s, he moved into the garbage business, helping to keep Clinton clean. Money's personality made him well-known through the community, and he entertained with whistling, cat-calls, laughs, and hand gestures. When he wasn't doing his soft shoe routine and tap dancing, his crowd-pleaser was his slack-rope walking act performed between the Howes and Van Allen Buildings crossing over 2nd Street. (Photograph courtesy of Bob Harris.)

The first triplets born in Iowa were born to James and Hannah Webster Burlingame in Clinton, in a log cabin on 15th Avenue S. and 4th Street on February 7, 1858. It is estimated they were only the third set of triplets born in the United States by that time. The names of Ada Cornelia, Ida Cordelia, and Clinton Cornelius were selected by the Clinton City Council. When Ida died in 1914, they were the oldest living triplets in the country. Ada and Clinton both lived to be over 80 years old. (Photograph from the Clinton County Historical Society Archives.)

No native of Clinton is better remembered than Lillian Russell, the regal, talented, and voluptuous stage star. She was born Helen Leonard on December 4, 1860, the daughter of Charles and Cynthia Leonard. She was just a youngster when the family moved to Chicago. At the age of 16, her mother took her to New York so that she could continue voice lessons under Leopold Demrock. It was at this time that she changed her name to Lillian Russell. She made a triumphal return to her "hometown" on October 25, 1896, when she gave a performance as the star of *American Beauty* at the Davis Opera House. The film version of Lillian Russell's life premiered in Clinton in 1940 and sparked one of the city's largest celebrations. (Photograph from the Clinton County Historical Society Archives.)

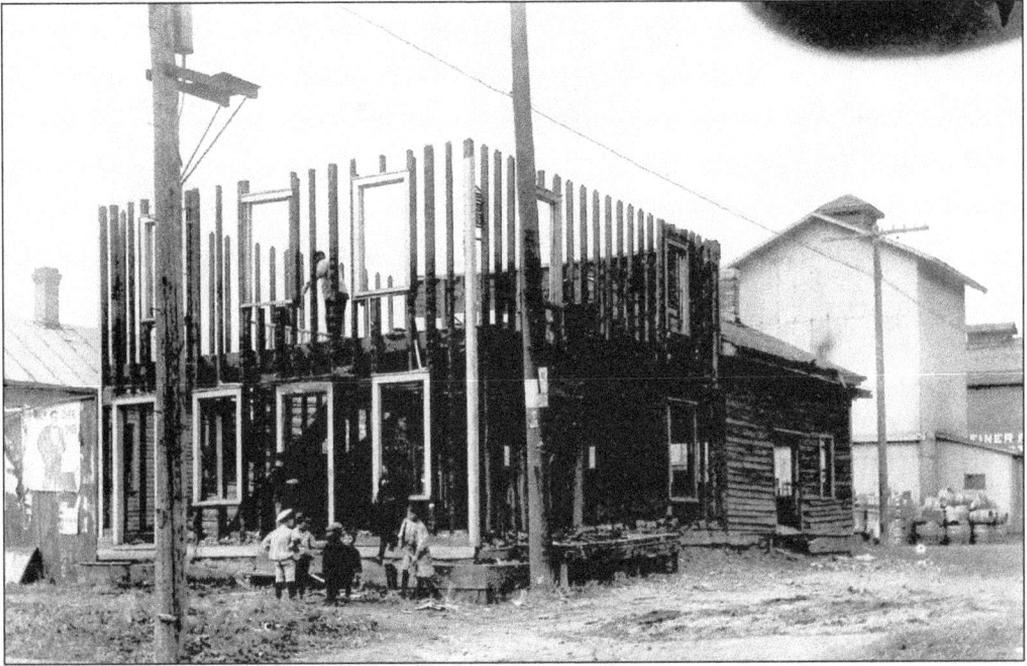

This image depicts the demolition of Lillian Russell's birthplace in the 100 block of 4th Avenue on October 19, 1907. (Photograph from the Clinton County Historical Society Archives.)

Allen E. Paulsen was born in Clinton in 1922. By age 13, he was supporting himself by selling newspapers and cleaning the lobby and restrooms of the Lafayette Hotel. After earning a degree in engineering and becoming a pilot, Mr. Paulsen became President of American Jet Industries. Besides setting many world aviation records and holding five aviation patents, he also earned the Horatio Alger Award. (Photographs from the Clinton County Historical Society Archives.)

In 1934, the Rich Manufacturing Company moved from Morrison, Illinois to Clinton, Iowa. For three decades, the Rich name brought to mind attractive wheeled toys, doll houses, toy boats, and wooden rocking horses. The toys, which were sturdily built and attractively designed, sparked consistent growth by the company. (Photograph from the Clinton County Historical Society Archives.)

With the outbreak of World War II, the Rich Company shifted to the war effort. Following the war, the toy line was expanded to include plastic rocking and hobby horses. In 1953, the company relocated in Tupelo, Mississippi to be closer to oak and pine wood. Late in the 1950s, a dam broke near Tupelo, and the plant was destroyed. It was never rebuilt. (Photograph from the Clinton County Historical Society Archives.)

112

Clinton's Bickelhaupt Arboretum was a gift in 1970 to the people of the community from Frances and Bob Bickelhaupt. It is well-known throughout the United States, as well as overseas, and it would be impossible to name all the collections in this beautiful 14-acre outdoor museum. The collection of dwarf and rare conifers is considered one of the best in the country. The arboretum is open daily from dawn to dusk and includes a Visitors' Center with a display of native animals, birds, and plants. (Photograph courtesy of Francie Hill.)

Jack Dermody was a Clinton native and graduated from St. Mary's High School. A U.S. Navy veteran, he was employed by the *Clinton Herald* for 33 years and held many leadership positions, including that of newspaper publisher for ten years. Mr. Dermody was instrumental in founding the "Community that Cares" project and was also involved in many civic organizations. While he assisted many organizations in raising funds for the community, he also worked quietly on his own personal crusade for people in need. (Photograph courtesy of the Dermody family.)

Clinton County, Iowa is the only geographical area in the United States—if not in the world—to be proudly known as the hometown of three NASA astronauts. George "Pinky" Nelson (upper left), Dale Gardner (lower left), and David Hilmers (lower right) all hail from Clinton County. All of them have been in space more than once and have logged many thousands of space miles. At this time, all three men have left the NASA space program to pursue individual careers. (Photographs from the Clinton County Historical Society Archives.)

This is a 1915 gathering of some of the business leaders of the city. Pictured in this photograph are, from left to right, as follows: (back row) Fred H. Van Allen, Secretary of the John D. Van Allen Department store; unidentified; unidentified; unidentified; and Albert C. Buechner, Grocer; (front row) Dr. Bachelder; unidentified; unidentified; Frank C. Brayton, Cashier of Champion Feed Mill; and Louis C. Moesinger, President of Marquis Hardware and Vice President of Iowa State Savings Bank. (Photograph from the Clinton County Historical Society Archives.)

Artemus Lamb Gates was the son of Emma Lamb and Marvin Gates. After he was born and educated in Clinton, he went on to Yale University, where as a star tackle he led his football team to victory over Harvard in 1917. During World War I, Gates developed an illustrious military career, and he was awarded the Navy's Distinguished Service Medal. He was also recommended for the Congressional Medal of Honor. In 1941, President Roosevelt appointed Gates as Assistant Secretary of the Navy. Later, in 1945, President Truman named him Undersecretary of the Navy. (Photograph from the Clinton County Historical Society Archives.)

Monsignor Ambrose Burke was ordained a Catholic priest in 1921 and lived his ministry until his death at the age of 103 years. At that time, he was the oldest active priest in the country. He served the parishioners of Clinton's Catholic community for 42 years in many pastoral positions until his death in 1998. Msgr. Burke was a well-known orator throughout the Midwest and was in great demand as an inspirational speaker. (Photograph from the Clinton County Historical Society Archives.)

Helen Ericksen was a lifelong Clinton resident and was involved in many civic organizations in the city. She worked as a nurse-anesthetist and was active in the Clinton Recreation Commission. Helen bequeathed a sizeable portion of her estate to establish a center for the children of Clinton. Today, the Ericksen Community Center, built within five years of her death, has served the children of Clinton well. (Photograph from the original portrait displayed at the Ericksen Community Center.)

Joe Less, a concert violinist in the 1920s, was never satisfied with the way he tied his tie. He felt that it never looked proper so he decided to invent a pre-knotted tie, which involved only slipping the narrow end of the tie through a slot in the knot. His three brothers, Walter, Louis, and William joined him in the enterprise and began manufacturing ties in the family home at 419 16th Avenue S. They called their business "One-In-Hand" Tie Company. Regular ties were purchased in New York, and the task of cutting them up and doing the necessary stitching was farmed out to Clinton women. The demand for the novel tie grew so rapidly that in 1935 the company erected a 2-story frame building near the family home for expanded facilities. For two decades, 1940–1960, the One-In-Hand was the only pre-knotted tie produced in the United States. The Less Brothers partnership was dissolved in 1966. (Photograph from the Clinton County Historical Society Archives.)

Henry F. Sanger Enterprises occupied most of the building located on the northwest corner of Main Avenue and 2nd Street in Lyons. A Five and Dime Store was on Main Avenue, and a Department Store was on 2nd Street. Everything was sold wholesale as well as retail. Almost any type of costume could be purchased after Mr. and Mrs. Sanger opened their Sanger Costume and Novelty Company at 513 Main Avenue in 1888. Mrs. Sanger traveled by car, train, bus, carriage, bobsled, and even once on an iceboat as she delivered costumes for over half a century. Mr. Sanger also managed Sanger's City Transfer Line, which hauled anything moveable. (Photograph from the Clinton County Historical Society Archives.)

Floyd (Bud) Smith's athletic capability has made his name known locally, nationally, and internationally in straddle-form high jumping. "Flying Floyd" began his career in high school and continued gathering honors throughout his college career. In 1957, he held the record for the best legal high jump in the world. Bud has represented the United States in the Master's World Games in Puerto Rico, Italy, and England, along with traveling to Moscow to perform and encourage older Russians to become involved in the Senior/Masters program. He was inducted into the Northwest Illinois Sports Hall of Fame in 1987. (Photograph courtesy of Floyd Smith.)

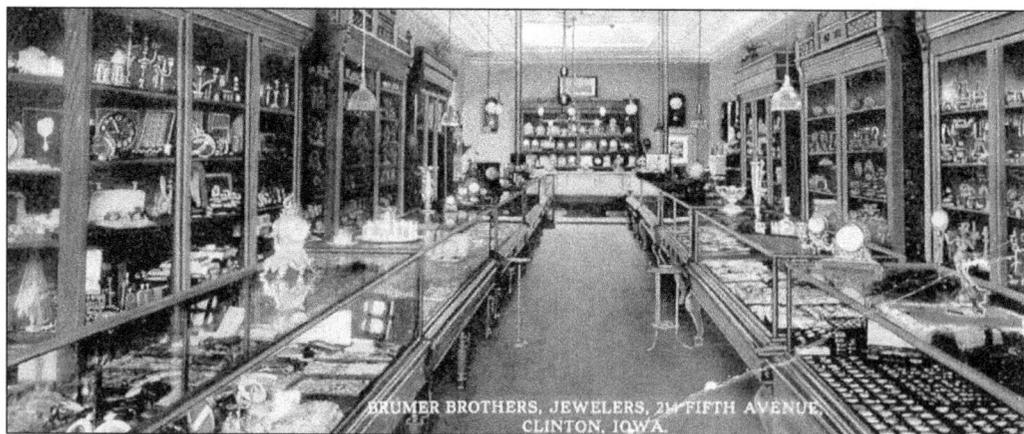

The Brumer brothers opened their original store at 214 5th Avenue in Clinton in 1855. They stayed together until 1892 when one of the brothers left to open his own store in DeWitt, Iowa. The family store remained at that address until 1937 when a grandson, Gus, started his own store with the help of his daughter, Marie, at 509 S. 2nd Street. Marie became Mrs. Delbert H. Dudley, and she and her husband continued in the family jewelry business from 1953 until retirement in 1995. (Photograph courtesy of Mr. and Mrs. Delbert H. Dudley.)

George H. Ough started his interior decorating and painting business in 1911. He drove his 38-year-old Model T Ford truck to work every day. While he was using it, the truck was believed to be the oldest vehicle in use in the city of Clinton. Mr. Ough bought the truck second hand and drove it over 252,000 miles. (Photograph courtesy of the Ough family.)

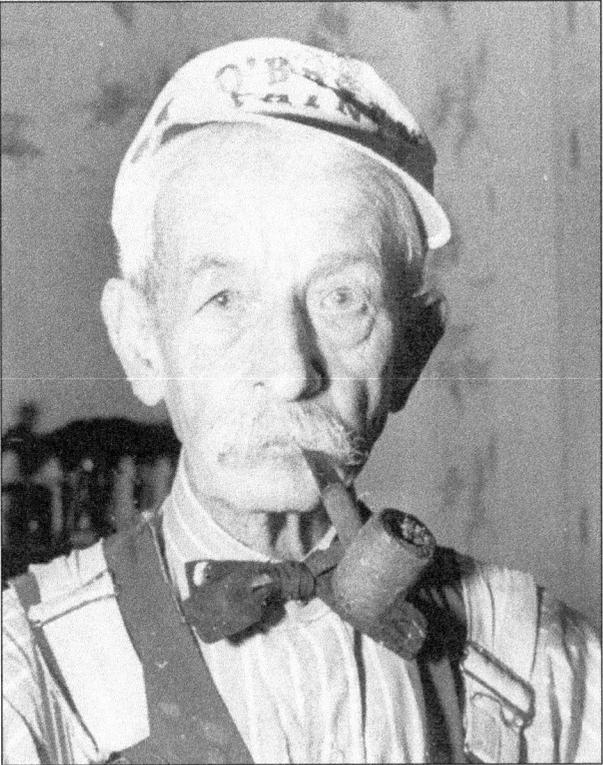

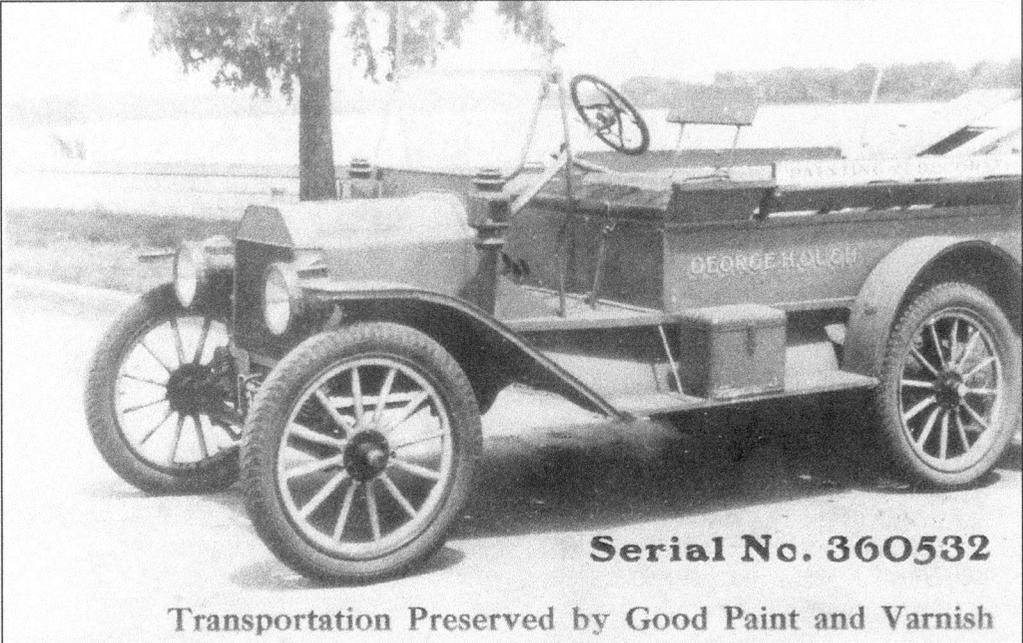

Serial No. 360532

Transportation Preserved by Good Paint and Varnish

When a photographer called on Mr. Ough, who was in his 80s, and wanted a picture of him and his beloved 1914 Ford truck, he was as pleased as a youngster displaying a new toy. This picture, printed from an early postcard, shows that in his early years of advertising, Mr. Ough prominently displayed his beloved truck. (Photograph courtesy of the Ough family.)

Robert and Ethel Soesbe are a well-known couple, active in the city of Clinton, who have donated their time to many civic causes over the years. Bob has spent 37 years working with the Iowa Federation of Labor, over 30 years with the Clinton County Historical Society, and is in his second term on the Clinton City Council—in addition to having donated 18 gallons of blood to the local Red Cross. For over 25 years, Ethel has given volunteer time to the Humane Society, the Clinton Women's Club, and the Clinton Federated Club. Both Bob and Ethel are active with the Clinton County Democrats. They are parents of nine children and enjoy grandchildren and great-grandchildren. (Photograph courtesy of Robert & Ethel Soesbe.)

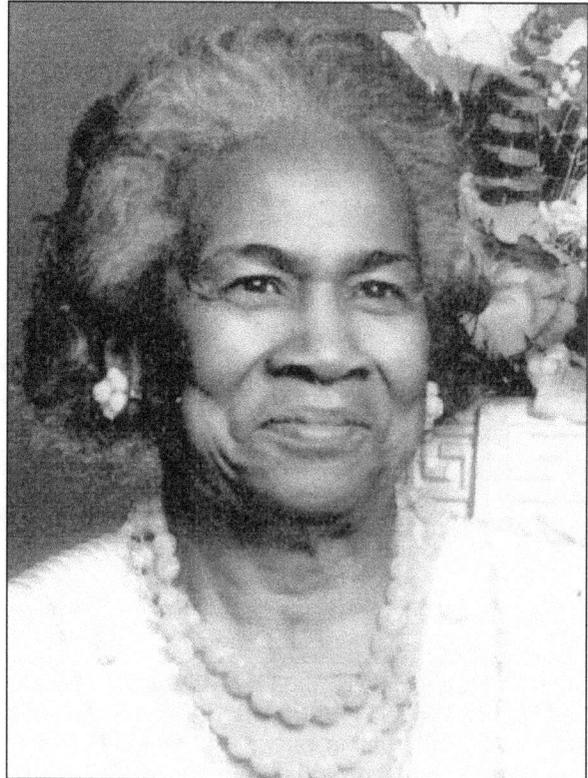

Clemmie Hightower has 62 years of state and local volunteering behind her and is still willing to provide more time to anyone who needs her. In 2002, a facility for helping women with substance abuse problems was named in her honor. The Hightower Place for Women is located at 2727 S. 19th Street. She also has spent 60 years with the American Red Cross and the YWCA, and former Iowa Governor Terry Brandstad appointed her to the Iowa Commission of Elder Affairs. (Photograph courtesy of Clemmie Hightower.)

In 1866, George M. Curtis founded the Curtis Brothers Company, which went on to manufacture interior and exterior millwork in Clinton for 100 years. The company's excellent craftsmanship is revered and still evident in many Clinton homes and businesses. Mr. Curtis was elected twice to the United States Congress, while remaining involved with community people and affairs. Due to his persistent effort, the city has benefited from its beautiful post office and River Park. (Photograph from the Clinton County Historical Society Archives.)

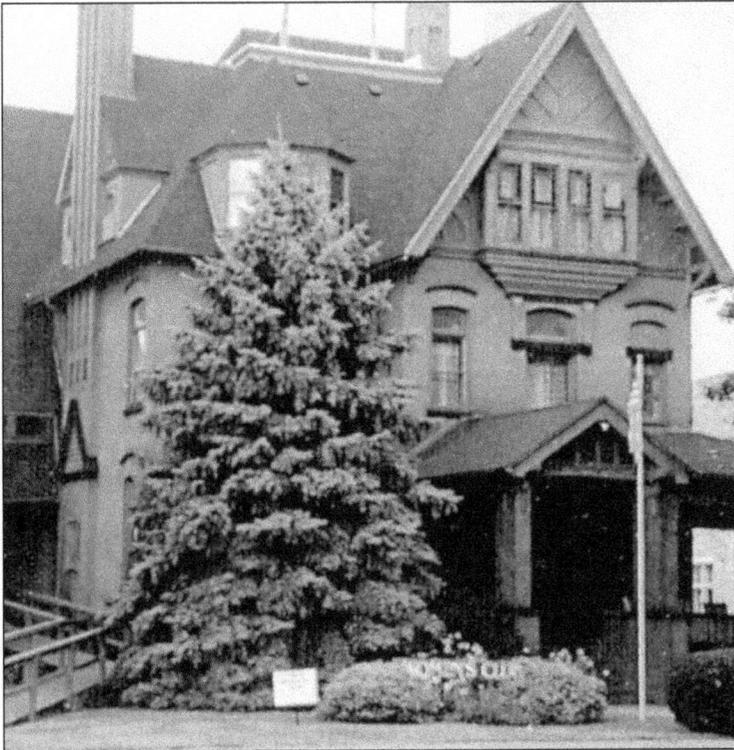

The family home of George M. Curtis is located at 420 5th Avenue S. and is now the home of the Clinton Women's Club. The building's historical and architectural importance was recognized in October of 1979, when it was placed on the National Register of Historic Places. (Photograph from the Clinton County Historical Society Archives.)

By the turn of the 20th century, Leona Specht had become a favorite dressmaker among the wealthy families of the city. When it became impossible to continue going from home to home, Mrs. Specht built the workshop pictured above, right off Bluff Boulevard. At one point in her career, Mrs. Specht had over 50 "pin girls" who did nothing but pick up pins off the floor after the seamstresses finished their day's work. She catered to a trade that extended from the Philippines to Europe, and few Clinton society weddings took place without a gown designed by "Madame Specht." (Photograph from the Clinton County Historical Society Archives.)

Paul Burden moved to Clinton with his wife, Madonna, in 1948 and worked at Clinton Corn Processing Company for 35 years. He spent 25 of those years as manager of the Clinco Credit Union where the slogan was: "One call to Uncle Paul does it all." For the next 14 years, Paul worked at the Generation Area Agency on Aging located at the Work Force Center. There he was known as the "Older Worker's Specialist." (Photograph courtesy of Paul Burden.)

Eight

THEN AND NOW

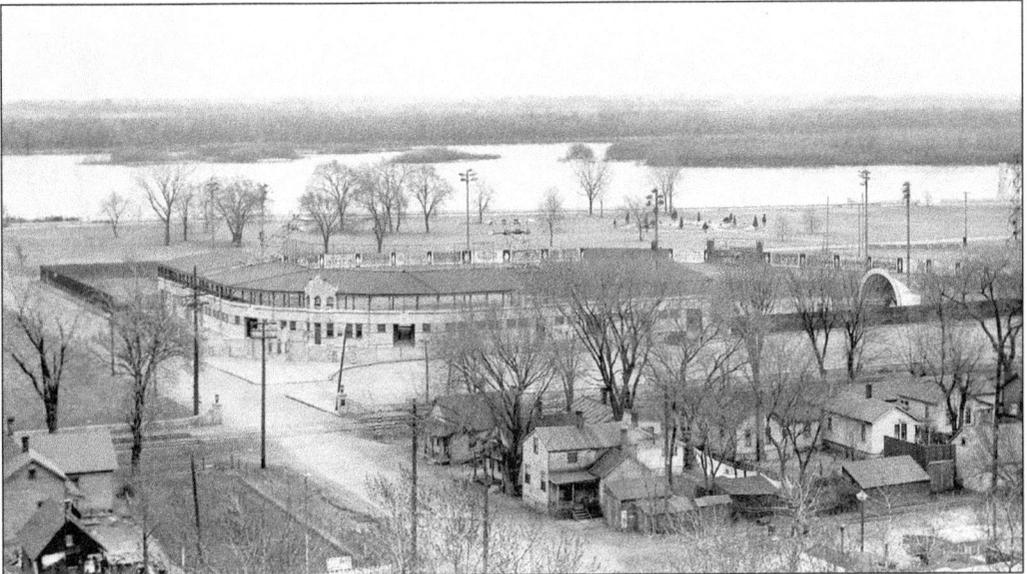

This 1937 picture shows the brand new Riverview Stadium, which was built on the banks of the Mississippi River in Clinton's Riverfront Park. The ball park construction began in 1935 as a WPA project, and the first game was played in the summer of 1937. The stadium remains the same today with minor cosmetic changes. (Photograph from the Clinton County Historical Society Archives.)

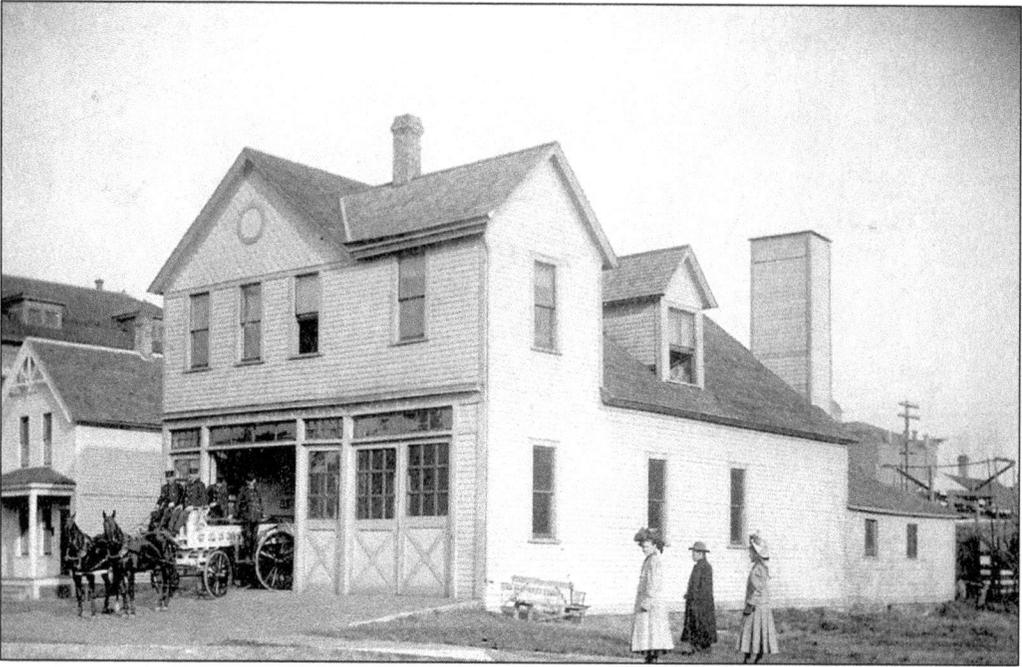

This frame house was home to Fire Station No. 3 at 2311 Roosevelt Street in Lyons. Bonnie and Beauty, matched thoroughbreds, were the pride of the Lyons Fire Station. Since horses aren't able to back up, there was a large door in the rear of the building enabling the horses to drag the fire wagon forward into the building. (Photograph from the Clinton County Historical Society Archives.)

In 1914, a new fire station was built. They moved the white frame station to an adjacent empty lot and used it until the new No. 3 station was completed. Even in the new brick station, the floor was dirt for the horses. A cement floor wasn't installed until the fire department obtained a new gas truck. (Photograph from the Clinton County Historical Society Archives.)

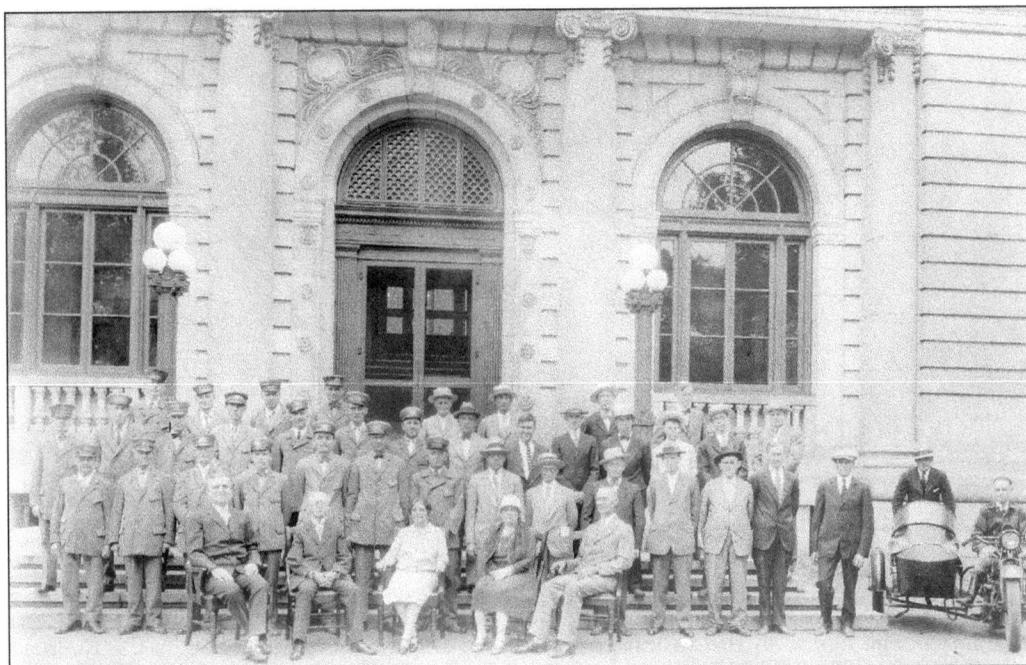

The United States Post Office, built in 1902, was the eighth building to replace previous post offices in Clinton. Located at 301 5th Avenue S., it was designed by architect Louis Simon and features ionic column capitols in a neoclassical design. The structure cost $100,000 to build and has pure white marble walls with mottled granite trimmings. This 1928 photograph shows the postal workers in front of the building. (Photograph from the Clinton County Historical Society Archives.)

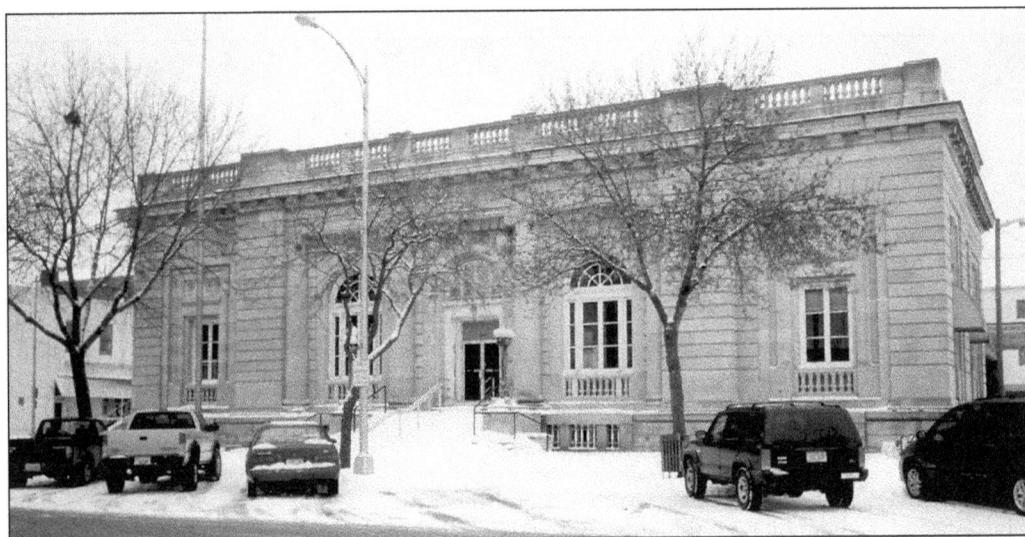

This stately post office building once named "The Pride of the City" now stands in the middle of a furor regarding its future. While many local business leaders are determined that the building should be destroyed and replaced by a parking lot, local historians and preservationists hope to determine some alternative use of the building. (Photograph from the Clinton County Historical Society Archives.)

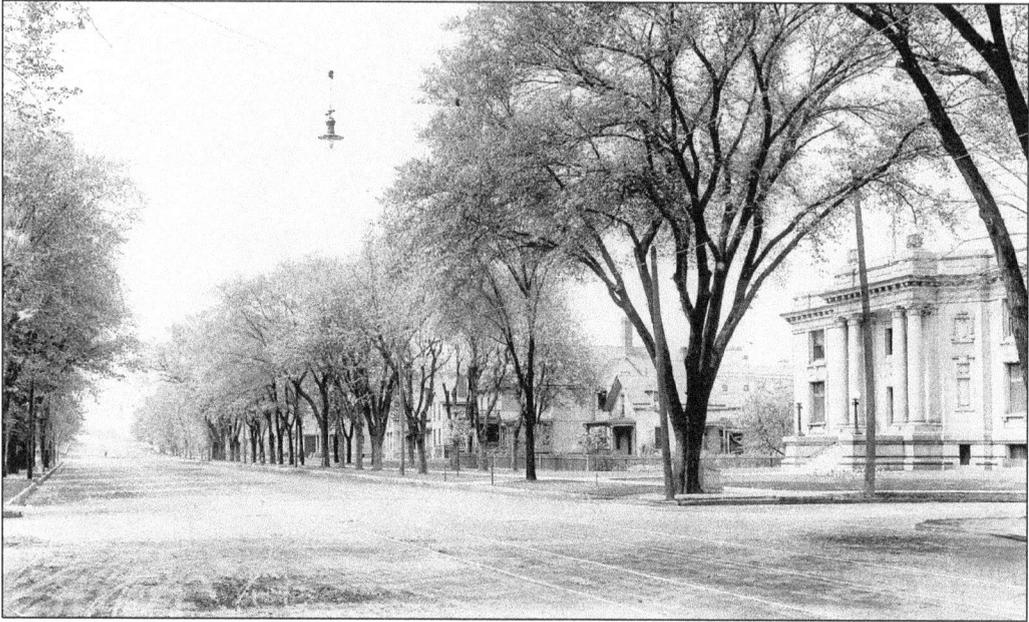

The first public library in the nation was conceived and established in 1864 by the Railroad Library Association. In 1902, the city of Clinton applied for a Carnegie grant to finance a library. The city received the grant when it agreed to maintain the structure. Emma Young Lamb, Chancy Lamb's daughter, donated the land at 306 8th Avenue S. Built of cut and dressed limestone in the Beau Arts Classicism style, the structure was designed by the Chicago architect firm of Patton & Miller. The local contractor was Daniel Haring, and it was finished in 1904. (Photograph from the Clinton County Historical Society Archives.)

The Clinton Public Library remains in the city's beloved Carnegie Building today. The surroundings have changed from a peaceful tree-lined avenue illuminated in the evenings by one of the city's acetylene arc lamps, to one amidst commercial businesses on one of the busiest thoroughfares in the city. Today's technology demands have led the Library Board of Trustees to look for an alternate site for the facility. (Photograph from the Clinton County Historical Society Archives.)

St. Patrick's Catholic Church came into existence by an order from the Bishop of Dubuque to the Rev. J.A. Murray to serve the needs of the growing Catholic population in the center of the city. In 1905, the church and its handsome rectory opened and helped capture historical heritage with its unequalled Romanesque style. Both buildings had matching cupolas, red Gladbrook pressed brick, black slate roofs, and the church featured an interior balance of columns. (Photograph from the Clinton County Historical Society Archives.)

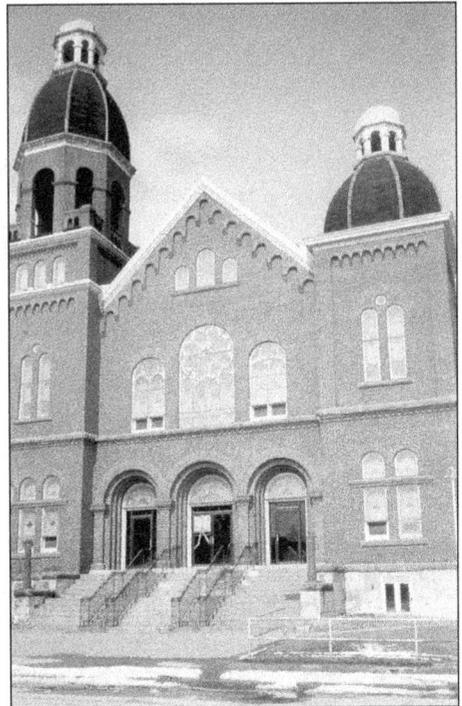

Today, St. Patrick's Church sits awaiting its fate of destruction. The bell of the church, which called the faithful to worship for so many years, was removed in 1997 and is now prominently displayed on the grounds of the Prince of Peace Catholic Academy and College Prepatory and Sacred Heart Church. (Photograph from the Clinton County Historical Society Archives.)

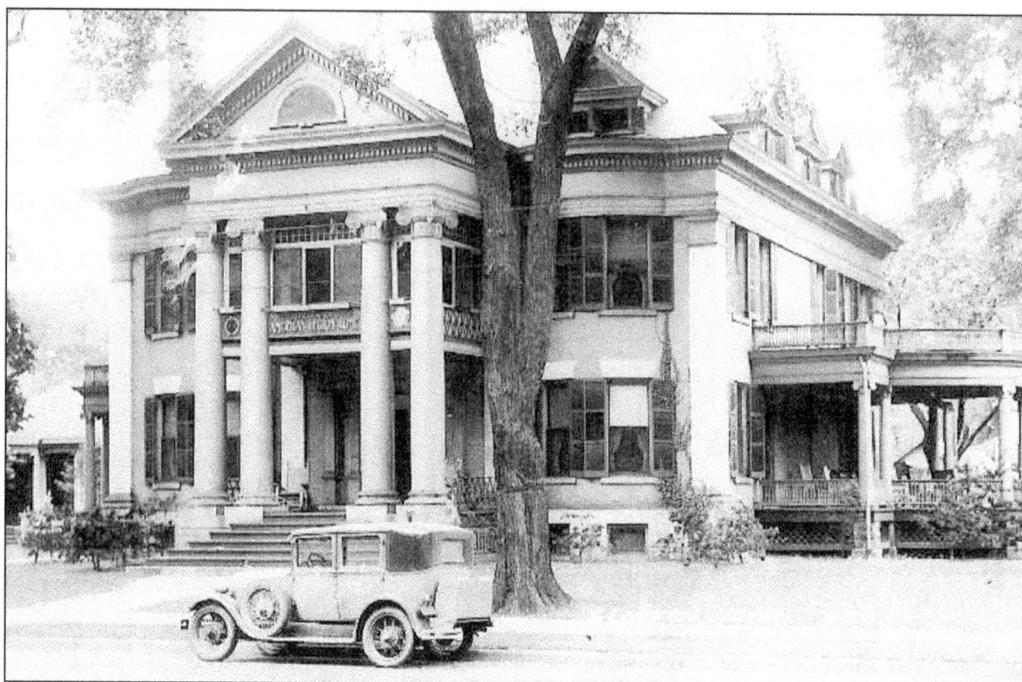

In 1919, the June Van Meter American Legion Post was organized by a group of veterans in the Revere Hotel. The organization was formed to oversee the rights of our American war veterans, arrange patriotic programs, represent veterans by marching in parades, and lend a hand to local civic organizations. In 1927, the post purchased the F.W. Ellis home at 318 6th Avenue S. (Photograph from the Clinton County Historical Society Archives.)

As the American Legion post grew, it moved from the 6th Avenue site into the Coliseum. The Ellis home was razed, and Clinton Lincoln Mercury built their car dealership on the site. The dealership is now owned by D. & D Lincoln Mercury. (Photograph from the Clinton County Historical Society Archives.)